Springwatch *and* Autumnwatch

Bill Oddie, Kate Humble & Simon King

With extras by Stephen Moss

Collins

First published in 2007 by
Collins
An imprint of
HarperCollins Publishers
77-85 Fulham Palace Road
London
W6 8JB

The Collins website is:
www.collins.co.uk

13 12 11 10 09 08

10 9 8 7 6 5 4 3 2 1

First edition 2007
This paperback edition published in 2008

ISBN 978-0-00-728510-5

Designed by Andrew Barker and Emma Jern

Colour reproduction by Butler & Tanner, UK
Printed and bound in China by South China

Contents

Introduction

Bill Oddie

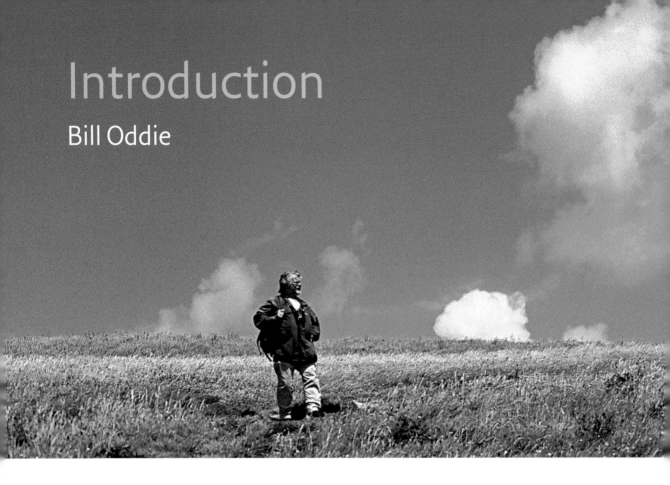

Not so much a programme, more a way of life". Readers of a certain age may recall that that was the title of a satirical TV series back in the 1960s. It featured John Bird, John Fortune and Eleonor Bron, all of whom I am happy to say are still going strong and have lost none of their wit and wisdom. Some things endure even in TV land. Quality topical comedy is one of them. How can topicality ever go out of date!? Quality wildlife programmes are another. Endurance is something very dear to the hearts of all who work and believe in *Springwatch*. "Survival" would be perhaps an even more illuminating word.

Quite an important matter survival! For us, and for nature. We are talking about the world, and all its life forms. Rarely in recorded history has this earth been more under threat. It is not always easy to sing along with Monty Python and "Always Look on the Bright Side of Life". But there is a bright side. There are several bright sides. One of them is called "knowledge". It is undeniable that some scientific advances have contributed to the condition the world and its life forms are now in. Pollution, habitat destruction, extinct and endangered species are all the products

of the advance of civilization, and the industry and technology that that involves. We humans are the cause. We are also the victims. We are also the only possible saviours. Whether you believe our abilities and characteristics to be god-given or not, there is surely not much doubt that it is our actions that will destroy or save this planet. In the short term – and it's getting shorter – it is up to us. Fortunately, we do have the knowledge, and that wasn't always the case. That is the other side of scientific advance. We know what is wrong. We know how many things can be righted.

We also have a saying: "knowledge is power". Alas, this is not entirely true. It is a sad, no tragic, and undeniable fact that many of the people who do literally have power on this earth – whether it be politicians, religious leaders, or military commanders – certainly do not display the knowledge that will allow us to protect life on earth. The knowledge that leads to action. The necessary action. The right action. Knowledge is power. Let it be power that is used for good.

So what – you may be wondering – is all this to do with *Springwatch*? I certainly do not wish to introduce a note of pessimism or despair. Neither in this book, nor on the TV. *Springwatch* is nothing if not a joyful programme. It is a celebration of the natural world. It records the undeniable fact that wildlife and human beings are potentially good for one another, and indeed often depend on one another. We aim to entertain and delight. We also aim to impart knowledge. Not just interesting facts about wild creatures, and how to see and enjoy them. But also information. Knowledge, about what needs to be done, how it can be done, and how you can get involved. Knowledge that leads to action. Knowledge that is indeed power. People power.

Oh yes, and there is one piece of knowledge that is all important: knowledge that we can make a difference. Our world can be saved. Or is that a belief? An act of faith? Blimey, I'm beginning to sound like Richard Dawkins!

At least please think about what I have just written. Get involved and enjoy. "Not so much a programme, more a way of life." Let's make it a happy and fulfiling life. That is what *Springwatch* tries to do. More a way of wild life?

Deeds or words? Both please. This book is full of words! The deeds are up to you.

Bill Oddie, March 2007.

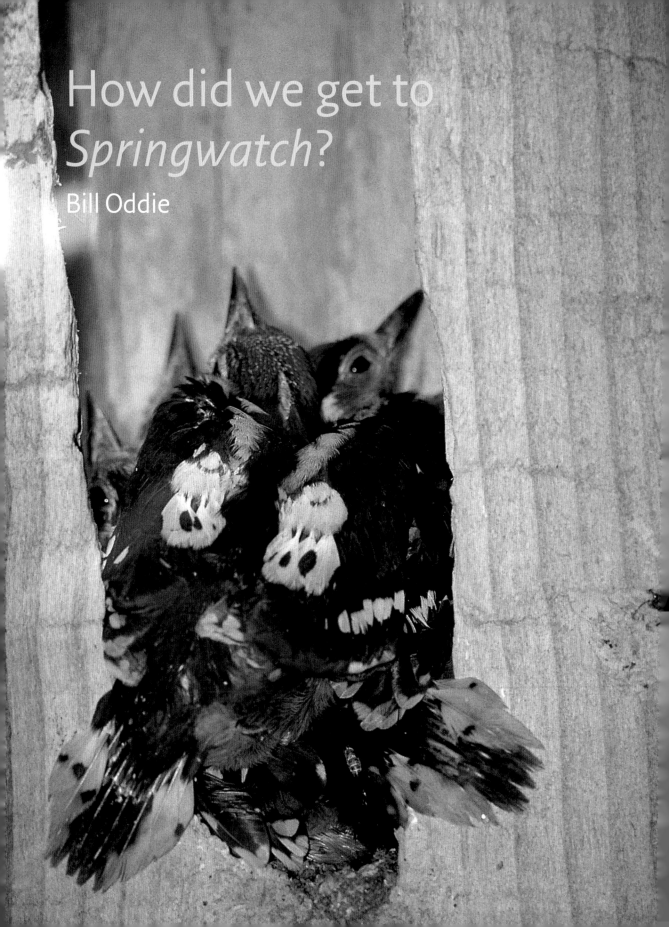

How did we get to *Springwatch?*

Bill Oddie

This is sort of a double history lesson! The story of how *Springwatch* came about, and also how its trio of presenters – Kate, Simon and myself – came together.

One of the things that undoubtedly makes *Springwatch* unique is that it is arguably the most elaborate live wildlife television series there has ever been, not only in Britain but anywhere in the world. However, this doesn't mean that is totally innovative. Live wildlife has been on the telly for quite some time. Being now in my mid-60s, I well remember the early days of broadcasting, when the sets were enormous, the screens tiny, the pictures in black and white, and "everything" was live! Animals were very much part of those long gone days, and I don't mean Muffin the Mule and Prudence Kitten! I can't say I have a totally photographic memory of the late 1940s and 50s, but I do recall watching *All About Animals*, with George Cansdale, and – perhaps on a rather more elevated level – *Look* presented by Peter Scott. I also remember such iconic and exotic presenting teams as Armand and Michaela Denis, and Hans and Lottie Hass. They weren't, of course, 'brought to you live', but I'm pretty sure some of the British fayre was.

Coming a little more up to date, it wasn't that long before Simon King appears in the TV picture! Not that Simon is older than me! If he is, I want some of what he's been taking! It's just that he started very young. The man referred to in *Man and Boy* was Michael Kendall, but he was often in the company of an inquisitive boy, who was then fresh faced and curly haired, as we reminded Simon, our viewers, and chiefly ourselves, by showing a very ancient clip on *Springwatch* two years ago! See, that's what happens if he chooses to maroon himself on some far away island, instead of mucking in with us down on the farm! But I digress.

The point is that, at a slightly more advanced age, Simon was often involved in the BBC's live wildlife enterprises, such as *Fox Watch* and *Badger Watch* in Britain, and just about anything from Kenya, live or otherwise.

However, it was not until 1994 that two of the present three first worked together. By then Simon was a grown up, established and widely revered 'authentic' wildlife presenter, as well as an accomplished cameraman in the same field. I, on the other hand, was something of an upstart in Natural History Television. I could hardly deny that a very large part of my life up till then had been frittered away perpetrating such nonsense as *I'm Sorry I'll Read*

Live pictures from inside a Great Spotted Woodpecker's nest, *Bird in the Nest* 1994. Achieved by sawing a slice off the tree, and replacing it with glass, then building a sort of tent round the trunk, which contained a very large camera on a tripod and a real live cameraman, who sat there for hours on end. Was this set-up 'cruel'? Only to the cameraman! But it wouldn't be allowed nowadays.

That Again and *The Goodies*. However, I could also truthfully claim to be not a total novice in the bird world, since I had been a schoolboy egg collector way back in the Muffin the Mule era, and an avid birdwatcher ever since. I had written learned ornithological papers, a couple of birdy books, and found an impressive number of rare birds, including a "First for Britain". The kudos of such a find in the bird world can hardly be overestimated. It is a bit like winning Wimbledon. It matters not one jot that the bird in question – a Pallas's Reed Bunting – is about as quintessential a boring "little brown job" as you might choose to totally overlook. Nevertheless, I did have far more birding credibility than, dare I say, most of the bosses at the BBC Natural History Unit, or indeed the vast majority of the viewing public, no doubt assumed. Fair enough really. I mean, my coming out as a wildlife presenter, after 30 years of doing daft comedy, is sort of the equivalent of Sir David Attenborough suddenly admitting that, for much of his youth, he worked as a circus clown. Which, by the way, he didn't. Not as far as I know.

Anyway, the show in question, launched in 1994, was *Bird in the Nest*. The presenters were Peter Holden – an undiluted birdman from the RSPB – myself and Simon King. I didn't know it then, but a tradition was being born in that Peter and I were the main anchors, stuck most of the time in a mobile studio – actually a tiny claustrophobic van parked in a farmyard – whilst Simon got to be the intrepid roving reporter, exploring more challenging habitats, out in the real wild. Well, as wild as it gets within twenty or so miles of Bristol.

Looking back, it would be churlish to deny that *Bird In the Nest* was very much an early incarnation of *Springwatch*. It was live. It went on for a week. There were cameras in nest boxes, bringing us endearing family pictures of species that continue to delight: lots of Blue Tits, Great Tits and Robins. The technology – especially the size of cameras – was much more cumbersome in those days, and yet the shows featured some set ups that have yet to be attempted in more recent years. Live pictures from inside a Great Spotted Woodpecker's nest, deep in a hollow tree trunk and – most incredible of all – new born Kingfishers in the pitch dark chamber at the end of a metre long tunnel. It was also the Kingfishers that confirmed just how involved viewers will get with the creatures they come to know. It was classed a national tragedy

Bill and Peter Holden from the RSPB, photographed on one of the rare occasions we were allowed out of our 'studio'. The van contained not only us, but two chairs, a table, at least six small television sets and several cuddly toys. It was also dark and very hot in there. Over the weeks Peter and I got to know each other almost too well! It was *great* fun.

when the parents were kept away from the nest by a hoard of jolly folk on a "treasure hunt", with the consequence that the chicks chilled and died. I will never forget Simon reporting that news with a passion that mixed shock and sadness with righteous anger.

Bird in the Nest was a big success. The viewing figures were impressive enough for a second series to be commissioned, and the 1995 version delighted and entertained an even bigger audience. Peter, Simon and I were all of a mind that such an enterprise could – and arguably should – run and run. However, someone didn't agree. To be perfectly honest I don't know who that someone was – or maybe it was a committee – but, in any event, they had the power to call a halt. *Bird in the Nest 3* didn't happen. I think there was evidence that many viewers were disappointed. Simon and I certainly were. I'm sure Peter Holden was too, but one of his most impressive characteristics is that his enthusiasm for birds will never be dimmed or dented. He simply returned to his RSPB duties, and poured innovative ideas into the society's work.

Simon returned to Kenya, and lots of other wild places , whilst I at least had the satisfaction of having passed the credibility audition, and busied myself with *Birding With Bill Oddie*, and subsequent series. However, whatever I did, much as I enjoyed it, I never lost my conviction that live wildlife really ought to be on the telly. Obviously, some people agreed, as such series as *Big Cat Diary* carried the concept to other continents. There were also sporadic one day live events I can't actually recall the titles of. But still nothing really like *Bird In the Nest*. It seemed almost perverse. Someone had already coined the phrase "An Avian Soap Opera" back in 1995. No one would question the audience pulling power of both wildlife and soap operas. I even attempted to revive the genre myself. I mapped out and "pitched" a series following the day to day wild goings on in a small rural village. I christened it "Rookside". Frankly, I was disappointed that I heard no more about it. Surely, it was at least a nifty title?!

Which is more than you could say for "Bugged". I heard rumours that something called "Bugged" was being "developed", as they say in television land. So what does "Bugged" suggest to you? Spies? Or possibly Flies? In fact, it began to transpire that it was going to be a series of wildlife programmes, coming to you live from various British gardens. There might well be a few flies in

Nestbox Camera - early 21st century version. At least it was small enough to fit alongside the box and was remote controlled. The birds were unaware that they were being spied on, thus making their behaviour a great deal more 'real' than *Big Brother*.

it, but hopefully quite a lot more besides! Several thoughts passed through my head. Firstly, was this idea being "developed", or would "remembered" or "resuscitated" be more appropriate words? Secondly, "Bugged" was a terrible title. Thirdly, that I totally approved of the concept, and lastly that I would love to be one of the presenters.

In spring 2003, the British public were treated to *Wild In Your Garden*, which answered all my questions and hopes pretty positively! Whether *Wild In Your Garden* was in any way modelled on *Bird In the Nest*, I really don't know. Maybe I was the only one old enough to remember the series. One of the signs that a TV presenter is ageing is that the producers are looking so much younger these days! There were obvious similarities to the old model, but also a great number of additions and improvements. For a start, it wouldn't just feature birds. Technology had also inevitably come on at an impressive pace. Cameras had shrunk, and could be inserted in the tiniest of openings. They could also see in the dark. And a little thing called the Internet was rapidly taking over the world, flinging open the door to interactive TV. This, to be honest, has had pluses and minuses for we who do live telly. Modern IT means that the viewers can get involved to a much greater extent – which is excellent – but it also means that they can get at us much much quicker – which can be a bit harassing. Questions, queries and complaints take their time when sent by post. Even phone calls soon create a "blocked line". But e-mails seem to drop out of the sky as swiftly as a plunging Peregrine, and as numerous as roosting Starlings. We presenters found it a little distracting to be trying to whisper our live commentaries whilst having a new sheaf of "Website enquiries" shoved under our noses every five minutes!

Oh yes, "we presenters". Who would they be then? There were three of us, just like on *Bird in the Nest*. Me and Simon again, and – no disrespect to Peter – but I'm sure he'd concede that Kate Humble brought something entirely different to the proceedings.

In fact, what Kate brought was a great deal of broadcasting experience, a splendidly clear brain, and a brilliant way of asking exactly the kind of questions viewers wanted to ask, or would be intrigued to find out the answers to – even if they didn't realize it! To be honest, these talents have only really been allowed to flourish during the last three years. In 2003, Kate was almost

literally incarcerated in a sort of control module that looked like a rejected set from *Star Trek*. Simon and I had garages! From the garages, we could watch pictures of our respective gardens, and whatever wildlife appeared in them, even when their appearances were nocturnal. *Wild in Your Garden* went out live not once, but twice a day, and the second broadcast was sometimes as late as eleven o'clock – at night! It was a strange experience. We were surprised that there were often still a million people tuned in. But not quite so surprised that we often had very little to show them. Sometimes nothing at all. This was particularly true of the very first "night show", which came off the air on the stroke of midnight! I emerged from my garage, at the same time as a rather shell-shocked producer emerged from the mobile studio. We looked at each other. My face was mischievous. His was ashen. After a short pause, he decided to ask the leading question: " So... How do you think that went?" My reply was heartfelt and totally honest: "Oh boy, I wish I was still doing comedy!" But I didn't mean I didn't want to be associated with *Wild in Your Garden*'s Night Broadcast. I simply meant "It would be so easy to send this up rotten! And such fun!" And of course *Dead Ringers* and other topical revues have been doing so ever since!

Nevertheless, *Wild In Your Garden* was a success. There were certain ironies. For a start, the title could have been questioned under the trades descriptions act. As I once said: "Welcome to wild in your garden, or rather wild in your garden if you live in the small area of Bristol, where our three gardens happen to be located."

It wasn't even a big area of Bristol, as I confirmed one evening when there was so little to be seen from my garage, that I wandered across and joined Simon in his, about two minutes walk away! Moreover, despite the sophisticated technology, the most entertaining wild stars were the least difficult to show. We had several Blue Tit families in easily accessible boxes. Simon's Foxes often frolicked out on the lawn, and – one of the first times Kate and I were actually allowed out together – we did a moth sequence that was lit only by the bright lamp that was attracting hundreds of them to a simple white bed sheet!

So, the concept of a live wildlife show, in Spring, spread over several days looked as if it might be about to take off. Everyone concerned was anxious to do it again. But the final decision was down to the then head of BBC2. I have never been quite sure

whether or not the fact that what viewers get is not necessarily what they want to see, but rather what one person – or possibly two or three – decide they (you, we) are going to get. The flaw in the system is that it is possible that a popular series may get axed because someone "at the top" doesn't like it. Even if millions of people do. That can and has happened, and probably will again. However, I can also argue that the really innovative programmes are not what the viewers have "asked for", quite simply because they don't know that they exist yet! In the world of comedy, you may get people saying "I'd like a good sitcom." But surely they wouldn't add "and I'd watch it if it was set in a pub, or was about rag and bone men" (I'm thinking of *Cheers* and *Steptoe* by the way.) Even more so, you can't imagine anyone – viewers or TV bosses! – saying what we'd like to see is a show with silly walks, the Spanish Inquisition and a dead parrot, written and performed by a bunch of Oxbridge graduates. "That's what we want!" I think it is correct to say that the job of the Head of BBC2 is to give the audience what they want, to a point, but also to search out and commission new, and often innovative, and indeed potentially "risky" programmes.

Which brings me to the somewhat ambiguous and unforgettable words uttered by the then head of BBC2, Jane Root, when asked if she was prepared to allow us to continue the concept introduced by *Wild In Your Garden*: "I want it big, or not at all!" A sentiment that could fit a number of contexts, but when applied to a live wildlife programme was indeed a challenge. I have no doubt that our executive producer might have responded with words along the lines of: "It'll cost you!" But credit to all. The challenge was issued. It was accepted, and as the events of 2004 were to prove it was triumphantly met.

It 'was' big. Not just two weeks. But three. Not just three gardens in downtown Bristol. The whole of the United Kingdom. It did exactly what it said in the title, as *Wild in Your Garden*, became *Britain Goes Wild!* In doing so, it undoubtedly set the template for *Springwatch*. Fortunately, the only area that didn't expand was the number of presenters! Kate and I were based at an organic farm at Fishleigh, in Devon. Simon was to extend his original roving reporter role. And how! He left the claustrophobia of his garage, and relocated in a place where agoraphobia would be more likely – the Bass Rock! Where he was marooned for a week with only a few

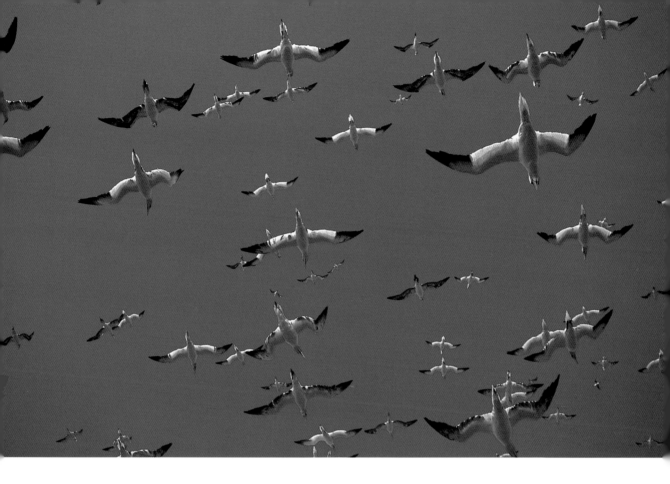

Gannets on Bass Rock, *Britain Goes Wild!* 2004. This was the view Simon got any time he looked up. Very lovely, except that the birds constantly bombarded him with "guano". It was on the Rock that Simon established his familiar "costume" of anorak and woolly hat, liberally spattered with white flecks

thousand Gannets for company. The second week was at least on land, in a Derbyshire quarry with a pair of Peregrines, and the third week he finally made the big city, based at the splendid London Wetland Centre, which brilliantly demonstrated the ironical fact that these days there is often more wildlife to be found in the towns than in the countryside!

The animal and bird stars weren't literally bigger, but there were more of them. Especially more Blue Tits and Badgers. The drama was more dramatic, although it verged on tragedy, when our cute family of young Pied Wagtails disappeared under mysterious circumstances, and under cover of darkness, presumably into the stomach of some mammalian predator, who timed its raid to perfection, coinciding with a late night excursion to some local nite spot by the so called "Wagtail Watcher", whom we henceforth referred to as the "Wagtail Murderer"! Totally unfair, but funny, in a black sort of way. Fortunately, he has a thick skin and enough resilience and talent to have since forged a career as a TV presenter himself, on a very successful children's show. Presumably, the children are oblivious of his shameful past.

A Cuckoo. So, does hearing the first cuckoo signify the beginning of spring? I hope not, 'cos Cuckoos don't arrive in Britain till the middle of April

2004 also saw the establishment of several regular *Springwatch* pre-recorded features such as "Mini Epics" – like tiny extracts from what they call "blue chip" wildlife programmes, amazing camerawork and a definite "story line". Also "Passionate People", which feature "amateur" wildlife enthusiasts. Finally – and perhaps most crucially – there was a greater emphasis on public involvement in wildlife conservation, in particular a campaign christened very appropriately *Make Space for Nature.*

Britain Goes Wild was an undeniable success. The whole format was surely now established. The viewing public was hooked. It was big, and so were the audience figures. It was soon commissioned for 2005. Speaking for myself, Kate and Simon – and I'm sure the rest of the team – we were delighted. We were also soon puzzled. Having hit the heights, they decided to change the name! Generally, this is not what you do when you have a hit TV show. And, frankly, I have never really understood why it was changed, or who did it. My initial reaction was, let's say, less than enthusiastic, as I recalled in an article some time later in *BBC Wildlife* Magazine:

"You can't call it "*Springwatch*!" That was me talking. "Why not?" asked my producer. "Because it's going out at the end of May!" "So?" "That is not spring!" "So when is spring then?" "It depends which bit of the country you live in", I pontificated. "Here in London, I'd say spring started at the end of March, or the beginning of April" "So it gets later as you go further north?" "Exactly. You would have to live in the Arctic circle for it to be the end of May!" "Alright then" she asked "In Britain, what would you call the end of May?" To which I replied emphatically: "I would say that the end of May was almost the beginning of summer". "We can't call a show Almost the Beginning of Summer Watch!" I acknowledged the facetious riposte, but went on "I know that, but if it goes out during the last week of May and the first two weeks of June, you can't call it "*Springwatch*". It'll just look silly ." At which point I got facetious myself, and accused the BBC of trying to totally re arrange the calendar. I mimicked a newsreader

"Good evening. The BBC have today announced that Spring this year will be in early June. This will of course have a "knock on" effect. Summer will begin in late September, and Autumn will move to mid December. All TV "Christmas Specials" will be rescheduled for next Easter, just after the start of winter, which will be in early April, which of course we all used to think of as the beginning of Spring. We apologise for any confusion this causes to migrating birds, wild flowers, hibernating animals, and viewers."

The BBC were neither amused, nor persuaded by my sarcasm. "*Springwatch*" it became. It was a huge hit. The only one left looking silly was me. I confess I was wrong. "*Springwatch*" is a great title. Short and memorable. I even

convinced myself that it was appropriate, in that the show was the wildlife equivalent of an end of term report, looking back on the events of spring, as it were.

The name may have changed, but basically the format and contents were very similar to *Britain Goes Wild*. Kate and I were still down on the farm. The Blue Tits became even bigger stars, particularly after we took a family each – Bill's tits and Kate's tits. A bit "Carry On" we admit, but unavoidable really. This led to the concept of "Tit Wars", in which I have to record that my family was totally victorious, as the whole of my brood fledged successfully, whilst poor Kate's pair failed to raise a single chick. Naturally, I accepted my victory in a mood of sadness rather than glee. Simon was once again dispatched to far away places, where we would inevitably get wet and wind-blown. However, he spent the first week on the glorious Farne Islands off the equally impressive Northumbrian coast. Amazingly, it was Simon's first ever visit to the Farnes. He clearly loved it, and it was satisfying for me too in that I had initially suggested the Farnes, which are one of my lifetime favourite bird places. The second week, Simon was back with breeding Peregrines, but this time the pioneering pair that have chosen to nest on a tower block, slap bang in the middle of London. His third week, involved a short drive across the city, to revisit the Wetland Centre at Barnes, which again proved very rewarding. As well as the title of the show changing, so did the name of our conservation campaign. *Make Space for Nature* became "Breathing Spaces". Frankly, neither Kate nor I were that enamoured of the new catch phrase. "Sounds like something to do with combating air pollution, or respiratory illnesses, rather than wildlife. " We got used to it – almost – but were eventually proved right when, some time after the series, the BBC lawyers received notification that *Breathing Spaces* was already the registered name of an existing charity involved with – you guessed it – respiratory illnesses. And yes, you would think the BBC legal department would have checked the copyright situation long ago. But they didn't. Which is why, in 2006, the campaign name changed yet again. From *Breathing Spaces* to ... *Breathing Places*! Which Kate and I found even harder to incorporate into a naturally flowing sentence, and still conjured inappropriate visions of an oxygen tent or a decompression chamber. Hey, but who are we to question a decisions reached after weeks of "market research", and consultations with various "focus groups", who were presumably unanimous in concluding that the way to improve on the snappy logo *Breathing Spaces* was to change one letter! Sometimes the best ideas are the simple ones. And sometimes not. Suffice it to say that, whenever Kate or I have been asked to explain the purpose or meaning of *Breathing Spaces* or *Places*, we have slightly mischievously replied: "Well, it's meant to encourage people to ... make space for nature." Where have we heard that before?

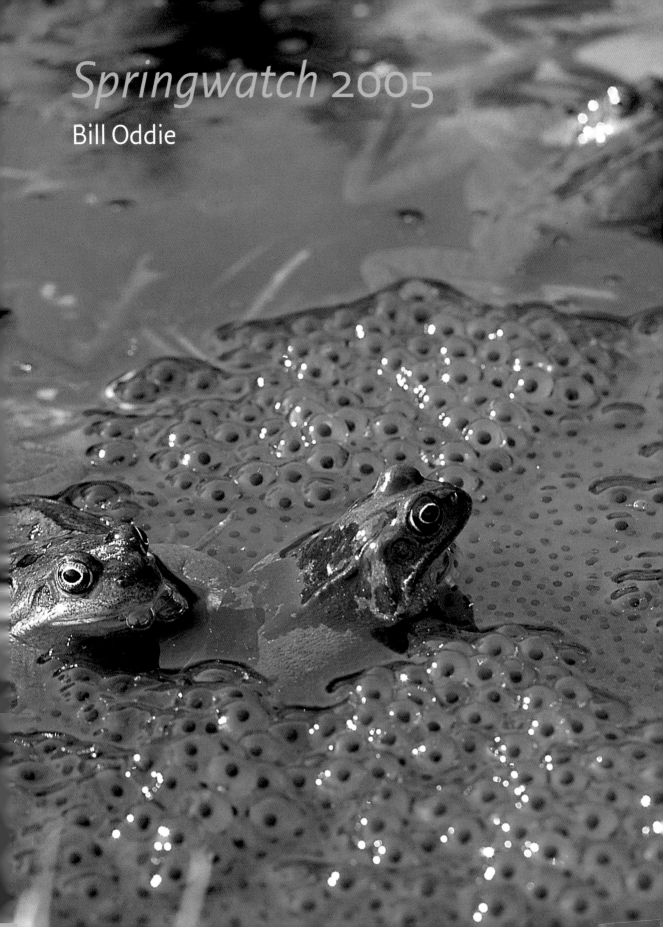

Springwatch 2005

Bill Oddie

But it's not the name it's the action that matters. In *Springwatch* 2005 the conservation and campaign message certainly took on a higher profile. Along with the setting up of various surveys by the Woodland Trust, exhorting the viewers to look out for the first dates of all things springy. Clearly the interactive side of things was escalating, and so were the audience figures!

Springwatch 2005 was a very big hit in any terms. Viewing figures and critical response. One of the major reasons for this is that we got far more mentions and "exposure" in magazines and newspapers. The cover of the *Radio Times* always helps, but we had that the year before as well. It was the national press that made the difference. Suddenly we were in the headlines. "The surprise hit of the season!" This slightly puzzled me, since I couldn't really see why a series that in essence was now in its third year was suddenly "a surprise" to journalists. To be honest, the success of *Bird in the Nest* ten years ago, had surely indicated that live wildlife is likely to be popular with TV viewers? But then again, I am used to this sort of "delayed reaction" from the media. Nearly every day, I am invited to comment on an issue that has been around for months, or even years, but the newspapers, or radio and TV have only just got round to, or possibly become aware of it. I get the call: "Ah Mr Oddie.. We wondered if you'd like to come in to Newsnight and talk about House Sparrows. We've just heard that they are becoming very scarce in London". "Well, yes indeed, they are". In fact they've been getting steadily scarcer for the past twenty years. So it's not exactly hot news. But it is still a mystery, so "OK. I'll come and talk about it." "Oh thank you. By the way, why are House Sparrows diminishing ?" "Nobody knows!" "Oh, so you wouldn't be able to explain it to the viewers?" "Well no, not really. Nobody can!". "Ah. Er, Mr Oddie, do you mind if we call you back later?" They don't.

However, I did frequently get interviewed about *Springwatch*. I'd like to think it may have been one of my remarks that helped spread the word. I made a comparison with various well known "Reality" TV shows involving humans, claiming that if viewers wanted "real" reality, they could only get it on *Springwatch*, where sex violence and even death were rife, and live! Many papers picked up on this, whilst at the same time, slagging off the human reality shows that were on at the time. The comparisons were truly insidious. So, I would personally, here and now, like to thank the broadcasters of *Big Brother* and *Celebrity Love Island* for choosing dates that coincided with *Springwatch*, and thus made us look even better than we were!

By the summer of 2005, it was clear that the *Springwatch* phenomenon was here to stay, for at least another year! The rest of this book tells the story of that year, and a bit more besides.

Frogs and frogspawn – so it must be spring!

Why Britain?

Simon King

Torrential rain, freezing temperatures, attacks from seabirds (which include being covered with their poo), precarious cliff-top locations. These are just a few of the treats I have had the great privilege to experience during the 3 years I have been working on *Springwatch*, *Autumnwatch* and *Britain Goes Wild*.

Of course, to some people, these may seem more like tortures than treats, but for me, being in the thick of it, even if "IT" is white and sticky, is what enjoying wildlife and the Natural World is all about. And that is what I'm all about. For as long as I can remember, Natural History has been the centre of my world. My favourite toys as a kid were the plastic model animals I collected. I would, even then, pedantically chastise any friends who tried to launch an attack with a Tiger onto a Zebra ... ("You can't do that, they live on different continents"!!). I didn't have many friends.

To be able to indulge my passion for wildlife in my chosen career is my good fortune. As a wildlife film maker, I have travelled and continue to travel all over the world, watching and filming the planet's most astonishing wildlife spectacles (I am a cameraman and producer as well as jabbering in front of camera from time to time). From Killer Whales in Patagonia for the *Blue Planet* series, to Great White Sharks and Arctic Wolves in South Africa and the Arctic for *Planet Earth* and the Lions, Leopards and Cheetahs for *Big Cat Diary*, I have been lucky enough to witness and record some breathtaking events.

So why then do I continue to sit in the rain on remote corners of the British Isles in *Springwatch*? Because, without a shadow of a doubt, these Islands, tucked off the west coast of Europe that so many of us call home, provide some of THE best wildlife watching experiences to be had anywhere in the world. That may seem like an extreme claim, but I mean it from the heart, and feel, now that I have travelled so extensively around the world, I am in a pretty good position to make it.

Don't misunderstand me. I am just as blown away by the wildebeest migration in the Masai Mara in Kenya as the next bloke (and since Kenya is where I was born, it too feels very much like home to me). But there is something about British Wildlife that just sets me tingling.

Here, we have such a wonderful mixture of habitats, landscapes and climates on such a compact, human-sized scale, that we don't have to travel far, live rough of work too hard before

Sunset in Scotland

The *Springwatch* Farm

Stephen Moss

For the millions of viewers who have tuned in to *Springwatch* over the years, the location is just as important as the wildlife. The Fishleigh Estate – or as we usually refer to it, simply 'the Farm' – really is a wonderful place. Set in the heart of the mid-Devon countryside, near the little market town of Hatherleigh, it shows that farming and wildlife really can go hand in hand.

This organic farm covers an area of just over 160 hectares (400 acres) – about two-thirds of a square mile. It lies just east of the A386 – the main road from Okehampton to Bideford – and south of the River Torridge, one of the loveliest rivers in Britain and the setting for Henry Williamson's famous story *Tarka the Otter*.

What is really fantastic about the farm is the variety and quality of habitats in such a small area. From *Springwatch*'s point of view, the most important of these is the oak woodland, which covers about one-sixth of the total area, but is home to many of our key characters including the Blue Tits, Pied Flycatchers and of course those amazing Badgers and their sett.

The remaining five-sixths of the farm is mainly grassland, used for grazing the herd of Red Devon cattle. This area is dotted with trees – some quite large ones – and the fields are divided and bounded by hedgerows, which contain a rich mixture of wild flowers, which in turn attract insects and nesting birds. Overall, the estate is a rich patchwork of fields, woods and water, perfect for attracting the widest possible variety of wild creatures.

Another crucial feature of the farm from a wildlife point of view is the large freshwater pond, known as 'the Lake', which runs alongside the main road below Fishleigh House. The Lake is a fantastic place to get close-up views of spawning frogs and toads – remember Bill's amazement when he found dozens of mating amphibians in 2005?! It also has a wide selection of dragonflies and all sorts of water-loving minibeasts. The Lake is also home to that charming family of Dabchicks (Little Grebes) that delighted us with their six fluffy little chicks in *Springwatch* 2005.

It's important to remember that the Fishleigh Estate is a working organic farm, whose buildings also provide a vital haven for wild creatures. The big house and its gardens are home to some of our common garden birds such as Robins, Wrens and Chaffinches, as well as less familiar ones like the pair of Spotted Flycatchers which usually nests there. The barns and other outbuildings are also home to many of our star characters,

Fishleigh buildings. The house and the barns are permanent. Our "production village" isn't, though we still get some complaints about being "an eyesore" on the lovely Devon countryside. Sorry!

including the famous Swallows, several pairs of Wrens and a small but very noisy colony of House Sparrows.

Finally, next to the house is a large, slightly sloping field where members of the *Springwatch* production team and crew spend four hectic weeks every year: the site of the 'Production Village', where the programmes are brought together for you to see.

Fishleigh Estate is about more than just the place and its wildlife. The people, too, are absolutely crucial to the success of the Farm, both as a business and haven for wildlife, and also of the *Springwatch* project. It is no exaggeration to say that without four people in particular, the quality of the wildlife and the programmes would be much reduced.

The owners, Ian and Sharon Sargent, have kindly granted permission for more than 100 people – and the vast amounts of cables, machinery and the other paraphernalia of live broadcasting – to descend on their home for almost a month every May and June. Until the late 1990s, Ian and Sharon lived in Sussex, where Ian ran a successful road haulage business. Desire for a change – and a better quality of life – led them to make the huge step of selling their business and buying the Fishleigh Estate. They moved down to Devon in the spring of 1998 and the hard work began.

They weren't alone. Ian approached a friend and neighbour in Sussex, Pete Walters, to see if he would come and work on the estate as the Farm Manager. Today, Pete and Ian have succeeded in creating a working farm that also has a place for wildlife. This reflects the changes currently taking place throughout British agriculture: as Pete says, "Today, the keyword in farming is conservation".

In spring 2001, just three years after Ian and Pete began work on the farm, disaster struck: the coming of Foot and Mouth Disease to the area meant that the prize herd of cattle had to be destroyed. Every cloud has a silver lining, however, and Ian decided that this was the perfect opportunity to go organic.

Soon afterwards, the estate was certified as organic by the Soil Association: meaning that no artificial fertilisers, pesticides or herbicides are used there. As a result, wild flowers and insects flourish in this little haven in the heart of the Devon countryside.

Hosting *Springwatch* has been a mutually beneficial experience, both for Ian and Sharon, and for the production team.

As Ian remarks, "They've taught us how television programmes are made, and hopefully we've been able to teach them about farming for wildlife!"

The final piece in the jigsaw – and crucial to the choice of Fishleigh as the place to base this huge live broadcasting event – was the presence of ornithologist Peter Robinson. After a distinguished career as a Fire Officer and as head of the Investigations Unit at the RSPB, Peter now spends much of his time on a long-term study of the birds of Fishleigh Estate.

Over the past few years he has put up over a hundred nestboxes for a wide range of birds, from smaller species such as Blue and Great Tits and Pied Flycatcher, to larger ones such as Jackdaw and Stock Dove.

By monitoring the success and failure of these nests, ringing the chicks, and recording the habits and behaviour of the birds across the whole estate, Peter has built up a comprehensive picture of the farm's birdlife. He is just one of many expert naturalists up and down the country who put in hundreds of hours of unpaid effort, sending their data to the British Trust for Ornithology, thus helping to contribute to our wider knowledge of Britain's birds. His expertise and local knowledge have been invaluable to the *Springwatch* production team.

Thanks to sympathetic farming methods and overall management for wildlife, an extraordinary range and depth of wild animals and plants live on the Fishleigh Estate, including:

102 different species of bird (seen on or over the estate), almost half of which are in the Red or Amber categories of conservation concern. Key species include Sand Martins, Dippers and Kingfishers on the river; Buzzards, Tawny Owls and Pied Flycatchers in the woods; Skylarks and Yellowhammers on the open grassland; and Barn Owls in the outbuildings.

28 species of butterfly – half the British total. As well as the common species, these include Silver-washed and High Brown Fritillaries, Brown and Purple Hairstreaks, and Wood White – all either declining or highly localised species.

23 species of mammal – including Otters on the River Torridge; Red, Fallow and Roe Deer; Weasel, Stoat and Harvest Mouse; and at least five species of bat. Not to forget the stars of many a live broadcast, the famous Badgers!

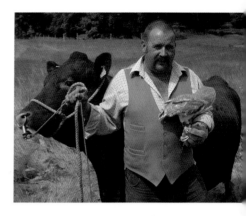

Three of a kind? How often do you see a bull, a barn owl and a man in a smart waistcoat in the same picture? The man is farm manager Peter Walters. The barn owl is a local "rescue" bird. And the bull has so far refused to divulge its name

A wide range of trees, ferns and wild flowers, including Lords-and-ladies, violets and a wonderful display of bluebells every May.

What this range of plants and animals reveals is that a mosaic of habitats – combined with sympathetic and careful farming for conservation purposes as well as profit – can create a really special place for wildlife. Fortunately, thanks to the miracle of live television, we are able to share this magical place with you!

The crucial importance of the farm's lake for waterbirds was clear in 2005, when a pair of Little Grebes nested there.

Little Grebes are a fairly scarce bird in Devon, with only a dozen or so pairs recorded most years, though nationally they are relatively common, with about 8,500 breeding pairs on ponds, lakes and rivers up and down the country.

The Springwatch team noticed the grebes fairly early on, but because the nest was some distance from the central hub of the broadcast, and to avoid disturbing the birds themselves, it took us a few days to get cameras on them.

When we did, these little birds managed to steal the show from the more familiar species in our nestboxes: the sheer beauty of their chestnut and brown plumage, and the intimate details we managed to observe during the live show, will never be forgotten.

Little Grebes are a resident species in Britain, and although quite widespread are often overlooked, because of their small size and retiring habits. Indeed when they are seen the adults are sometimes mistaken for baby ducks or the young of some other waterbird, due perhaps to their rather fluffy rear end! This has given them a number of local folk names, including Jack Ducker, Spider Diver, Penny Bird, and the widespread alternative name of Dabchick.

Surprisingly perhaps, grebes are amongst the most aquatic of all birds, hardly ever venturing

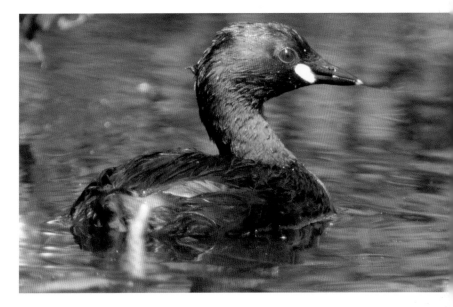

onto land. Their legs are right at the back of their body, enabling them to paddle along and dive more easily – a position that has given rise to a less polite name, Arsefoot! Because of this, they are ungainly when trying to walk, so spend the vast majority of the time swimming or when nesting, squatting or standing on the nest.

The nest itself is made from aquatic vegetation, and literally floats on the surface of the water. Little Grebes lay up to six eggs, which although white at first, soon stain greenish-brown. This is because when the adults leave the nest to feed they cover them with water weed to prevent them being seen by predators, which rapidly discolours them. Our pair had not only laid six eggs, but hatched six young – though it took us a while

to count them all as the tiny chicks were expert at concealing themselves amongst the vegetation or on their parents' backs!

Unlike all the songbirds featured in the programme, Little Grebes belong to a group of birds whose young are 'precocial' – a word from the same root as precocious – meaning that they are able to fend for themselves as soon as they are born. Watching these tiny chicks – each of which would fit into a matchbox – swimming around and pecking for food was quite a privilege.

They have to be pretty independent: within a few weeks the parents will, if conditions are suitable, lay a second clutch of eggs, and will even go on to raise a third brood of chicks if they are able to.

Not all birds on the farm nest in boxes, like the Blue Tit families. Another favourite character, the Swallow, usually nests in the old barns just below the main house – hence its official name of 'Barn Swallow'. And unlike the tits, Swallows do get more than once chance to breed: most pairs raise two, some even three, broods in a single season.

With about 725,000 breeding pairs in Britain, Swallows are one of our commonest – and certainly one of the most familiar and well-loved – of our summer visitors. We await their arrival in April with eager anticipation, and include them in all sorts of rhymes and proverbs. To quote Shakespeare: "One swallow doth not a summer make..." Indeed we know them so well that perhaps we take them a bit too much for granted. After all, their story is little short of incredible.

Consider the bare facts. Sometime in February, a Swallow hunting for flying insects five or six thousand miles away in southern Africa, will begin to feel the impulse to head north. But why should they leave the warmth of their African home and travel from the southern to the northern hemisphere to breed, when they could stay put and save themselves the effort? The reason is that with so many other kinds of swallow in Africa, there simply isn't enough food to go round; while the long hours of daylight and lack of competition from other species in Europe means that the journey is certainly worthwhile.

Whatever the reason, we should be thankful that this beautiful little bird does choose to brave the many hazards of the migratory journey – including weather, predators, and crossing the Sahara desert and the Mediterranean Sea – to reach our shores.

Swallows are mainly rural birds, and the farm at Fishleigh is simply perfect for them: with plenty of flying insects thanks to

Ian Sargent and Pete Walters' wildlife-friendly farming. The old barns also provide the perfect place to nest – not just for the Swallows, but also for our cameras, which bring us live pictures of the nest, on television and the website, during the whole of the Springwatch broadcast and beyond.

The nest itself is a bit of a messy affair: a cup made of mud pellets (also available in the muddy patches of the nearby farmyard) mixed with grass, and lined with feathers. (Amazingly the nest featured on Springwatch is the very same one that we have shown for three years now; surely it must fall down at some point!)

The female lays four or five long, oval, glossy white eggs, lightly spotted with red, mauve and grey, which are incubated for between 11 and 19 days. Once hatched, both parents fly back and forth at very regular intervals – usually once every few minutes – to bring tiny insects which they have caught on the wing to feed the young.

To get the best views of the Swallows we usually stand outside the barn, where we can watch the male and female swoop in and out on their long, graceful wings. Given good views, the male can be told apart from the female by his even longer tail-streamers – almost two-thirds of his total length! They can also be watched as they hawk low over the big field below the Production Village, especially on fine, warm evenings when the insects are out in force. Watching a Swallow turn in mid-air to grab an insect – vacuuming it up in that huge gape – is a real privilege.

During the time Springwatch is on the air we really notice the difference as the youngsters appear to grow before our very eyes. After a couple of weeks we simply can't believe that they can stay in the nest any longer without it bursting at the seams.

Even when they do leave and venture outside into the big wide world for the very first time, they usually return for a few evenings to roost in the safety of the nest.

Once the youngsters are out and about we often see them being fed by the adults; though they soon learn to grab insects for themselves. It is incredible to think that within a few short weeks these little birds will be heading off on that incredible journey all the way back to Africa – on their own, as the adults generally leave before them. What is perhaps even more incredible is that the Swallows we see back on the farm next spring may well be the very same ones we saw depart in autumn: Swallows are well known for returning to the neighbourhood – sometimes even the very same nest – in which they were raised. If you live in a more urban or suburban part of Britain – as of course most of us do – you are unlikely to have nesting Swallows in your neighbourhood. Instead, two other long-distance migrants from southern Africa are likely to visit during the spring and summer months.

The first to arrive – generally in mid-to-late April, though sometimes earlier –is the House Martin. House Martins can easily be told apart from any other species by their neat, compact shape; dark blue upperparts with a smart white rump; and all-white underparts.

As their name suggests, nowadays they build their nests underneath the eaves of houses, using tiny pellets of mud painstakingly collected and stuck to each other to form a cup with a tiny entrance hole for the adults to get in and out. Before the coming of human habitation, House Martins nested on cliff faces (and in some places still do) – so perhaps we should really call them 'Cliff Martin', even if that does sound like a 1950s pop singer!

House Martins have suffered

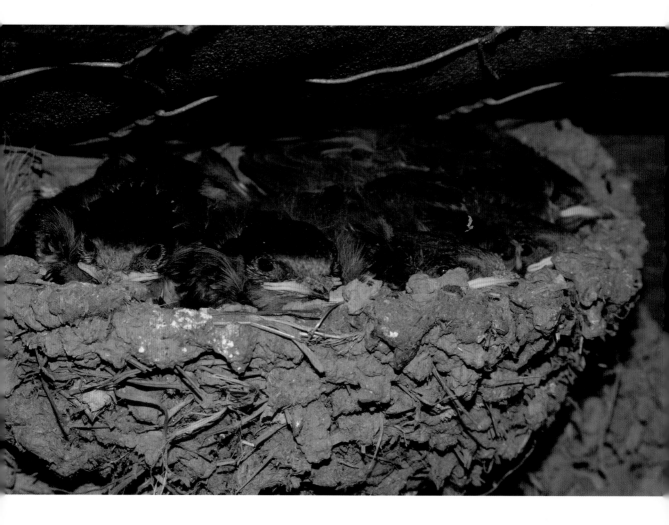

a major decline in recent years, although more than 400,000 pairs still breed in Britain. The drop in numbers appears to be because of the lacks of both suitable nest sites – some people find the sound and mess produced by nesting birds unacceptable – and more importantly nesting material, as there are far fewer places where mud can be easily collected than there used to be. You can help House Martins by putting up artificial boxes, which saves them the trouble of building a nest for themselves!

The other species you are likely to see if you live in a town or city is the Swift. One of the signs of spring chosen for our Springwatch Survey, Swifts arrive back in Britain from late April onwards, though the main influx usually comes with a spell of fine weather in the first week of May.

Swifts are truly incredible birds: perfectly suited to an almost entirely aerial existence. They are so adapted to the air that once they leave the nest they fly all the way to Africa and back without ever touching down: eating, sleeping and even mating on the wing.

Swifts are easy to tell apart from Swallows and House

Swallows – Cute. Sleek. Cheery. Graceful. And incredible travellers. Bill's favourite birds!

Martins: all dark, with long, scythe-shaped wings and a short tail; they also scream loudly, especially on fine evenings, earning them various nicknames including 'devil-bird'. They really are a miracle of evolution, and we are privileged to have them here for the short period when they breed – by the end of July most of the 60,000 pairs that breed here have departed south to spend the majority of the year catching tiny insects under African skies.

Far Away...

Bill Oddie

Regular viewers would have noticed that over the three years a clear pattern has been established. Namely, that Kate and I are always based at a nice friendly farm in Devon, whilst Simon is sent away somewhere remote and almost invariably wet. It does also rain in Devon of course, but on such occasions, Kate and I either have concerned "personal minders" who rush over with a selection of efficient and yet fashionable waterproof clothing, or possibly a very big umbrella, which with any luck we won't even have to hold ourselves. It is our wet weather equivalent of having an exotic "slave" wafting us with fans of Ostrich feathers. Which incidentally they will also do if the temperature rises. It is not that we are spoilt or mollycoddled, it's simply that we are both sensitive creatures in our own different ways, and take quite a lot of looking after. My excuse is advancing age. Not sure what Kate's is! We also spend a lot of time lounging on the comfy sofa, watching Simon on a large TV screen. Naturally, seeing him getting soaked or buffeted by gales makes us feel... well, it varies from day to day actually. Sometimes we feel sympathy, other days slight guilt. Or it just gives us a laugh, and makes us appreciate how we don't ever have to suffer like that down on the farm.

The truth is, of course, that Simon enjoys being far away, unmolested, and uncomfortable, in places where he can indeed feel at one with the wildlife. As it happens, Kate and I are by no means adverse to adversity in the pursuit of birds or animals, or – in Kate's case – fish. However, it was long ago decreed by higher authorities, that our live broadcasts must not only feature the "almost inaccessible" (Simon), as well as the stuff that the public can see in their own gardens or in local fields or woodlands, such as they might encounter on, for example, a cozy farm in southern England. So Kate and I have no choice. It's a tough job, but someone has to do it.

The fact is that urban, suburban, and visitable countryside habitats are every bit as productive for and supportive of wildlife as remoter regions. It's just different. That's all. Maybe next time we should swap? Simon can be down on the farm, staying in a delightfully cozy rural hotel, whilst Kate and I are marooned together on an otherwise uninhabited island. I'm game. Kate?

The inside of the storage building on Rum, when the island was invaded by Simon and the BBC *Autumnwatch* team. The antlers were shed by the many generations of Red Deer that have inhabited the island. The steel boxes were needed to transport cameras, lights, cables, monitors, recording machines etc. etc. Nothing must be forgotten – you can't nip back to the mainland and get it!

Farnes

Simon King

On the final week of *Springwatch* 2005 I headed north again, this time to spend time in an area that had for years been something of a grail for me. The Farne Islands are a string of small, rocky outcrops off the coast of Northumberland. I had heard stories of them being some of the finest seabird colonies in the country, but before now, I had never had the opportunity to visit them. And here I was, not just visiting, but spending over a week in this wonderful avian metropolis.

Inner Farne was to be the focus of our attention. At about 10 acres it's not big, but it is absolutely hooching with birdlife. Even as you approach on the boat, the sea around the island is like bird soup, with Guillemots, Razorbills and Puffins bathing or preparing for a fishing trip.In fact, it is not simply the number and variety of birds that makes the Farnes so special, but also the level of acceptance shown by the wild inhabitants towards human visitors. This is thanks to the protection that has been afforded for many years by the National Trust, giving the birds the confidence to take human beings in their stride (or, more accurately, in their flap I suppose). This confidence makes for wonderful wildlife watching. I was able to sit within a metre or so of nesting Shags, Kittiwakes and Razorbills, not to mention the Puffins. Farne very quickly began to live up to its reputation.

Once you have negotiated the bathing flocks of birds on the approach to the island, your boat arrives at the little pier on the North-east bay. Here, you are greeted by the reserve wardens, all wonderful people whose passion for the place and its birds is tangible from the moment you meet them. The head warden during our visit was David Steel, and his friendly frame was topped with the most extraordinary ten-gallon, black and white, cowboy hat – it looked like he was wearing a Frisian Cow. This hat represented more than an expression of David's character, it was essential armour. The path that leads from the shore to the top of the island is flanked by hundreds of breeding Artic Terns, one of the most southerly populations of this delicate swallow of the sea. Delicate to look at, but their character is anything but demure. Despite having chosen the edge of a footpath as a nesting place, many of the birds regard a walking human as a potential threat, and deal with the invasion by repeatedly dive bombing and stabbing with their needle sharp beaks. Even the most hirsute

Arctic Terns defending their territory against the intrusion of Simon and the BBC *Springwatch* team. Heaven knows, they were about to become TV stars. No gratitude, these birds.

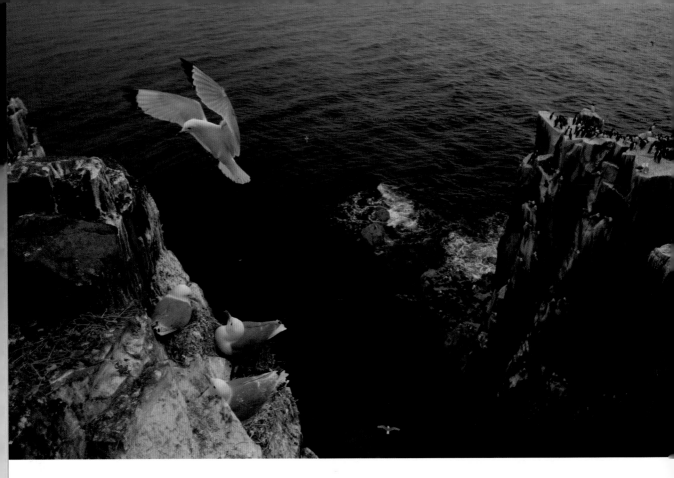

Kittiwake gully on Inner Farne, where visitors can enjoy close-up views of the birds and the cliffs literally echo with their lovely wild calls ...

Then I am challenged to try and get this line into a live transmission. It's very, very childish, I know, but amazingly satisfying to slip a line into an otherwise fairly serious rhetoric, without anyone noticing apart from those who are looking out for it. This series' proposed line was : "Nobody leaves baby in the corner". This, (or something very like it) apparently comes from the movie Dirty Dancing, starring Patrick Swayze and Jennifer Grey, and is delivered by him as he sweeps the heroine onto the dance floor for the finale. But here I was, talking about Puffins, Terns and Shags. Not the most obvious of circumstances to slip in such a line. My salvation came in the form of an Eider Duck. Eiders nest all over the islands, and many are incredibly tolerant of human activity. One of the nests we featured in the series was situated in the courtyard of the old chapel, which dominates the centre of the island's high ground. This female had chosen a recessed area to make her nest, which, while safe from passers by, made it very difficult for her flightless new hatched chicks to follow her down to the sea a day or so after they had emerged from the egg. They needed a little help. Baby ducks. Corners of

courtyards. I think you're getting the picture! If you ever have a chance to see the series again (and being live, I very much doubt that you shall), look out for the moment I slip in the line! My reward for successfully meeting the challenge was a resounding cheer in my earpiece from the production crew. Well worth it!

Inner Farne was everything I had heard it might be and much more. The Puffins, terns and other sea birds provided us with a wonderful array of true – life dramas to challenge the most sensational of so called reality shows, all set against the most wonderful backdrop of ever-changing seascapes. Heaven.

Puffin. Many people's favourite bird. In case you're wondering, they can hold that many sand eels because their beaks have a flexible "hinge" and serrated edges. Unlike many British seabird colonies, the populations on the Farnes continue to thrive

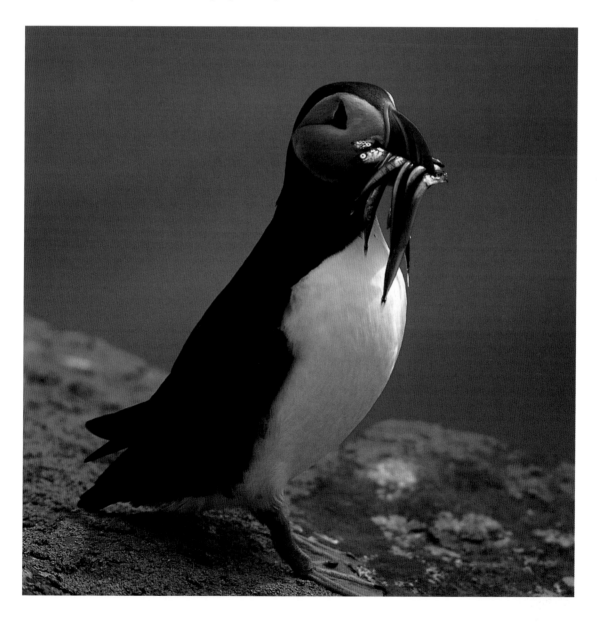

37

Sea Eagles

Simon King

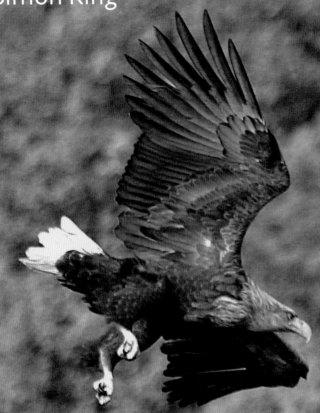

W e could have made life easy for ourselves by staying on the mainland, on locations with mains electricity for all the gear, with cafes for tea breaks, with tarmac roads for the vast trucks we need to ship the gear. We could have, but we didn't. Instead we plumped for what we hoped would be some of the best wildlife watching in the country, kicking off with Sea Eagles on the Isle of Mull.

If you had to pick a figurehead to represent wilderness and freedom you'd be hard pressed to find a better one than a bird whose wing span covers an area about the same size as your front door, and whose piercing gaze earned it the ancient name (roughly translated) as "The Bird with the Sunlit Eye". Sea Eagles are impressive, imposing, immaculate, immense, impeccable, imperious, implacable, (that exhausts the "imps" I think), and utterly, utterly beautiful. The thought of spending many days watching them at the nest was absolutely thrilling, though having worked with eagles in the past, I was a little nervous of the effect our presence might have on the birds. I need not have worried. With an enormous amount of help from the RSPB, Forest Enterprise, Scottish Natural Heritage, and the Mull and Iona Community Trust, we were able to concentrate on a well established pair of eagles, which nested on the banks of Loch Frisa. Indeed, Frisa was the name given to the male of the pair, whilst the female was known as Skye (her birthplace). With great care, we introduced a hide to the woodland edge where the birds built their nest, in which Johnny Rogers would sit for many hours each day getting the most magnificent close up views of the adult birds as they tended their two chicks.

We stationed a second hide half way up a nearby hillside close to an old deer carcass, where we hoped we might see the parent birds pop in for a light snack of fetid flesh. The gruelling task of sitting in this hide with a finger on the button of the recorder, fell to an enthusiastic young chap who had joined the project for some field experience. After four days, sitting in a puddle for 10 hours at a stretch, occasionally washed by the heady scent of rotting flesh, our intrepid young volunteer still had nothing but a curious Hooded Crow to show for his efforts. Oh, and a very stiff neck!

In the end, carcass-cam never did reveal a view of the eagles feeding on carrion, but we did get the chance to watch them in all

Also known as White-tailed Sea Eagle. Fair enough, but it's only the adults that have white tails. Rather less flatteringly, they have also been called "flying barn doors"!

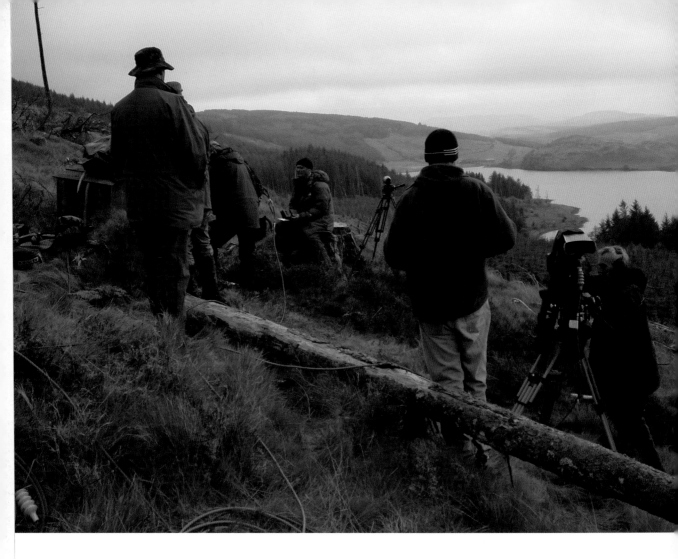

Filming the Sea Eagles. Mull is a magic island but it does rain quite a lot there! As is often the case, though, the camera doesn't "see" the rain in this photo. Neither does it see the several thousand midges that have acquired a taste for Simon

remarkably rapid path to the point where the fish had landed. She grew from a speck, to an eagle, to a barn door in what seemed like seconds, circled once, eyeing her target, then folded her wings and snatched the fish elegantly from the surface. It was over in an instant but I have a lasting memory of her yellow eye, set against the pale plumage of her head, apparently scrutinising me, before making her decision to snatch her prize. A wonderful reintroduction to a bird I had last watched some 3 years earlier.

We asked the children of a local school on Mull to choose names for the two Sea Eagle chicks we featured on the show,. From the wonderful list they came up with, we chose Itchy and Scratchy. These names seemed particularly appropriate for the young birds, which spent a good part of each day trying to rid themselves of the fluffy white down which had covered them as newly hatched young. I'm not sure how many of our viewers

would have associated their names with their likely inspiration – the super-violent cartoon characters watched avidly by the animated anti-hero Bart Simpson! When the chicks took to squabbling over food with violent pecks, it gave their monikers an even greater relevance.

During our week of transmission from Mull, we experienced very variable weather. I often quote Billy Conolly's words of wisdom about the sometimes inclement climatic conditions in Scotland: "There's no such thing as bad weather, only the wrong clothes"! I remained dry and warm despite the occasional downpour, but the hidden menace in the highlands and islands is a much more insidious discomfort. MIDGES!!!!! I write with expletive capitals because it's very hard to say the word, or write it, without becoming emotional.

A medieval torture involved stripping a criminal to the skin, binding his hands and feet and then tying him to a tree. That's it. The midges did the rest.

Any evening which was wet and windy, was blissfully clear of the little biters. If conditions remained calm and clear – the midges would rise up from the heather and work their evil. We were of course all covered in insect repellent, from the organic bog myrtle extract kind (reasonably effective) to the wholly synthetic paint stripper kind (effective on the midges but goodness knows what else it's destroying). But midges, as their name suggests, are small. Small enough to get in your eyes, your ears, down inside your shirt, up your nose. Places you don't want to put paint stripper or bog myrtle. And once settled, regardless of their location, they set about trying to get that all important meal of blood that will allow the females to breed.

Time and time again, I would be trying to jabber about the antics of the eagles, when all I felt like doing was run screaming from the hillside and diving into the loch.

It was a small price to pay for the wonderful experience of watching these regal birds over a period of a week or so. The eagles touched a nerve with the public, and we kept up to date with their progress with the help of Dave Sexton, the RSPB warden who keeps watch over the birds, throughout the rest of the series and over the rest of the year.

What is spring?

Stephen Moss

Eagle-eyed viewers who remember the highly successful series *Britain Goes Wild* back in 2004 may be wondering why it changed its name the following year to *Springwatch*. After all, the presenters were the same, as was the main location on the farm at Fishleigh.

What had changed is that more and more people were asking a simple question: what is happening to Spring? And in particular, is Spring coming earlier than it used to? So in response to your questions, we decided to find out.

It all began with the *Springwatch* Survey, launched at the beginning of 2005 in partnership with the Woodland Trust. This wasn't just some idea dreamed up by people at the BBC, but a proper, scientific survey linked to a long-term project run by the UK Phenology Network. The idea was simply to record sightings of what are called 'key indicator species' – or in layman's terms, signs of spring.

Another question asked by many viewers – and indeed by Bill himself – was "if the programme is about spring, why is it going out in June? Shouldn't you call it Summerwatch?!"

In fact there is much argument about when the Spring season officially begins and ends. The Meteorological Office, for example, regard the calendar months of March, April and May as Spring; and June, July and August as Summer.

However, another widely-accepted definition of Spring is that the season begins on March 21st (the date of the Spring Equinox, when day and night are of equal, 12 hour lengths throughout the world), and ends three months later on June 21st (Midsummer's Day). The word 'midsummer' does confuse many people, but the derivation of the word is from the German meaning 'with summer', rather than having anything to do with 'middle'. So by ending around June 18th, the three weeks of *Springwatch* just make it into the spring season! The advantage of coming so late is that the series is a kind of 'end-of-term report' on the season and the ups and downs of its wildlife.

Mind you, nature has its own version – indeed many different versions – of Spring. Some traditional signs of spring, such as Snowdrops and birdsong – can occur as early as the end of January, while the last returning migrants to arrive back on our shores, such as the Spotted Flycatcher and Turtle Dove, often don't get here until the middle of May. Just to confuse the picture,

Bluebells

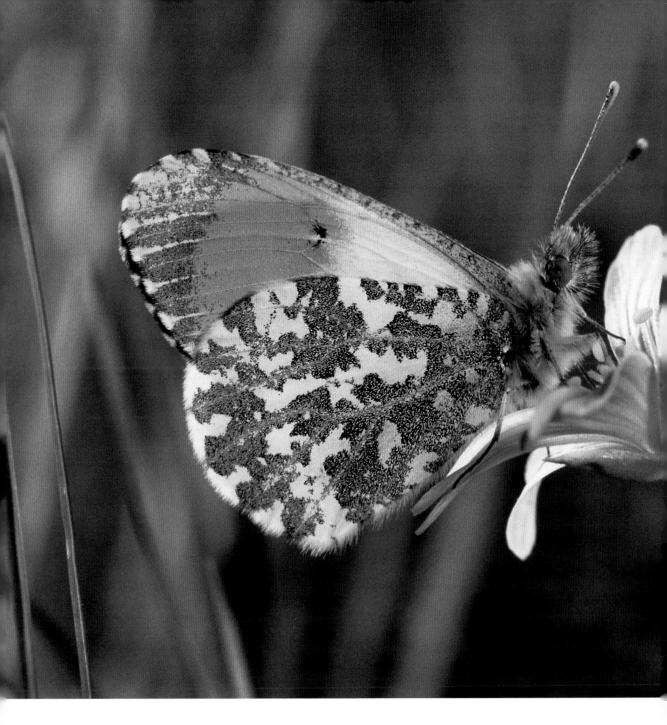

return (or autumn) migration of some birds can begin as early as the middle of June!

From nature's point of view, spring is less of a defined period of time than a linked series of events, running from January (and in some cases even earlier!) To the end of June or even July. Much of this activity revolves around breeding (especially of birds) and flowering of plants.

Orange-tip - an early Spring butterfly. Some species of butterfly spend the winter as eggs or chrysalis. Others arrive as migrants from Europe. And some even hibernate in dark, dry corners such as garden sheds or behind curtains!

Because this is the time when so much food is available, spring is a key period in the lives of many of our wild creatures – especially birds. Indeed it is no exaggeration to say that this is the 'crunch time' for individual animals in the 'race to reproduce', and pass on their genetic inheritance to a new generation. If they fail to do so, there is no guarantee that they will ever get another chance.

foxes, gulls and crows are also likely to do OK; whereas rare, specialised and endangered creatures such as the Bittern, Wood White butterfly and Natterjack Toad may not.

The ways in which global climate change are likely to affect our environment, and as a result our wildlife, are:

Earlier flowering and breeding: Wild flowers are already appearing several weeks earlier than they used to; a trend that seems likely to continue. Meanwhile our resident creatures, including many birds, mammals, amphibians and reptiles are starting to breed earlier than before – in the case of some birds even before Christmas. In some years this can be beneficial: allowing Blackbirds, for example, to raise an extra brood of young. But if there is a cold snap late in the winter or in early spring, this can kill off any chicks and bring breeding to an abrupt end.

Insects emerging earlier: Studies of moth caterpillars have revealed that they are emerging several weeks earlier than they used to. Resident birds which depend on these larvae to feed their young, such as Great and Blue Tits, appear to be responding to the change by shifting their own breeding earlier in order to make sure that their chicks hatch at the time when the most caterpillars are available. However, migrant birds such as Pied Flycatchers, whose return to Britain is governed by changes in day – length on their African wintering areas, are unlikely to be able to respond so rapidly to the change. In a worst – case scenario, in which the birds are unable to change the timing of nesting, flycatcher chicks will starve.

Wild creatures moving north: Many of our wild creatures are on the northern edge of their range in Britain, so climate change is providing a great opportunity to extend their ranges northwards as the climate warms up. Birds such as the Nightjar and Dartford Warbler, once confined to the south of England, are shifting northwards; as are many of our common butterflies such as the Comma and Peacock, are expanding into northern England and central Scotland, bringing a welcome splash of colour to gardens. But not all creatures can take advantage of these new opportunities: butterflies whose habitat is limited simply can't move northwards, as they have nowhere to go!

New colonists from the south: The English Channel presents a formidable barrier to plants and animals trying to extend their range northwards in Europe; but not an impossible one. Birds, of

course, are able to fly across, and in recent years we have seen species such as Cetti's Warbler, Mediterranean Gull and Little Egret establish themselves as British breeding birds. All sorts of exotic species may follow: Hoopoes and Bee-eaters breed just the other side of the Channel – and both species have bred in the past in Britain – while one of the world's commonest and most adaptable birds, the Cattle Egret, may also take advantage of warmer summers to breed here. Insects are also arriving in numbers never seen before: summer 2006 was the best year ever for rare and exotic moths from the Mediterranean and continental Europe, and the trend seems set to continue.

Extinctions in the north: There is a downside to all change, however; and in the far north of Britain we are set to lose some of our most special and iconic wild creatures. The Cairngorm plateau, in the highlands of Scotland, has always been a little piece of the Arctic in Britain; but recent winters have seen low or erratic snowfalls, while peaks that used to be covered in snow virtually all year round are now bare and grey. Three specialised breeding birds, the Ptarmigan, Dotterel and Snow Bunting, depend on snow cover to sustain their lifestyle; the Ptarmigan in particular, which moults into a pure white plumage for camouflage every winter, is especially vulnerable to predators if the snow is absent. A whole range of Arctic–alpine plants, together with mammals such as the Mountain Hare, are also under threat is the warming trend continues.

Habitat change: Changes in climate will inevitably have long-term changes on habitats, especially specialised ones such as wetlands. More severe droughts, or heavier rainfall in winter, bring change; while the longer growing season is having a major impact on specialist areas such as heathlands, where trees and scrub can colonise much more rapidly than before. Conservationists are well aware of these problems, and are doing what they can to solve them; though some habitats will inevitably change forever.

Long-term changes: some environmentalists are predicting catastrophic changes such as major rises in sea levels (and as a consequence, floods), droughts across Africa, and the melting of the polar ice caps. Such events would not just have a disastrous effect on the world's wildlife, but also, of course, on its human population.

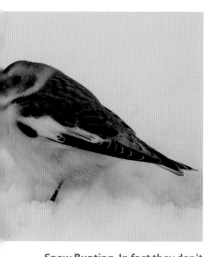

Snow Bunting. In fact they don't actually depend on snow! But they are birds of northern latitudes, most common in Iceland, which is probably where most of the birds we see by the British coasts in winter are from

The *Springwatch* survey

Stephen Moss

Faced with such potential disasters, and constant headlines in the press about the effects and consequences of climate change, it would be easy to bury our heads in the sand and hope the whole thing will go away. But as well as making changes to your own lifestyle to reduce your impact on our climate, you can also take an active role by taking part in the *Springwatch* Survey – as many thousands of you already have done!

The survey wasn't dreamt up by the BBC, but is part of a major, long-term, scientific study by the Woodland Trust, Britain's leading woodland conservation charity. The data is fed into the UK Phenology Network, a partnership between the Woodland Trust and scientists at the Centre for Ecology and Hydrology, and is the biggest survey of the timing of the seasons and wildlife activity anywhere in the world.

When we launched the *Springwatch* Survey in early 2005, the aim was to get more people involved as active participants, in order to improve the range and quality of the data, so that the scientists had something more to work on. We could never have guessed that so many people would take part; or that you would come up with such a fascinating set of records.

Taking part in the survey was simple, quick and great fun. We asked you to record the date and place where you first saw any of six 'signs of spring', selected by the scientists to represent the whole range of the spring season from January to May. The six subjects chosen were:

Bumblebee
Seven-spot Ladybird
Frogspawn
Peacock butterfly
Hawthorn blossom
Swift

The first three usually appear sometime before Easter, while the last three generally come afterwards – in the case of the swift, not until late April or early May. So there was plenty to keep up interest right through the spring period. These particular plants and animals were chosen because they are fairly common, widespread and easy to identify.

Most sightings came in via the website, though we also distributed postcards to places such as public libraries up and down the country. What really surprised us – and the scientists

Hawthorn blossom. Not to be confused with the very similar Blackthorn, which flowers much earlier. Hawthorn is sometimes called May blossom, because it flowers quite late in spring.

monitoring the records – was just how early many creatures began to appear.

Everyone involved with the survey was overwhelmed by the amount of interest and number of observations it attracted. Overall, tens of thousands of participants sent in over 160,000 individual records of the six species, with bumblebees (over 45,000 records) well out in front, followed by the ladybird (32,000) and frogspawn (almost 28,000).

Taken together, the average dates of the sightings were then compared with those from the period from 1961–1990, to find out if these key signs of spring are appearing any earlier than they used to.

The first surprise was that our earliest 'spring signs' were occurring in November of the year before: with a very early report of frogspawn coming from Pembrokeshire in south-west Wales on 1st November 2004, followed by another early sighting from the Lizard peninsula in Cornwall (one of the mildest areas of the country) in mid-December. The first bumblebee was seen on 6th December, while the Seven-spot Ladybird and Peacock butterfly were both recorded on Christmas Eve!

Snowdrops, Lesser Celandine and Rooks nesting (events recorded by the wider survey) were all seen before Christmas, and there was a flurry of sightings of bumblebees in January, coinciding with a spell of unseasonably mild weather. During the winter of 2004/05 there were also several reports of overwintering House Martins and Swallows – a very rare event indeed. The first peak of frogspawn – before the late February cold snap – coincided with Valentine's Day on 14th February!

After a short but sharp cold snap in late February, a very warm spell in March (coinciding with a one-off programme to launch *Springwatch*) brought out large numbers of Peacock butterflies, including several on and around the farm. We also enjoyed the spectacle of dozens of mating frogs and toads, intertwined around each other in the farm's lake.

Your commitment to the *Springwatch* survey was certainly impressive – if sometimes a little too enthusiastic! One participant taped a (dead) bumblebee to a survey postcard, while another sent in a half-chewed card – apparently the culprit was an over enthusiastic rabbit. The Woodland Trust also received a barrage of photographs, most of them showing mating frogs!

But the real importance of the survey was that when the data was analysed by the scientists, they were able to add to the proof that signs of spring are definitely appearing earlier – sometimes up to three weeks earlier – than they used to. Though a single season's data can never be conclusive, as the picture builds up it becomes ever clearer that something unusual is happening – almost certainly the consequences of climate change.

An unexpected – but very welcome – consequence of the publicity for the survey was that many people who had been recording signs of spring for many years contacted the Woodland Trust with their results. For some species, this allowed the scientists to build up a much clearer picture of what had been going on for the last 20 or even 30 years.

And for the scientists there was one final triumph. Sightings of our commonest bumblebee, *Bombus terrestris*, up and down the country, helped bee expert Mike Edwards to confirm something often suspected: that this species of bumblebee is active on mild, sunny days throughout the winter. They are able to do so because so many garden plants now continue to flower almost all year round, providing much-needed nectar for the bumblebees to feed on.

The *Springwatch* Survey continued in 2006, with over 100,000 records received of the six key species. Thousands of *Springwatch*ers became so hooked on recording that they now regularly record their sightings, throughout the year, for the UK Phenology Network. For more information check out the BBC website, or contact the Woodland Trust: details can be found at www.woodland-trust.org.uk

7-spot ladybird. Ladybirds spend their winters clustered together in dark, dry places. Like many hibernators they may be enticed out on mild days before spring "officially" arrives

Bass Rock

Simon King

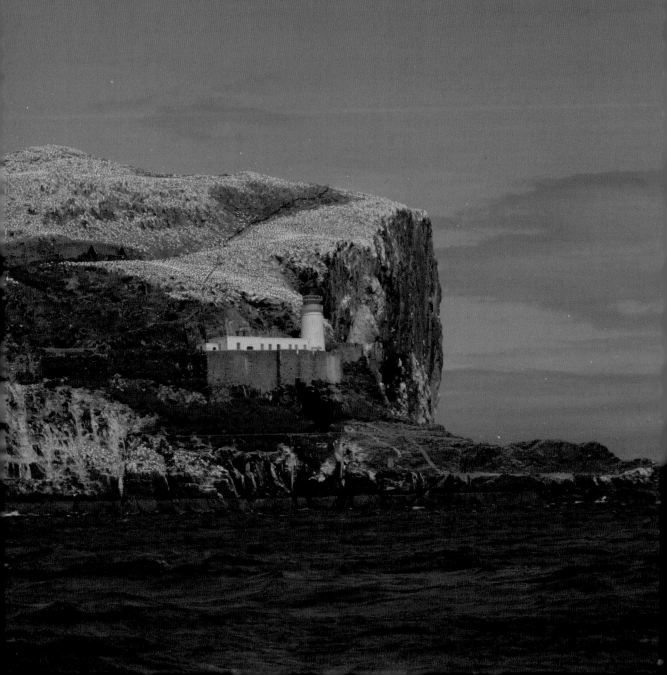

The top of the rock is white – literally wall-to-wall Gannets

To some people, it comes as a surprise to learn that Britain is probably the best place in Europe for a variety, number and spectacle of seabirds. Unless you travel to the very far north – the sea-cliffs of north Norway or Spitsbergen, you are unlikely to match the quality of views – and sheer excitement – of sitting in a seabird colony on one of the many offshore islands or coastal headlands of the British Isles.

There are several reasons for this. First, we are on the north-western edge of the Eurasian landmass, and as a group of islands we are surrounded by seas. Not only that, but these seas have historically been amongst the most productive, in terms of fish and other food for seabirds, in the world.

Having so many small offshore islands is also a huge advantage for the seabirds. Because many species nest on the ground, they are very vulnerable to mammal predators such as foxes and rats. By nesting on remote islands they minimise or even eliminate the risk of losing their eggs or chicks in this way. Even for those species that nest on inaccessible cliff ledges, such as Guillemots, there is a huge advantage being on an island surrounded by sea - food is literally on their doorstep.

Because they need to avoid predators, and nesting sites are limited, most seabirds nest in colonies. Another reason for this is that there is no point in a seabird defending its feeding territory: unlike a Robin or Blackbird, which need to defend the area where they feed, birds

In the year 2004 the series (then called *Britain Goes Wild* as a follow up to the previous year's show; *Wild In Your Garden*) saw me visiting 3 locations, one on each week of the transmission period, with 3 very different wild events.

In week one I revisited a spot that had already earned a place in my heart from my work there as a wildlife cameraman – The Bass Rock off the East Coast of Scotland. This crumb of an island is host to one of the largest colonies of Atlantic Gannet in the world. At the time some 40,000 pairs nested there, turning the top of the island white with their plumage and droppings.

Gannets rock. I suppose I could add an apostrophe to that statement to describe their home (Gannet's Rock ... OK, I'm being pedantic) but I'm referring to the charisma of this, the largest and for me most dynamic of British seabirds. From the designer lines of their plumage to their ice-cold stare and resonating, guttural calls, Gannets embody the spirit of the wild ocean. Catching a glimpse of a group of birds riding the updrafts created by the waves is a thrill. But to sit amongst thousands of them as they jostle for a nest site and raise their families is to rub shoulders with a truly wild spirit of the sea. I was able to do just that for over a week and loved every minute of it.

For some, the smell generated by a seabird colony can tip the nausea balance after a bumpy ride across the sea to reach them. But I can honestly say I find it quite pleasant. I may of course be very odd, but the heady, salty, fishy musk generated by thousands of seagoing birds is so evocative I wish I could bottle it. I doubt however that I would get very rich on a new line of scent for the earthy among us. Just imagine: Guano ... for men! Or how about Spraint ... the scent of the wild! Anyway, I think you get my point. Being amongst the Gannets was close to heaven for me.

There were of course members of the crew for whom it was a little less like heaven. My floor manager, Marco De Giorgi, (it's his job to make sure I am where I am supposed to be at any given time, and to give me visual counts in and out of the pieces I present in the show) is very fond of the great outdoors. But his passion was sorely tested by one of the island's other inhabitants. Bass rock is home to many other seabird species besides Gannets, among them Herring Gulls. Some of these nested on the steps leading up to the Gannet colony and every day we would pick our way carefully around their nests as we scaled the steps to the top.

One pair in particular were very vigorous in their defence of what they perceived as a threat to their new family, and would repeatedly dive and scream at our heads as we passed by. They would also release whatever they had in their guts with remarkable precision, and it was just such an attack that caught Marco full square across the head and back. All very well, but Marco had come prepared for the worst that Scottish weather might throw at us with the finest new coat. Post Gull attack, the leak-proof hood of that same new coat (which he had forgotten to pull up over his head) had acted as a basin, and now held what looked like a cupful of gull poo. Marco did eventually see the funny side of it – about 3 years later!

Marco is just one of a team of highly talented and dedicated people that get *Springwatch* on the air. Our OB team (OB stands for Outside Broadcast) consists of about 24 people that travel the nation with me to beam pictures back to the HQ in Devon and so into your homes. Many are technical staff whose ability to work magic with wires borders on alchemy. I have, in the past, made the mistake of asking one of the guys I work with just what a certain piece of electronic wizardry did. Some 20 minutes later I was left feeling like the most stupid human on the face of the earth, and wishing I had paid a little more attention in physics lessons. It was made all the worse by the explanation starting with the phrase; "Well, in simple terms its"

Getting a live image out of a location like the Bass Rock requires an enormous amount of gear and a team that knows how to use it. Even the changing tides played their part in complicating matters, since, as water levels rose and fell, so the gear that sent the signal back to the mainland (thence to be beamed up to a satellite before reaching the control centre in Devon) had to be adjusted to compensate for the effect of radio waves bouncing off the surface of the sea.

During one of the transmissions from the Bass, I was in the middle of describing the events of the day over a short film we had prepared that morning, when a stream of gannet guano landed across my face from one of the hundreds of birds flying overhead. Nothing new there; but a small amount of the deposit plunged squarely into my mouth. Much as I find the scent of a seabird colony evocative, I can't say the same for the taste! I was left spluttering and coughing mid sentence whilst on air, desperately

like Gannets and terns feed on constantly shifting populations of fish, which they would be unable to defend even if they wanted to.

That's not to say that territorial squabbles don't occur: they do, but in a different way. Seabirds such as Gannets carefully nest just a little over a neck and beak's reach from their neighbour. If the rival does come a little too close for comfort, a sharp stab with its bill usually sends him back where he belongs!

Simon has been fortunate to visit two of the most spectacular and awe-inspiring seabird colonies - not just in Britain but in the whole world. On Britain Goes Wild in 2004 he spent a week on Bass Rock, out in the Firth of Forth within sight of Edinburgh. He and the crew were transported to a totally different world from the genteel Scottish capital: thousands upon thousands of pairs of Gannets, creating a spectacle for the eyes, ears and nose it would be hard to beat. We followed the fortunes of the 'Lighthouse Family', as they reared their hungry chick (it's no coincidence that a greedy person is sometimes referred to as a 'gannet').

But it's when the adult Gannets are hunting for food that they really show just how spectacular a seabird can be. Hanging in the air on those long, pointed wings, they use their powerful eyes to seek out the shoals of fish in the clear blue sea below.

Once they have found their target, they fold back their wings and plummet down at breakneck towards the surface of the sea. As they break the water they use their forward-facing eyes to seek out their intended catch, then grab the fish in their sharp, powerful bill and fly out of the water and back to the nest. Incredible!

For Springwatch 2005 Simon was back at a seabird colony: this

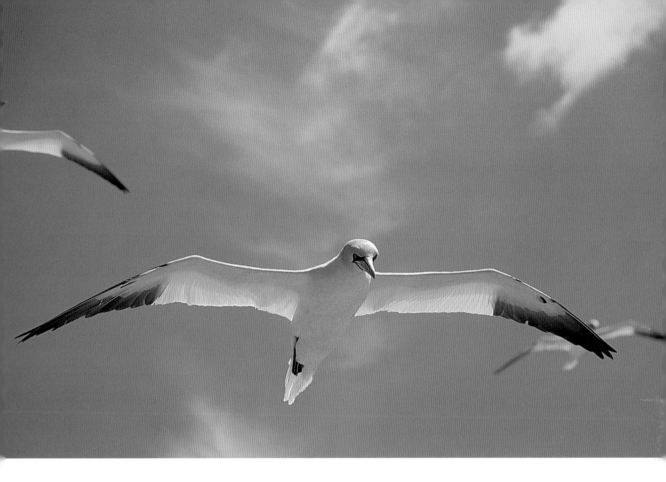

Simon tried his best to "personalise" his Gannets by giving several of them names. Kate and I never admitted it, but they all looked the same to us!

time on the Farne Islands off the coast of Northumberland. Easily reachable by boat from the little port of Seahouses, this really is a wonderful place for all the family – provided you don't mind being attacked by the nesting Arctic Terns. As Simon soon discovered, if you venture too near their eggs or chicks (and the nests are almost everywhere so it's hard to avoid them) the adults will dive-bomb you, pecking at your head with their sharp (and appropriately blood-red) beaks!

Arctic Terns are quite incredible creatures: undertaking the longest migration of any living creature, from their breeding grounds in the northern hemisphere to the oceans around the Antarctic

trying to hold it together as I described the nesting antics of the birds on the film. When the camera came back to me, I think I may have appeared a little red faced. With white bits!

Wherever we travel in the nation, we are helped in our mission by conservation bodies and local people who welcome us with an astonishing degree of warmth and enthusiasm. On the Bass, it was the Scottish Seabird Centre and the people of North Berwick who made possible the work that we achieved. I had enjoyed this hospitality previously when I was filming the Gannets of the Bass for the series *Blue Planet*. Then, in my role as a specialist cameraman, I had the task of filming these, the largest of our nesting seabirds, plunge-diving after fish in ultra slow motion. For all its rugged beauty, the Bass can be battered by foul weather on a regular basis. The *Blue Planet* film trip was blighted by thick mists that only shifted when gale force winds drove in from the north, making it impossible to film the birds out at sea. Each day, the producer, Alastair Fothergil, would make the journey in his small hire car to the local fishmonger, to collect a crate of herring or mackerel in the hope that we would make it to sea and would

continent - a round trip of more than 22,000 miles, or up to half a million miles in a single bird's lifetime. It is almost impossible to imagine, looking at the tiny, fluffy chicks on the Farnes, that they will be strong enough to undertake such an epic journey just a few weeks after the Springwatch broadcast.

Terns aren't the only seabirds on the Farnes. Kittiwakes, one of our most attractive gulls, fill the air with their cries - calling out their name! Shags, with some of the ugliest yet strangely compelling offspring in the bird world, nest on the cliff tops. And on the cliffs themselves, hundreds of auks: Guillemots and Razorbills - the penguins of the north.

But if there is one bird which visitors to the Farnes absolutely must see - and it's not hard to do so between May and July - it's everyone's favourite, the Puffin. Also a member of the auk family, the Puffin has a very different

be able to encourage the gannets to dive with a few tit-bits. Each day, a little of the fishy water from the crate would slop into the luggage space in the back of the car. By the end of the first week, the stench inside the little hatch-back was eye-wateringly revolting! I would see Alastair arriving from afar, the top half of his body thrust out of the driver's side window, in a desperate bid not to asphyxiate before arriving with the day's fishy offering.

We eventually got our break. After almost 2 weeks, the wind dropped and the skies cleared. All was looking good as gannets began to circle over our little boat attracted by the herring we threw from time to time into the sea. I readied myself for the shot, camera primed at water level, expecting the explosive power of the diving bird to appear in front of me at any moment. And then, someone turned the lights out! Filming in slow motion requires very bright conditions, and in our enthusiasm to check weather forecasts and procure fish, we had overlooked the fact that it was the day of the total eclipse of the sun! At our latitude the eclipse was partial, but enough to put all filming on hold until the moon, sun and earth had shifted out of alignment. I imagine I was one of the very few people in the nation gently cussing this rare and potentially exciting event!

Bass Rock film crew

style of nesting from its relatives. Instead of perching on narrow cliff ledges, it lays its single egg underground – using a rabbit's burrow if there's one available, and digging its own if not.

Puffins always appear comical: that combination of the brightly coloured bill and waddling walk would melt the stoniest of hearts – but they are birds like any other, and must make a living and raise their family. This is no easy feat: not only do they have to catch small fish – mainly sand-eels – by diving underwater they also have to run the gauntlet of marauding gulls, eager to snatch not just the Puffin's food but even the bird itself.

Life is hardly any easier once the breeding season is over. All the seabirds leave the Farnes: some, like the Arctic Tern, heading thousands of miles away; others, like the auks, flying out to sea, where they spend the autumn and winter months bobbing on the waves and diving for food. This brings its own dangers: autumn and winter storms can easily drive them ashore, where many are washed up, dead or dying.

And now our seabirds face a new problem. In recent years, birds in many colonies, especially those visited by Simon in 2006 on Shetland, have struggled to raise any young at all. This is because of food shortages, which scientists increasingly believe are due to the effects of climate change.

As the water temperatures warm up, the sand-eels and other fish on which many of these seabirds depend for food are either heading deeper below the surface, or further north, in order to find the colder water suitable for their own needs. If the poor breeding seasons continue, even these very long-lived and resilient birds will face major population crashes in the near future.

We did eventually manage to film Gannets plunging after fish from both above and below the surface, and some of these images were used in the *Blue Planet* and during *Springwatch* to illustrate their mastery of the elements.

A Gannet's "best side"? – straight at the camera, they always look a little "cross-eyed", and indeed just cross!

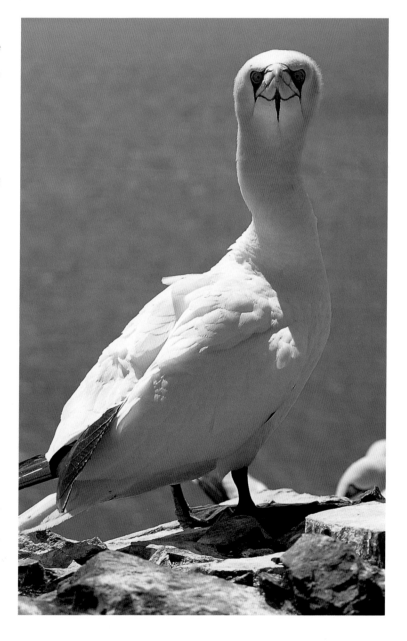

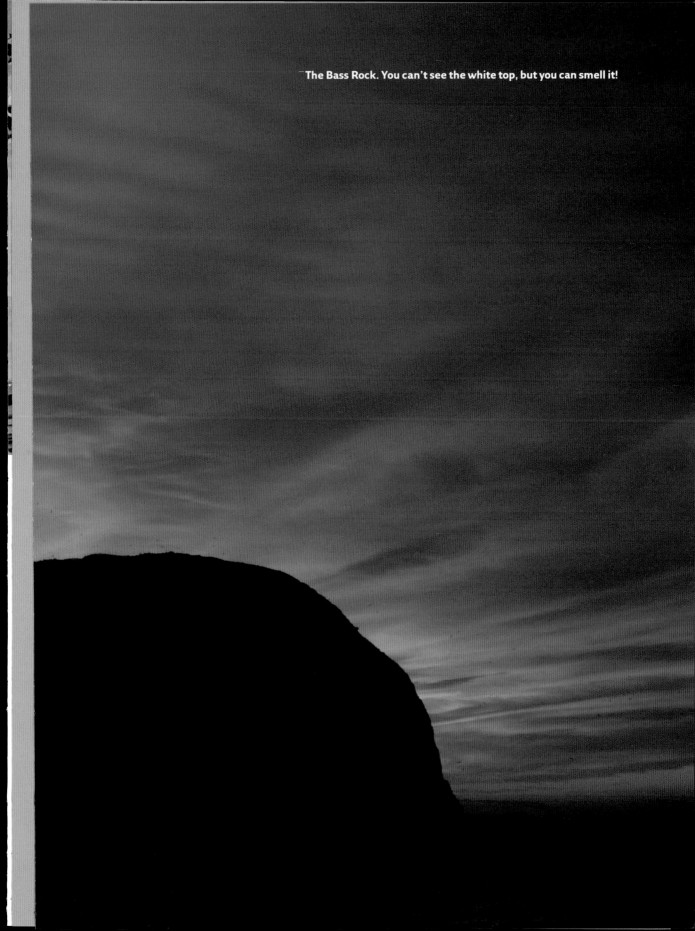

The Bass Rock. You can't see the white top, but you can smell it!

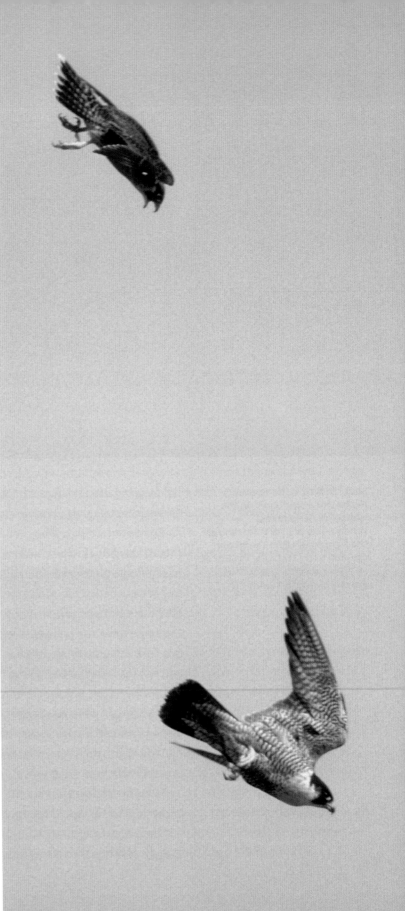

of destruction, the Peregrine
population plummeted, and by
the late 1960s the bird was on
the verge of extinction – at least
in England. But in the nick of
time, the banning of DDT and
more enlightened attitudes from
the majority of people meant
that the killing stopped, and this
stunning bird was able to begin
its comeback.

But few people predicted
how rapidly the Peregrine would
begin to move into our towns
and cities – wholly new territory
for the species. The reason for
this is that as the population
grows (the current UK estimate
is about 1400 breeding pairs),
established nest sites are fully
occupied, and so surplus pairs
need to find new places to breed.

What our cities offer is an
almost exact reproduction of the
bird's natural habitat: prominent
perches from which they can
survey their territory (including
the Telecom Tower and Tate
Modern art gallery in London!);
window ledges and flat roofs on
which they can build their nest;
and most important of all, plenty
of available food: lots of birds,
including of course the 'flying
rats' – Feral or Domestic Pigeons
that infest our city centres.

What makes the Peregrine so
different from the Feral Pigeon,
however, is that it has hardly had
to alter its behaviour at all;
unlike the pigeons, which
descended from wild Rock Doves
and have adapted to cope with
all the pressures of city life.

Today, Peregrines can be
seen regularly not only in
London, but also in many cities
up and down the country:
including Cardiff, Swansea,
Exeter, Birmingham and Bristol.
The RSPB often sets up special
watchpoints, staffed by experts
and with telescopes trained on a
nest or favourite perch, enabling
anyone to see the Peregrines. For
more details, visit their website
on www.rspb.org.uk and click on
'Aren't Birds Brilliant!'

Peregrines don't just stoop to catch prey. They may be chasing off rivals, or encouraging their offspring to "leave home", or indulging in aerial mating dance

was it growing rapidly in size, and, as it neared our position, the sound of the air ripping through its plumage, like someone tearing linen. We never managed to capture the moment on air, but it was times like these that helped to stoke the furnace of enthusiasm!

The Peregrines we looked at during *Springwatch* had just one chick that year, which, I'm delighted to say, fledged and as far as we can tell, flourished, thanks largely to a dedicated handful of local people who kept a careful eye on it throughout the season. Their care continued once we had moved on to our final location for the series; the London Wetland Centre.

The first cockney Peregrine, with its proud parent. Peregrines first moved into London in the 1990s, but this was the first bird to successfully fledge in the capital

Wetland Centre

Simon King

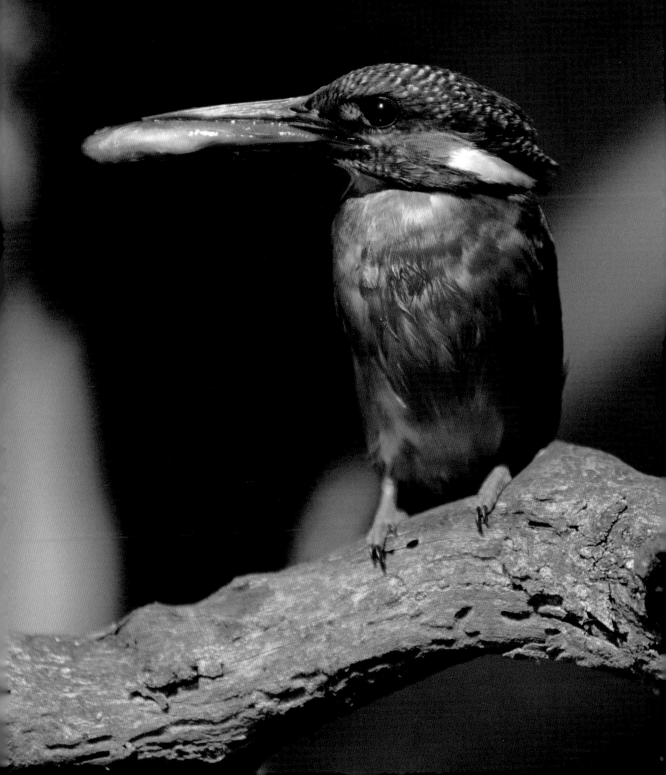

This is such a great place! Bang, smack, wallop in the heart of the city in Barnes, it screams out to be described in clichés like "an oasis in the urban jungle" and "a walk on the wild side", many of which I'm sure I used when I was talking about it on air. It is a shining model for the correct way to combine housing developments and the natural world, and was the brainchild of the late, great Sir Peter Scott who started the Wildfowl and Wetlands Trust (WWT) that continues to manage and run it to this day. Sir Peter, whose interest in wildfowl stemmed from hunting them as a young man, and who became their most devoted guardian, had his eye on the Barn Elms reservoirs whilst they still supplied most of the freshwater for the people of West London. These concrete bordered tanks attracted a lot of ducks and other water-birds in the winter months, but lacked the habitat to encourage breeding.

When, in 1989, the reservoirs' role as a water source became obsolete, developers were quick to see the opportunity to drain the tanks and convert the area into prime real estate. The WWT negotiated with the council and developers and managed to strike a wonderful deal which, simply put, allowed a percentage of the land to go to very high end property development, and the remaining acreage to be converted into a varied wetland habitat for wildlife, funded substantially by the money from the developers.

The patchwork of lakes, canals, marshes and reed-beds has been very carefully built from scratch to maximise diversity for wildlife. Our transmissions followed nesting Little Ringed Plovers, Foxes, Herons and other wild residents of the reserve. These species are not unique to the centre of course, but being in the heart of the city and exposed to thousands of benign people every year, creatures that might otherwise be very shy, virtually ignore human presence. And that gives you cracking views! I have seen Grey Herons many thousands of times, but I have never had better views than those achieved at the London Wetland Centre. And the Foxes, too, are virtually bombproof. They tend to stir in the late evening, when most of the public have left the centre, and they can cause a bit of mischief. We had one camera crew stationed close to a breeding earth (the name for a Fox's den) on the edge of a reed-bed. Cables had to be run over many hundreds of metres to feed the sound and images back from the earth to our control centre, and these proved to be irresistible to the young Foxes.

A Simon Kingfisher?

Polly & Willy

Kate Humble

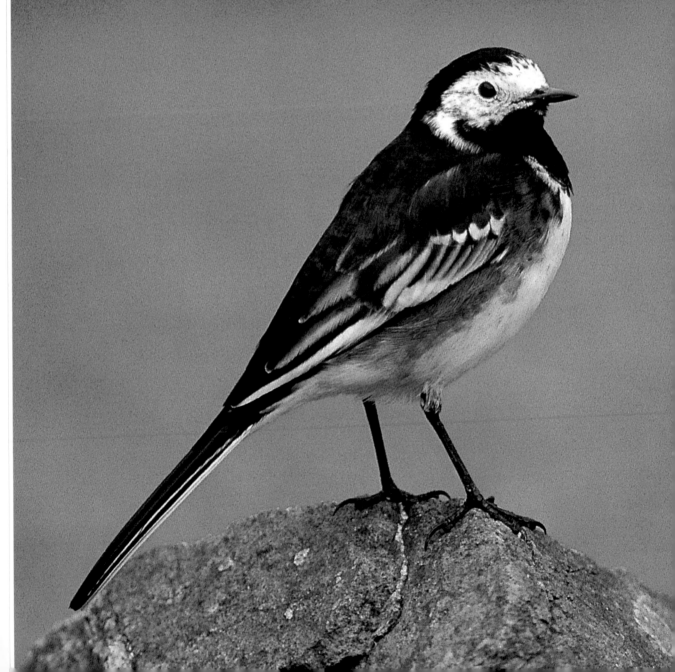

Not everything has a happy ending on *Springwatch*. Over the years we've seen chicks die because adults have been too young and inexperienced to look after them; we've seen chicks threatened by squirrels and greater spotted woodpeckers; nests of flycatchers and dabchicks destroyed by predators; a whole family of wrens perished when the female failed to return to the nest - she had almost certainly been killed - and the chicks died of starvation and exposure; but no story seemed seemed quite as tragic as that of Polly and Willy the pied wagtails.

It was our first year on the farm and we were all nervous. More than a hundred people, several miles of cable, trucks, tents and portacabins had descended on the Fishleigh Estate, a beautiful organic farm in the middle of the Devon countryside. Our aim was to do twelve live broadcasts over a three week period following the real-life dramas of the natural world during its busiest and most productive time of year, Spring. We had no idea whether it would work, whether the idea would sustain over so many hour long programmes, or indeed, whether nature would provide the characters and material we were so desperately relying on. We needn't have worried. Nature can be unreliable but pick a place where there is plenty of food, shelter and nest sites - and Fishleigh has plenty - and you can be pretty sure that something will happen. And it did. Over the three weeks we followed nine different species of bird which had nested on the farm. With the help of tiny, remote controlled cameras, we were able to follow the fortunes of families right up until they left the nest without them ever knowing that they were being watched. Specially constructed nest boxes, with built in cameras, gave us wonderful insight into the early lives of Blue Tits - one family successfully rearing thirteen chicks! - Great Tits and Jackdaws. We also found and secretly filmed the nest of a Mistle Thrush, a Robin, Blackbird and Wren. Finding nests is an art and takes time and endless patience and the cameras are rigged only by people who have a special licence. But Polly and Willy wanted to make it easy for us. They built their nest right at the entrance to the farm and our production village. They tucked it into a bank, barely a metre off the ground and right next to a busy main road. Partially hidden by grasses, it was still a very exposed site and people and cars were constantly passing right in front of it. The adults seemed unconcerned. Polly laid five eggs and sat, gazing beadily out

Bill and Simon try to be all masculine, but they are by no means immune to becoming emotionally attached to our wildlife characters. Kate is unashamedly so - and quite right too!

Who can forget the saga of Polly Wagtail back in 2004 - when the nation watched in horror as a pair of Pied Wagtails chose to nest by the busy main road just outside the farm gate? Polly and her partner became local - and indeed national - celebrities, before tragedy struck when the nest was raided by an unknown predator. Fortunately, as Kate has described, the story ended happily when they found a safer place to nest back on the farm.

Pied Wagtails are one of our most attractive yet often overlooked birds. Equally at home in the rural countryside or on suburban and city streets, they flit around from place to place looking for the tiny insects on which they feed - picking them up from the cracks between stones or on roofs and walls using their sharp, slender bill.

In winter, Pied Wagtails gather in large roosts, often in what appear to be the unlikeliest places such as motorway service stations, shopping malls and high streets. What all these locations have in common is that they are well-lit, warm, and as a result fairly safe places, where most nocturnal predators, such as owls, will be reluctant to go.

A few years ago Bill witnessed one of these roosts in the Devon market town of Newton Abbot - not all that far from the farm itself. As dusk fell, and the street lights came on, the streets fell silent as the shoppers hurried home. At first, all we could hear was the occasional distant call - a two syllable 'chis-ick' sound. Then we heard another and another, and soon little groups of birds were arriving on the tops of the shop roofs.

Within a few minutes, as the sky turned dark, they were landing in a small tree planted outside the local Marks and Spencer's. Soon it became impossible to count them properly, as the branches of the tree filled with these little black-

through the grass as Willy searched for insects with which to feed her. Making the most of his nest's position, Willy took to hunting on the main road, collecting insects killed or disoriented by the passing traffic. The sight of this tiny bird flitting amongst rumbling lorries and speeding cars was enough to give us all a collective heart attack, but both he and Polly proved that a combination of Pied Wagtail agility and road savvy was enough to not only to survive but also to emerge from the fray with a good meal.

In the middle of our second week four of the five eggs hatched and the following day the final egg also hatched. By now we and our regular viewers had become terribly attached to these perky little birds and wanted to prevent, if at all possible any tragedy befalling them and their newly hatched chicks. Normally there would have been no need for concern, but their choice of nest site seemed so unwise we felt the only thing for it was to assign them a body guard. Mike, a brilliant naturalist with years of experience in the field, was assigned the task of Chief Polly Watcher. Meanwhile Willy, who had always been fairly attentive, went into overdrive. Not only was he providing food for Polly and his new brood, but also for two juveniles from a previous brood who were seen hanging around the nest site. It seemed that we, unconsciously, were providing rich pickings for the wagtail family. Moths and other insects drawn to the security lights gave them all a regular supply of food, rather more safely and easily obtained than hunting in the road. The chicks thrived on this regular, protein rich diet and grew quickly. As they got bigger Polly would leave the nest too for short periods and we would get a glimpse of five little heads with their out-size beaks, peaking out of their little grassy hollow. Mike continued to watch them, only leaving them to grab a few hours sleep himself between the hours of one and five in the morning.

Tragedy struck in the early hours of the Monday of our last week. Mike returned to his vigil at 5am and found the nest on the ground at the bottom of the bank. It had been pulled out of its hollow and all the chicks were missing. Both Polly and Willy kept coming back over the next couple of hours with food and were searching for the chicks. Mike was distraught. We all were. Having nested literally on our doorstep, Polly and Willy had become part of our slightly unusual, temporary extended family. But who or what was responsible? We never found out. Magpies were spotted

and-white birds. By the time they began to fall silent, we estimated that there were at least 400 birds in the tree – possibly even more. What was really amazing is that no-one else seemed to have noticed the birds, despite this being one of the natural wonders of winter happening right on their doorstep.

The wagtails on the farm nest in all sorts of places, as we have seen. Like Robins and Spotted Flycatchers they are sometimes attracted to open-fronted nestboxes; though of course these are much more vulnerable to predators than the classic boxes with an entrance hole used by the tits. Nevertheless many Pied Wagtails breeding in southern Britain manage to raise two broods, while further north they usually have one. They are common and widespread throughout Britain, with at least 300,000 nesting pairs, making them one of our commoner breeding birds.

Two other species of wagtail breed in Britain: both of which can cause confusion to novice birdwatchers. Despite its rather dull name, the Grey Wagtail is one of our most beautiful and elegant birds: grey above (with black on the head of the male), and white below, with a lemon-yellow belly which often leads to confusion with another member of its family, the Yellow Wagtail.

This species is much more yellow, with greenish upperparts and no sign of black or grey in its plumage. The other big difference is that Yellow Wagtail is purely a summer visitor to Britain, whereas Greys are found here all year round. Grey Wagtails are partial to fast-flowing rivers, and can often be seen on the river Torridge bordering the farm, where a few pairs breed.

Pied Wagtails (centre) and other species, Bill's sketches from *Bird in the Nest*, 1994

over the road looking hungrily in hedges for nests, but it could just have easily been a fox or a stoat or another bird like a crow. And what of Polly and Willy? A couple of days later, just as we were preparing to do the last show they were spotted. From their behaviour it was clear they were prospecting for a new nest site, but this time well away from the road and high up in the roof of one of the barns. Much more sensible!

Springwatch 2006

Bill Oddie's Diary

"I'm a celebrity, get me into here!" This is what I call a reality show. In 2006, I decided to keep a daily diary, not only about what happened day to day, but also "behind the scenes" stories, relevant thoughts, musings, and even a little philosophy about the whole business of working in wildlife television in general, and on *Springwatch* in particular

Wednesday 24th May

Mid morning

Yesterday, I was due to come down to Fishleigh and do a prerecord with Kate. The director's idea was to do "something along the river", which would probably involve me canoeing. I'd suggested that Kate snorkelled. I could cover wildlife above the water and she, below it! However, just as I was leaving home to get the train, Stuart (the director) rang to say "don't bother! There's been masses of wind and rain, and the river is a swollen torrent." I have mixed feelings. I was quite looking forward to a little paddle, but then again the last time I "rode the rapids", the inflatable boat tipped over, and I was hurled into the maelstrom. I have a dim recollection of someone reaching out to try and grab my hand before I floated away on the raging current. Presumably they succeeded, coz the next thing I knew I was

sitting in the front of the boat paddling proudly like Sanders of the River. Which was fine, except that I couldn't remember what country I was in, and what I was doing there. It was at least two hours before I was willing to believe that I was in Costa Rica doing a travel item for BBC Radio and finally recognized the bloke who had given me this information and kept asking "are you alright?" as my director! As it turned out I had not only lost my memory, but also – more permanently – one of the recorded tapes. We finished off the programme back in London, in Regent's Park, simulating the sound of rapids with a washing up bowl and a flannel! OK the keen eared birder may have recognized the screeching of British Black Headed Gulls screeching in the background, but otherwise the Regents Park Rose Garden passed quite convincingly for the Tropical Rain Forest. I couldn't help thinking that Radio Travel shows could save an awful lot of money by not actually ever going anywhere. I also vowed that one place I personally would never ever go again was in a canoe on a swollen river. But hey, surely I would've made an exception of the docile little stream at Fishleigh, especially if I would be rescued by Kate Humble in a wet suit. I might even have needed the kiss of life. But it was not to be.

I decided I might as well go down to Devon anyway, as there was no real reason to stay at home. So I took the train to Exeter. I was met at the station by Jessica, a typical member of the *Springwatch* team, in that she is young, lively and undeniably attractive (more of that later!)

That evening, several of us convened for the first supper at the splendidly picturesque Mill End Hotel. And yes, it does have a working water wheel. The reunion included more senior members of the team ("seniority" being the qualification for staying at such a lovely place, rather than at a local B and B. No disrespect to them mind you). After much gossip, wine and more gossip, I eventually tottered upstairs and re-acquainted myself with my room. I presumed other people had used it since I was there a year ago, but I still considered it as "mine", not least because it had a "history", and a slightly spooky one at that. Two years previously – when *Springwatch* was called *Britain goes Wild* – I had stayed in the same room, and become suspicious that it may have been haunted, by something very worrying. Every morning, I woke up to find black marks on my pillow. No, not mascara or hair dye, mine or anyone else's. The marks were absolutely symmetrical and

undeniably resembled claw marks, made by something with very large hands. It was as if whatever it was had placed its "paws" either side of my head, and presumably then decided against ripping me apart, and simply left black prints. To the surprise of my colleagues I was curious rather than terrified, as became obvious when I took my pillow downstairs and plonked it on the breakfast table as evidence that I was not hallucinating or attention seeking. "So what do you lot make of that then?" I asked. Some said the marks looked like the imprint of a large butterfly. Others that they were surely left by bird wings. with bird attached, or not? If not, I must have looked like the sleeping Hermes with them either side of my head. And where were the wings now? They couldn't have flown off. There was one vote for "an angel", but most people agreed that the marks most resembled claw marks. Made by very large claws. The fact that they hadn't actually pierced the pillow, and were not accompanied by footprints, or any other visible evidence of a beastly nocturnal visitation – even my emergency Mars Bar was un-nibbled – surely suggested that they were of "ghostly" origin rather than anything from the natural world, as it were. I mean be, honest I've heard of the Beast of Dartmoor but if it does even exist and whatever it is – a panther, a bear maybe – the odds were well stacked against it nipping into my bedroom night after night, nuzzling up to me on my pillow, without waking me up, and scuttling away leaving only its claw marks. I mean surely even beasts are in the habit of giving a human face a slobbery lick, even if they don't feel inclined to bite a chunk out of your neck. However, I don't believe in ghosts, and day after day I strove to discover a less paranormal explanation. After about two weeks, I finally sussed it out. I slept with the window open. It was hot. We were near a stream. Midges had invaded the room, and settled on my bed, including my pillow. I am clearly unwittingly wriggly in my sleep – I recalled my wife announcing that I was hyper active in bed in a way that was certainly not a compliment. Presumably my body, and in particular my head had been turning from side to side all night. The black marks on my pillow were not The Devil's claws. They were squashed flies! There are still members of the *Springwatch* team who refuse to believe this logical and admittedly disappointing explanation. They tend to be the ones who habitually watch "Most Haunted". In any case, I feel that

Mosquito? One things for certain – it wasn't mosquitos that left their marks on my pillow 'cos I would have been woken by their buzzing and bitten to pieces. So the insect here portrayed is innocent. However, he and his friends are not quite so beloved by Simon

subsequent stays in the same bed in the same room have supported my theory. The stream is still there, but it has been less hot, and I keep the window closed. Under these circumstances, the pillow has remained "unclawed". Q.E.D.

Thursday 25th May

It's now 7.50a.m. I have slept well. However, I woke up with an unfamiliar feeling! I am nervous! This is not like me. I am totally prepared for the imminent "challenge" of three weeks live telly. I have research notes to elucidate any complicated topics that might crop up. I have files full of ideas, and "interesting" snippets that are handy should we run short of items, or have "technical" problems. Added to which I am rarely lost for words anyway. I am fortunate that neither hard work or heavy schedules seem to stress me much, probably – though I say it myself – I am rather an "organized " person. A man of lists and labels! I am also very adamant about the need for occasional periods of "rest and recuperation". To this end, I have my "relaxation props", in the form of several music magazines, and an electric guitar. This is a new element this year. In fact, I can't play guitar, but I am endeavouring to learn for another BBC 2 series called Play It Again. Which really ought to be called just Play It, since it involves "celebrities" learning instruments they have always wanted to play. It might seem appropriate that my nervousness is in anticipation of Kate's response to discovering that she is going to have to share out caravan with a Fender Stratocaster (as played by all rock stars who wish to be very loud), but she need have no fear since I also have earphones. She wont hear a thing, except my occasional screams, or yells of "yeah!" as I rip off a particularly tasty lick.

So why am I feeling nervous? Or perhaps a better word is "scared." Yes. If I am honest with myself – which is never a bad idea! – I am scared of my own 'temper'. The fact is, there are some recent aspects of my personal life that have been, well, rather unsettling. I am "carrying anger" – as a "shrink" would say. The danger is that that anger might get vented on the "wrong" people or on inappropriate occasions. I have always had an abrasive side,

but at least I would claim that it is usually aimed in the right direction. I would say that though wouldn't I!? In recent years, I honestly think I have mellowed quite a bit. But the fact remains that three weeks of live telly involving nearly a hundred people, working very hard and very closely with each other, adds up to a very complex and potentially volatile "dynamic". There will be disagreements, problems, disappointments. Tempers can get frayed. Mine is a bit frayed already! And we haven't even started yet!

Yes, I really do think this explains why I am a bit nervous. Mind you, having figured that out, I feel calmer already! Added to which, I am pretty sure that, once we get started, my nerves will disappear altogether. They will be replaced by doubts, irritations and so on, and – unless I control myself – a bit more crossness than is justified. I'm not anticipating it – but I do feel the need to get going, and find out what shape I am in, as it were. The one thing I do know is that, as well as any other emotions, the overwhelming one is of excitement.

We are all excited. Excited at being back in our "Production Village" , excited at meeting one another, and, of course, excited about our future "stars", especially the birds nesting round the farm. Several nests will already have been found, but I have every intention of finding some more. My schoolboy egg collecting days have left me with quite a skill at nest finding. That doesn't of course mean that I condone egg collecting but it is some personal consolation to me that balances up the guilt at my childhood delinquency.

It will also be fascinating to see how the situation this Spring compares with recent previous years. Last Spring (2005) was 2 weeks ahead. This one is a month behind! So much for "global warming" then? No, but I do think "climate change" is a better phrase. Certainly this years spring climate has "changed" from last year's, but of course that is not the point. Whatever is happening is complex. And it is worrying. But now is not the time for worries and doubts. It is time for another reunion.

Later that morning ...

It was merely grey when we left the hotel. Half an hour later, as we turned off the road into "production village", the heavens opened. I lept from the car and dived into the caravan that would be home

Production village and cables. I have no doubt some statistically minded technician would be able to calculate the number of miles of cable that had to be laid to make *Springwatch* happen, but so what?! The fact is, it was an awful lot! Imagine these tangles of giant spaghetti criss-crossing fields and farmyards all over the area, over fences, across streams, through woods, alongside roads and up and down trees. And imagine if there's a fault somewhere –maybe a Fox bites through a cable – how do you find it?!

for the next 3 weeks. Eventually, I'd be sharing the limited space with the lovely Kate Humble, and the equally lovely Lisa, our make-up supervisor. Yup – incarcerated in close proximity with two deliciously attractive and intelligent women. A tough job, but someone has to do it.

However, right now, I am alone. Neither Lisa nor Kate is expected to arrive in Devon till this afternoon, and they'll probably go straight to the hotel, if they've got any sense. It is freezing in here. It's even more freezing outside. And it's still raining. No, make that 'bucketing down'. It has been like this for several days,

The Farmhouse. If it looks idyllic and delightfully cosy - it is! Missing from this photo are various resident labradors, House Martins in the sky, and BBC personnel arriving, departing, or just standing admiring the ambience, and wishing they lived there

and if it carries on much longer, our caravan and the rest of the production village will be washed downhill, into the river and carried off on the torrents, until we float out into the English Channel. By Monday, when we're due on air, we should be safely beached on the coast of Normandy! I suppose we'll just have to make the best of it.

"Bonjour et bienvenu a "Regardez le Printemps" - oui, c'est *Springwatch*. Cette annee nous sommes en La France, pas Devon. Comprenez?"

Actually, no, I doubt that would work. After all, I suspect that

much of the appeal of *Springwatch* is that it is quintessentially British. So, in true British spirit, we'd better batten down the hatches, tighten the guyropes, make sure the anchors are holding and hope it stops raining!

Mid-day

It hasn't. It's like a flippin' Monsoon out there; sheets of water, howling gale. The caravan is being buffeted like a boat, and for all I know the rest of production village may have been evacuated. I can't see out of the windows, 'cos they're all steamed up, and I can't hear any evidence of human life, because all other noises are being obliterated by the cacophony of the rain clattering on the roof. I feel like I'm incarcerated inside a one man submarine!

The thought inevitably occurs to me – what is this weather doing to the birds nesting round the farm? Indeed, are there any birds out there at all? I have now been here for over two hours, and I haven't been able to step outside! I haven't a clue whether or not we have boxes full of Blue Tits or families of Badgers, or whether this year's potential cast is 'better' or 'worse' that last year's. The only bird I did see as I dashed – or rather splashed – from the car to the caravan, was a Swallow. It was skimming low over the soggy waves of meadow grass as effortlessly as it would have skimmed over the real waves of the English Channel only a couple of weeks ago, or the waves of sand as it crossed the Sahara desert, heading north in early April, on its way back from spending the winter in South Africa! Fantastic. That's why Swallows are my favourite birds. I wonder, is it one of the pair that nested in the farm cowshed last year? Or is it maybe one of last year's youngsters? Were any of them ringed? I must go and have a look in the cowshed. If it ever stops raining!

It never did stop. Eventually, I went out and braved the rain. Everything seemed strangely subdued. The swallow was on the nest – same nest as last year, on the same beam, in the same barn. Same bird? – I don't know. I couldn't see her legs – to check whether or not she was sporting a ring. Otherwise, I noted a Blue Tit going into the same box as last years 'failures' – "Kate's Tits." A single Spotted Flycatcher on the fence – is there a mate? And a House Sparrow in and out of a hole in the wall. A pair of Pied

Wagtails teetering along the top of the roof suggested that either they weren't nesting, or had recently lost a nest. No House Martins yet. And not much else of anything. A long distance view of the lake revealed nothing. However, I did bump into Peter Walters, the farm manager, who confirmed that there was a pair of Pied Flycatchers in a box in the woods, but a Wood Mouse was systematically taking their eggs. Our CCTV cameras may well record the criminal tonight in which case I reckon we should put the call out.

"Police wish to interview a diminutive rodent with big ears and long whiskers; may answer to the name of Woody".

There was also a Woodpigeon's nest. A flimsy nest in a flimsier tree. And a box with a single Jackdaw chick, and 2 addled eggs. Apparently, Jackdaws aren't doing well this year. We must try and find out why not?

I had a quick peep inside the barn, where several small monitors (TV screens) were already showing live pictures. There is a Great Tit brood being fed so efficiently they may well have fledged by Monday, so they'll miss being on the show. There's the Swallow too. Still huddled up on the nest, still not showing a leg. And on the largest screen a familiar sight indeed: a nice wide shot of the numerous entrance and exit holes of the Badger sett. Otherwise showing what "badger cam" so often shows. Nothing. But, be fair, it's hardly Badger time of the day is it? And it's hardly Badger weather either.

By the time I returned to the caravan, I was soaked. Fortunately, Kate arrived and rescued me. We drove back to the Hotel together, gabbling away ten to the dozen. We are aware that there are some viewers who have conjectured as to whether Kate and I get on with each other. Not get it on, just get on. Are we just work mates, or friends. Well, all I will say is that if you ever get to ride in the car with us, you'll soon get your answer. But we're not letting you in, cos we like it when there's just the two of us and we can have a jolly good gossip! Oh yes and whenever we meet up in the morning, there's a lovely big hug. Does that answer your question!?

Back at the hotel, I do a radio bit with Chris Evans, and then a press interview for the *Express*, before joining Kate who is still talking to the *Mail*. The lady reporter asks us: "What are the high points of doing "*Springwatch*?". Kate and I answer almost in

If you go down in the woods today - and in fact any time during the past few weeks - you'd find *Springwatch* "riggers" setting up remote-controlled cameras. This weekend we will discover whether or not they work!

unison. Certainly the gist of our answers are more or less identical. "It's the human co-operation and public response that give us the real job satisfaction." We'll both drink to that.

And so we do. After supper, the wine flows more freely, the banter gets sillier and more surreal, until we all agree that a decent night's sleep is in order.

At 11.oop.m.ish we all retire. Tomorrow is the official rehearsal day. Please, please let it stop raining! Goodnight.

This was the mole equivalent of breaking INTO prison camp! We would have loved to have had them on the show, but a mole tunnel was one place we really *couldn't* get a camera!

been involved in *Springwatch* since the beginning. Fiona the Executive Producer, Tim the series Producer, David the overall director, Colin and Alex the day producers. I could attempt to explain exactly what their particular jobs entail, but its all rather complicated and they do sort of overlap in some areas. I'm not sure if we – or indeed they! – know exactly where some of the lines are drawn. There are plenty of other "old – sorry, I mean familiar – faces" and there are also quite a few new ones. I'm not sure what Kate's thinking, but I personally am delighted to observe that a high percentage of the newcomers are young women – 20 somethings, early 30s – most of them uniformed in the fashion of

the day: loose casual tops, jeans settled snugly on their hips, a generous display of bare midriff, and possibly a belly-button stud or a cheeky little tattoo, peeping out above what on a man would be derided as a "builder's bum", but on an attractive young woman is sheer heaven. Well, it is to an old but still lively codger like me. I hasten to add that I am not a "lech". There are as it happens some male presenters who could be said to qualify for such a derogatory title. No names of course, although let's face it some of them have already been outed in the less erudite Sunday papers or gossip mags. You have never seen me thus exposed and I hope you never will. However, I would hardly be human or male not to approve of the increasing number of feisty young females who work in television in general, and natural history in particular. This is particularly admirable as frankly far too many TV departments – and many other professions – are still very much male dominated, and much the worse for it. My idea of hell is a room packed with middle aged blokes! Worse still a business or a world run by them. Which, lets face it, it largely is.

Would it be fanciful to suggest that wildlife – delightful in itself – also attracts delightful human beings? And if that includes "youngsters" – both female and male – who are not only "fit" – literally and figuratively – but enthusiastic, and very good at their jobs, that to me is something to rejoice in. The fact is I love working with people (much!) younger than me. I'd like to think I can relate to them (having experienced three daughters and their friends) and it is very gratifying that they seem pretty much at ease with me. To quote the saying "Age is a state of mind", which isn't literally true, but it's the thought that counts!

Meanwhile, back in the wedding tent that is the *Springwatch* main space ...

In fact, after a general welcome and good luck, the actual meeting was fairly short, and only involved Tim, Colin, Alex, Fiona and me and Kate. We ran through the basic theme for the three weeks, which could be summed up generally as an even greater emphasis on public involvement with local conservation initiatives. In other words, not just sitting back, relaxing and admiring the Blue Tits, but getting out and doing stuff. Not that there's anything wrong with sitting back and relaxing. We also ran through the contents of the rehearsal show that we'd do later in the day. It soon became clear that the fact that this was our third

Inside "the Tardis" – Mission Control! Director, producers, vision mixers, and lots of other people "without whom the show would not be possible". However, I have only just noticed the headless ghost and the very small nun at the back!

season at the Farm meant we had a pretty sound basic template for how it worked. In other words, the same kind of ingredients, the same shape if you like.

Afternoon

After lunch, we did our "technical" rehearsal. As David had warned us, several pre-recorded items were either unfinished or unavailable, but it soon became clear that – to coin a phrase – it was all coming back to us. Even the link up with Simon King, nearly a 1000 miles north on Shetland, worked smoothly. What's more, for once, Simon was enjoying better weather than us. We

were under grey skies, getting dampened by drizzle; he was squinting into a sparkling sun under a crystal blue sky. The kind of clear, clean light you only really get up in the Northern Isles, or out west in the Hebrides. We were treated to some delightful footage of two Otter families surely destined to become stars. Whilst the little screens in our barn featured not only the returning Swallow sitting on eggs, but also a brand new family of tiny Blue Tits, just hatched, looking like minuscule pink plastic aliens, and 2 more eggs, one of which began to crack open during the last moments of the rehearsal! My reaction was suspended between – "wow! That's happening right now, before our very eyes, and "damn, pity it couldn't have waited till Monday! I don't think we've ever had a live hatching! But … maybe someone's recording the moment right now".

Maybe? I was willing to bet that they were. The *Springwatch* crew don't miss much.

The "technical" had gone just fine. After that, we had our tea and prepared ourselves to do a full "dress" as-if-live rehearsal in the evening. Kate and I then began to have insidiously outrageous and almost rebellious thoughts. Or were we becoming grossly and dangerously overconfident?! Almost in the same breath we mooted the same almost blasphemous question: Do we actually need a rehearsal?" Within minutes the question had gone from rhetorical to actual. We weren't sure if we were being mutinous in asking David the Director. But we were certainly delighted when at 7.00pm with barely a moments hesitation he called us all together and announced boldly: "I don't see any point in rehearsing any more. That's a wrap"! Which is TV and film speak for "OK folks you can go home now! Or in our case, "You can go back to the Hotel".

11.30 p.m.

Another fine meal. Tasty wine, coffee, a brandy, and a bit of a natter about everything from restructuring the whole of the BBC, to whether or not we are wise to be planning to do *Autumnwatch*? No-one could accuse us of not thinking ahead. But we have to. That's how big this thing has got. Any minute now, we'll be discussing what we do for *Springwatch* 2007. Before that happens … I am going to bed.

Monday 29th May

7.30 a.m.

On the train to Exeter. Frankly, I was quite dozy, and fancied an apres brekky nap, so when an elderly gentleman came and sat opposite me and engaged me in conversation I was polite but inwardly thinking: "Oh no, please, can I just read my paper and have a snooze?". As it turned out though, Stan was fascinating company. 85, and living alone, he'd served in Burma in World War 2, and was now long retired. He was frankly not as mobile as he could be, and certainly couldn't go on long walks. But he could go on long train journeys. He told me that he was on his way to Penzance, in Cornwall. There he would get off, have a couple of hours strolling by the seafront and the harbour, maybe have a light lunch, possibly meet up with a German lady, and then he'd be back on the train, which would return him to London quite late in the evening. A round trip of 400 miles, achieved in about 10 hours! He often went on similar excursions to other parts of the country. Clearly, he enjoyed these days out but announced that this one was all the more memorable because he had someone to chat to. Namely me. What's more, he was at great pains to thank me for my nature programmes in general, and *Springwatch* in particular. I was flattered and moved by his gratitude. My only slight tinge of regret was it struck me that he wouldn't be home on time to see tonight's first show! Nevertheless, Stan's complimentary remarks were a perfect illustration of one of the most satisfying aspects of doing *Springwatch*. It seems people don't just enjoy it as an example of relaxing telly. It seems to matter to them. They get involved. I think I'd go so far as to say they feel better for it. They don't just tell us, "I like that programme" They say, "Thank you". That has to be the very definition of job satisfaction..

11.30 a.m.

Back at the Farm. A very relaxed air. Nobody is panicking and the weather is relatively benign. There is a chilly north wind, but it accompanies a cold front, which usually means it will at least be dry. There are black clouds on the horizon, but they're scudding across, rather than deluging like last week. Heaven knows, the rain wouldn't stop us, but let's face it, it wouldn't help.

The planning meeting went fine, with the running order bearing considerable resemblance to where we left it last Thursday. One family of Great Tits had got stage fright and flown the nest, but this was balanced by the Swallow family, who had hatched over the weekend, and were surely destined to be welcomed with a collective country-wide "aw" this evening. They would have plenty of competition in the "aren't they sweet!?" stakes from not one, but two almost equally young Blue Tit clutches. What's more, we'd be able to promise the viewers that, over the next 3 weeks, they'd be able to witness the chicks progress from egg to first flight. It was also more or less guaranteed that some wouldn't make it; sad, upsetting even, but let's face it, tragedies and disappointments are essential ingredients in any good drama, including the wildlife soap opera that is *Springwatch*.

14.00 hrs

After lunch, time to pre-record a 20 sec "trail". Meaning, a tiny trailer to be shown throughout the day. I have had an idea to send

This field may appear either almost flat or on a gentle slope. It is, however, much steeper than it looks. Going down it will bring you to the farm lake. Going up will bring you to your knees. This year we have "golf buggies" for use during the show so we don't miss our "cues", or arrive out of breath or needing oxygen

up the fact that I am due to appear on the telly today in no less than 6 different programmes! Frankly, I really wouldn't blame any viewers or TV critics for saying: "Oh, not him again!". So I intend to get in first! My idea is to flick through the pages of *Radio Times*, becoming increasingly incensed as I see my name time and again. "*The Paul O Grady Show*, with guest Bill Oddie. Mark Lawson interviews Bill Oddie. Ancient repeat of the Goodies, with Bill Oddie (and two other blokes). Bill Oddie's family history in *Who Do You Think You Are?* What do I think I am? Over exposed, that's what! And what's this? 8.00p.m. *Springwatch* with ... OK, that's going too far. I'm not doing it! So that's 8.00 o'clock tonight on BBC 2, *Springwatch* with Kate Humble and Simon King. I do hope you will be watching it. I will be!"

Of course, I didn't really mean it! Wild horses wouldn't get me off this show!

Having recorded the trail – to fit into 20 seconds I had to go so fast I sounded like Pinky and Perky (well one of them, not sure which). During the afternoon we did what is known as a "top and tail" technical run. This means we don't actually bother to do any of the words, we just make sure the various machines are working. "VT" – meaning the machine that plays prerecorded video tapes. "Live feeds" – meaning are we actually getting any pictures from our cameras? "Sound" – meaning are all the various microphones working? To find out whether or not Kate, Simon and I are working, we have to wait until the proper run through, which we do as if it were a live show. In other words, we are not allowed to stop! It began at 5.30 and ended at nearly 7 o'clock. Clearly we had a bit of a problem. The program is only meant to last an hour. Clearly there was far too much in it. Now there is, of course, that old saying "Better too much than too little", but when it comes to live television I'm not sure I agree. If we do a run-through that lasts lets say "only" 50 minutes, I reckon that's fine. You can bet that the actual show will be longer anyway, because something unforeseen will happen. And even if there are still five minutes or so to "fill", it's never much of a problem. Frankly, I personally am rarely lost for words. Years of doing programmes like *Just a Minute* stand me in good stead! Added to which, viewers are hardly likely to complain if we leave them with five more minutes of baby Blue Tits. In fact, they'd probably be grateful. However, if the show is too long, it means that a few very rapid decisions have to be made.

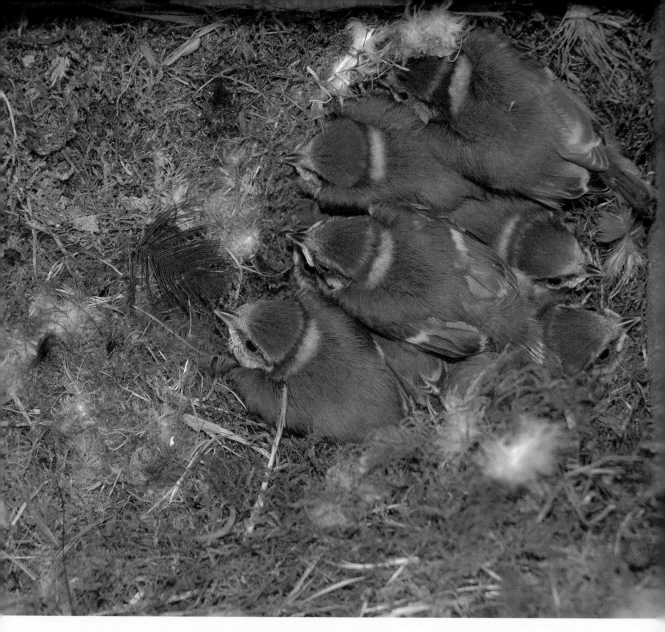

We are on the air at 8.oop.m., so what's going to have to go? Well, it won't be me or Kate or Simon. Though no doubt we'll be told to "keep it tight". Which means "no ad libbing, Bill." Like I can resist! And, let's face it, there are only three of us, whilst there are masses of birds and animals. What's more, they won't stomp off in a sulk if they get dropped at the last minute, or have their slot curtailed. I, Kate or Simon won't stomp off either, but we might get a bit stressed at having to reorganize our scripts and notes. In my case, it will mean having to write out another card in nice legible letters. It probably won't come as a surprise to viewers that I don't actually use a script. I simply write down "bullet points".

Blue Tit chicks, *Springwatch*, **2006. I honestly believe viewers would be happy to have a whole hour of Blue Tits, which would also make the show a lot easier and cheaper. But not so much fun!**

Spot the cameramen. There are in fact three people in this picture. The middle one is obvious enough, but the blokes either side are heavily camouflaged and therefore almost invisible. A pity, because they look ever so rugged in their paramilitary gear. The bloke in the middle has either not seen them, or is thinking how butch he'd look in a similar outfit

Single words or short phrases that will remind me of what's in the next item. Hopefully! I have over the years managed to reduce a whole one hour programme to one side of a postcard, an achievement of which I am rather pathetically proud. Kate, on the other hand – both hands actually – tends to have a separate card for each item. Since there are rarely more than about a dozen items, it hardly means she's lumbered with a great sheaf of cards. What's more, she thus avoids the danger of referring to the wrong one, or not being able to read her own writing. Both things have, of course, happened to me, which makes my single card system even dafter. But I am not only stubborn, I never learn. Simon however does sort of learn his pieces. He presumably has them written out neatly on cards as well, but he always seems to be word perfect both in rehearsal and on the real show. We all have our methods. Different strokes for different folks. The ultimate aim though is to try and make the viewers believe that we are making it all up as we go along. Which we sometimes are. The one thing none of us have never used is the "autocue", as beloved by hosts of Awards shows. I'm sure you have noticed their eyes

following the words that scroll through just above or below the camera. That really wouldn't work for us. Imagine Kate trying to draw my attention to the Blue Tits doing a ballet dance, and I refuse to look in case I lose my place in the script!

Meanwhile, what are we going to cut to make sure the first program fits into its one hour? There really is rather a lot in it! Swallows at the nest, Jackdaws in a box, Red Kites up a tree, 2 pairs of Blue Tits, and two families of Great Tits, a tower full of pregnant Bats, nocturnal footage of Wood Mice and Badgers, the live Badger set up, which we have to visit if only to say there's nothing happening, and from further afield, Ospreys in Scotland, and Seals and Otters with Simon up in Shetland. Add to this, various bits about "passionate people" – passionate about wildlife that is – a "mini epic" – not Minnie Mouse, mini epic as in a short technically bogglingly clever film about mating hedgehogs, plus various mentions of surveys, conservation campaigns, websites, all delivered with a large dose of sheer enthusiasm (which takes a bit of time to do it justice)! Yes, undoubtedly too much. The cutting session began at 7.00 and was forcibly ended at 7.30 so that Kate and I could have a bite to eat, write out new cards, go to the loo, have make up applied, all more or less at the same time. I hasten to add that my make up is less elaborate than Kate's. In fact, I confess that I offer no job satisfaction whatsoever to Lisa, our lovely make up artiste. Frankly, I am like a little boy trying to avoid having his hair combed. Lisa usually has to chase me with a powder puff. She says it is to reduce the glow of my shiny nose, but I think she just enjoys chasing me. I certainly enjoy being chased! But Lisa, I'm sorry. I must drive her barmy.

10 minutes to 8 o'clock

I may appear calm to the point of nonchalance, but I still appreciate a bit of encouragement. I check my mobile, and am delighted to find several "good luck texts". Aren't people nice? In less than ten minutes I will be talking to 4 million people. Live. Them and me. Surely I am nervous now? Well, honestly, no I'm not. But I am excited. My feeling is one of rather gleeful anticipation. There is something almost a bit naughty about it! I mean, it's "live!" Once we are on the air, I can say what I want and nobody can stop me! I might never work again, but it is still a rather thrilling position to be in. It also carries quite a

responsibility. I mean, I don't suppose the BBC actually want to hit the headlines in the tabloids. Positive publicity is fine, but not "Oddie Shames *Springwatch*" "4 million viewers outraged!" A BBC spokesman said …

I don't think I'll bother to find out what he'd say. Not tonight anyway. But I can't wait to get going. Won't be long now. Kate and I are now up in the Barn being kitted out with our mikes and earpieces. It is a lot more elaborate than you might expect. The mike is tiny. Barely bigger than a button. It is pinned somewhere in the region of the lapels, just above cleavage, as it were. Fitting it therefore can either be a pleasure or an embarrassment, both for the sound person and the presenter. Chilly fingers rummaging inside your pullover. Depends, whose they are, doesn't it? Our sound person is Louise, so I guess I'm the lucky one. Can't speak for Kate. The lead (thin cable) from the mike snakes downwards until it is attached to "the belt". This is a bit like something as worn by a commando, or maybe a builder. It is wide and quite heavy, because it incorporates several contraptions such as battery packs and small radios. Most of them have nasty little prongs and aerials which stick out from them and into whoever is wearing the belt. Come to think of it, Kate is used to this sort of discomfort 'cos she goes deep sea diving. In fact, she's used to having lead weights round her waist, which is no doubt why she rarely grumbles about the sound belt. I whinge almost constantly about it. But not as much as I whitter on about my earpiece. Another cable comes from another pack on the belt, and ends up inside the presenter's ear. It's not just a bare wire. It's like a customized ear plug. Specially moulded to fit the individual. So it should be nice and comfy. Mine isn't. I don't know whether to blame the moulder or the maker. Or maybe it's my ear's fault. Maybe it changes shape, depending on the weather or the air pressure or something. My ear piece seems to get a bit less comfortable each year. Do ears shrink as you get older? Anyway its not very snug tonight "but I'll manage" I stoically assure Louise. "You'll have to", she reminds me. At least its working well. I can clearly hear David the director wishing everyone "good luck", and another voice telling us there is "one minute till transmission." That's all I can hear. Kate, on the other hand, has what's called "open talk back". Mine is "closed talk back". This means that I hear only the very minimum. Just the director's instructions and "the

Springwatch

Inside the barn. Let's face it, this looks like a scene from a new American sitcom. Or perhaps it's a new Muppet movie. Isn't that Kermit on the man's shoulder? But why the string of England flags? Confused? We often are

count." I once tried Kate's system. For about half a minute. It was like having an earful of Saturday night at the social club, or the Friday rush hour at Waterloo station! As well as the director and several other studio based people yabbering away, there were the sounds of people gossiping, panicking, having nervous breakdowns or watching the football on the telly. Not to mention the football itself. How Kate filters it all out so she only hears what she wants to, I simply do not know. I've asked her why she prefers to have so many voices in her head, whilst also trying to listen to me, and talk to the viewers. She says she finds it more relaxing! "I like to know everything that's going on." Ooh well, in that case we'll pipe in the shipping forecast, Sky News and the local Taxi firm tomorrow night! I repeat, I don't know how she does it. But she does. In fact, she is just about to. At this point, we both hear exactly the same thing. That authoritative female voice telling us that the waiting is over. No going back now. It is the inexorable countdown. "20 seconds to transmission. 20, 15, 10, 9, 8,7,6,5 . . . Cue V.T. Run titles." Music to and in our ears.

Springwatch 2006 is underway!

Inside another Portakabin, but this time in Shetland. Frankly, I have no idea what these three people do, but I'm sure we couldn't do the show without them

Later that evening

It went really well. As well it might. We've been rehearsing for three days!

The atmosphere back in the hotel bar was a mix of relief, reassurance and satisfaction, rather than ecstasy. If anything, we had rehearsed too much, in that – certainly for Kate and myself – the actual broadcast had lacked that special frisson of stepping into the unknown that you can really only get when you do something for the very first time. But – to quote another cliché – "better safe than sorry". If there had been technical troubles at the end of last week, there would have been time to fix them. Moreover, we now knew that we not only had the "first team" cast of feathered stars, there were plenty more waiting in the wings. (Or should that be waiting with wings?) Certainly I am sure all the technical people and the "bosses" were very happy. It is all very well for the presenters to crave the adrenalin rush, for those not "performing" there is a great deal to be said for being "ahead of the game". We clearly are.

Tuesday 30th May

8.00 a.m.

A rather surreal – and yet all the more enjoyable for it – start to the day. I broadcast to the nation, whilst still lying in bed ! It was for Virgin radio, which seems oddly appropriate under the circumstances. It was a pretty silly interview, in the good sense. The satisfying aspect was that *Springwatch* seems to have caught the imagination not only of what one might call the expected or loyal audience – the ones who habitually watch wildlife programs – but also is reaching viewers and listeners who are – how can I put it? – less sedate, more trendy, hipper, younger even!? Personally, this pleases me for at least two reasons. First – and most importantly – because it means we are getting the wildlife "message" more widely spread. And secondly – and totally unimportantly – because I get to do daft interviews, that often also touch on rock music, sport, comedy and other things I am "into" as old hippies like me say.

Talking of being silly. A confession about *Springwatch* rehearsals. They have been getting sillier year by year, and I can feel them already deteriorating further this time. At this point I must stress that, though the silliness is shared pretty evenly amongst the back room staff, such as cameramen, directors, editors and so on, it is the presenters who are occasionally, sometimes, perhaps guilty of taking the silliness onto an almost irresponsible plane. I would also like it known that I am by no means excluding Kate from this accusation, though I would concede that she knows when to stop. I don't.

So what am I talking about? What is this silliness to which I allude? A lot of it is harmless enough. For example, over the years, we have accumulated a fine collection of fluffy and woolly toy birds and animals. During rehearsal Kate have been known to cuddle them, stroke them, put them into ambiguous postures, throw them around, and occasionally even appear to eat some of them. Some of these "toys" are puppets, who more than once have been tempted to take over the show, or do their impressions of more televisually famous characters such as Basil Brush, Tweety Pie or Bugs Bunny. To be honest, they have sometimes been so entertaining we felt tempted to warn our repressed and inhibited real Badgers that if they didn't pop out of their sett more

Rehearsing the start of an item outside the "swallow" barn. The birds took no notice of us, and frequently zipped in and out the door behind me, where they nest each year. As you can see, sartorial elegance is not my strong point

often and do something interesting, they could well be replaced by puppets. We even asked the BBC to assess the health and safety risks of employing a small puppeteer (a child or a midget) to crawl down a Badger hole and stick a Badger (or indeed any other puppet) out whenever we said "and now let's go live over to the sett." Who knows, we could try the same sort of thing when the real badgers were in shot as well. Imagine if they were lollopping around in their usual indolent fashion, and suddenly a crocodile popped its head out! That'd surely distract them from scratching their private bits for a few minutes eh? It could still happen. But it hasn't yet.

Neither have I yet provoked a torrent of abuse and outrage from incensed viewers. This is of course – as I have already alluded – one of the dangers and temptations of doing a live show. I personally believe in the dictum: "better out than in." Therefore, it is during rehearsal that I and Kate purge ourselves by unashamedly breaking all the rules of Broadcasting. Swearing goes pretty much unnoticed in drama or indeed comedy these days, but has as far as I know it is yet to become acceptable on

Inside the barn. The six monitors from which Kate or I can choose the action. In this case two views of the same sleeping Blue Tit. The back end of something – a Great Tit? And three holes on the Badger's Sett, which they've just disappeared into! Let's go over to Simon!

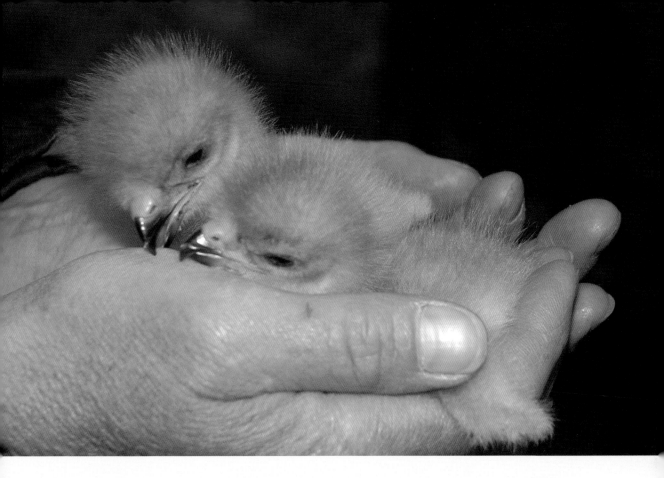

Buzzard chicks, *Springwatch* 2006. The sort of picture that would provide at least a "Oh, aren't they ****ing cute?!" during rehearsal. In fact, we were deprived of the pleasure. These birds were being ringed before being popped back in their nest. Note that, at this point, there are two of them

wildlife programs. Heaven knows we are but human, and I don't suppose Sir David Attenborough would mind it being known that he has been provoked into the odd fruity expletive, but not in front of the cameras. Actually, I reckon that when confronted by some of the breath taking dramas he has witnessed, he shows extraordinary self control not to let out an oath of admiration. I mean "Gosh that is really extraordinary " is a rather long winded way of expressing something that can be forcibly articulated with one single syllable word. Believe me, when you see a Killer Whale leap out of the water only a few yards away, it's hard not to just go "****!". Fill in your own letters! Such moments are not common during *Springwatch* rehearsals as Blue Tits and Badgers – lovely though they be – are rarely as cataclysmic as Killer Whales. Our bad language tends to be more along the "builders adjectives" lines. "What a surprise, the f*ing Badgers are down their f*ing holes as f*ing usual." I'm not even sure why we do it? Childish really.

What isn't quite so childish, is using rehearsal as a cathartic outlet for the kind of strong feelings that simply cannot be

expressed on the BBC, at least not in this context. These usually refer to some of the famously taboo topics: politics, religion and royalty. As a non royalist, atheist, left winger I confess I find it quite inhibiting to have to suppress my feelings, especially when dealing with subjects where attitudes, beliefs and convictions are extremely relevant. But the BBC must remain impartial, which is as it should be. However, especially on matters of conservation and the natural environment, it seems to me to be avoiding the real issues if politics have to also be avoided. But avoided they must be. I know, this cos I once didn't. Once and once only! As I protested: "it was only a joke." It was two *Springwatch*es ago. We were featuring a pair of Peregrines nesting on a towerblock in the middle of London. We were seeing them catching a daily diet of London pigeons. "So" – I said – "what does Ken Livingstone, the Mayor of London, who claims to be such a fan of wildlife do? He bans the pigeons from Trafalgar Square! Well, I don't suppose the Peregrines will be voting for you Mr L.!" Big mistake. I might have got away with the name check, but not the mention of voting. Elections were imminent, so I might as well have given a party

political broadcast on behalf of the "anti Livingstone party". "Bill Oddie says DON'T vote for bird hater Red Ken." Which soon becomes" BBC say don't vote Livingstone." The BBC would be in big trouble. As it was, only I was in trouble and even that was limited to a sigh from the Executive Producer which said "Bill...why did you have to say that?" To which of course my answer would be "Well I thought it was quite funny." That is of course, not the point, as presumably our Exec was told in no uncertain terms when she was hauled before the beak and asked why she couldn't control her presenters. "Control? Bill? These words do not exist in the same sentence." Fair enough.

Since then, I swear I have restricted my indiscretions to rehearsal, though I can rarely – no, make that never – resist the temptation to "tease". I'd presume it would be obviously in jest if I go into a tirade about the Queen inviting George Bush round for Blue Tit Kebabs in return for granting the Duke of Edinburgh the shooting rights for the Arctic Tundra. Nevertheless, I know that after rehearsal someone will need reassuring : "You're not really going to say that are you?" "Of course not! They didn't eat Blue Tits. It was Fricassee de Dormouse."

But why do I do it? It is not just devilment, honest. There is reason behind the nonsense. I believe a great part of the appeal of *Springwatch* is its spontaneity. Never quite doing it properly – or indeed seriously – before the actual broadcast sort of keeps it fresh. Kate is more restrained – less irritating – but she is perfectly capable of spinning a fine comic improvisation on the techniques of harpooning slugs, and I am pretty sure she'd agree that our silliness is our way of implementing an old theatrical adage: "Bad rehearsal, great show." It is nearly always true.

Talking of which. The second show seemed to go pretty well, with that extra edginess that comes, I'm sure, from it being less rehearsed than the first one.

Wednesday 31st May

We have just had the viewing figures for yesterday's show: 3.7million. The bad news is that is nearly a quarter of a million people less than watched the previous night. The good news is that we know where they went! They were presumably watching England's football team playing a warm up game before the imminent World Cup. Well, that's what I would have been doing if I hadn't been appearing live on BBC2. The better news is that 3.7 million is still an awful lot of people. Or is that a comment on how mediocre England are these days?! The fact is, I am not really very interested in audience figures. The "bosses" have to be of course. Jobs and reputations are based on whether the figures are too bad or good enough. But what is good enough? As far as I'm concerned, it is purely a practical thing. My criterion is simply: "are there enough people watching to make the powers that be commission another series?" This is not simply because I am desperate for work! It's because I happen to believe that *Springwatch* is a super series, and that it sort of represents a lot of the qualities of what one might call "good quality television". (I'm not saying that "bad" television can't be entertaining too, but I think you know what I mean.) It also happens that I love working on it, and I love working with a fantastic team of people. Therefore, all I really want to hear from up top is: "They are delighted with the audience figures. More of the same next year please." Which still begs the question what is good enough in numerical terms? How many people have to watch a series to keep the powers happy. Well, it depends which channel the show is on. Anything over two million is pretty good for BBC2, but would be considered very disappointing for BBC One, and a total catastrophe for ITV. For either of the main "terrestrials" as they call them in TV land (BBC One and ITV1) a show really has to be getting 7 or 8 million before bosses start even thinking about purring and recomissioning. Our 3.7 almost certainly wouldn't be enough for them. But for BBC2 the regular *Springwatch* audience of round about 4 million really is pretty darn good. Quite why the various channels require and attain such different levels of viewing I really am not at all sure. I have asked people who spend their lives studying this sort of thing and they soon lose me in a very confusing labyrinth of statistics, social groupings, target

**Goldfinches, *Springwatch* 2006.
Always something new. Frankly, I
had never realised that
Goldfinches nested way up high in
big trees. We're so used to seeing
them feeding on thistles. Our
camera team needed a huge
"crane" to get some truly unique
and very pretty pictures**

audiences and such. Apparently, there are members of the public
who simply never watch BBC2 or CH 4. Why not? On principle? "I
am not watching that hoity toity left-wing snobby arty stuff!" Do
they mean us? Or maybe they simply have never bothered to get
beyond the first two numbers on the remote. Actually, on my
remote 2 is BBC2. Or maybe they haven't got the energy to change
channels at all. I dunno. And in a perfectly unjudgemental sense, I
don't really care. I am well aware that my producers are
permanently disappointed by the fact that my reaction to their
euphoric announcement of our viewing figures is close to total
apathy. "Oh really? That's nice." I am of course delighted that a lot
of people see the show. It'd be an awful waste otherwise! What is
much more satisfying is to read the viewers comments on the
"message board". Each day these are posted as a sort of "morale
boost". And – assuming the comments are complimentary! – it
certainly is. In fact it's more. It is a true measure of job
satisfaction. The indication that most people have enjoyed the
show, and there are nearly 4 million of them. Now that is good
news. It really doesn't work like that for the footballers does it? 10
million people watched England, but doesn't mean they played
entertaining football. They didn't!

Meanwhile, today's potential crisis is that we seem to have lost contact with Simon King! Early this morning, his team called from Shetland to say they were going to go "over the top". Presumably this didn't mean they were going to re-enact a scene from World War One, or even a Blackadder sketch. What they were going to attempt was however a considerable challenge. They were due to uproot cameras, cables and all, and set off to where they hoped to bring literally live, happening as you view, action from their Otters. The odds would be stacked against them, since Otters – even the most watched ones like these on Shetland – simply do not tend to be visible for very long, and it's almost impossible to predict the time that they will be. So far, on the first two broadcasts, Simon's Otter pieces have come courtesy of long patient hours "in the field" by our wildlife cameramen, who were well hidden in a hide. They have been terrific, and have included such magic moments as an Otter cub playing tag with a gambolling lamb, and a family of five – mother and 4 cubs – tumbling around play-fighting like frolicsome puppies. But each 3 minute piece had involved maybe 10 hours filming, and a couple more editing the best bits together. So what chance of literally live action? For the moment, we couldn't even discuss the odds with Simon since we had completely lost contact with him. Had the microphones broken? Had the cables been severed by a local sheep? Had they gone out of reception range – "over the top ... of the hill" we presumed? Or were they lost? The day passed, and still no news.

Later that day

Good news and not so good news. Simon was once again audible in our earphones and visible on our screens, but the Otters weren't. The crew had indeed relocated "over the hill", which had meant they lost their mobile signal, and we didn't re-establish contact until more cables had been laid and satellite dishes re-positioned. This meant that Simon's 'feed' was now on 'radio' – or some such technical jargon I didn't really understand – but which translated as "we might lose him any time!". In other words, at any moment during the live show Simon, and indeed Shetland itself, could disappear off 4 million T.V. screens! Well, that should be fun!

A vast range of communication equipment includes portable satellite dishes like this one, along with walkie talkies, radios and mobile phones. Nevertheless, it only takes a dip into the hillside or a passing sheep to block the signal and we can lose touch for hours. And we did!

After the show

It didn't happen. But neither did the Otters. Simon's disappointment was palpable for all to see. Several times we went over to him with an optimistic air of wide-eyed expectancy (Kate does this look particularly well): "Now, let's go back to Simon, and see whether or not he has live Otters". Each time, there was Simon gazing wistfully out at miles of empty seashore, muttering apologetically: "Well Kate, I'm afraid no Otters so far". On the final visit, he literally apologised to the whole nation! "I'm so sorry", he said. I thought he was going to shed a tear or two. "Maybe tomorrow", he sighed. It was as if he personally felt guilty and responsible, prepared to take the 'blame' himself for disappointing 4 million viewers. He would never, of course, chastise the wildlife. "They're wild, they're free, they don't answer to anyone". He might well have added, "Not like me. I'm stuck here in the rain, feeling miserable and guilty. But I am here, now, live and otterless. Ah well", he sighed, "maybe tomorrow".

I just hope the Otters were watching. If they were, surely they couldn't let down one of their most eloquent and sincere champions two days running? Surely they were thinking, "Look, I know we couldn't care less about 4 million viewers, and we certainly don't care about the scruffy little bearded bloke, or that bubble haired babe, but ... that Simon. He's been filming us for years. He really really cares about us. He's like one of the family. And he's proud of us. He just wants 4 million people to see how sleek and gorgeous we are. I mean, it's not like he's expecting us to actually do anything we don't usually do. Just a bit of swimming. Maybe a dive or two. Possibly a few minutes scampering. Catch a couple of fish. Twitch the old whiskers. All the normal stuff. Except we'd be doing it in front of the cameras, between 8 and 9 o'clock. We're often out then anyway. So what d'you say ... We do it for him? For Simon".

So did they? ... I shall let you know in due course. But first, Simon would like the chance to eulogise about Shetland! PTO

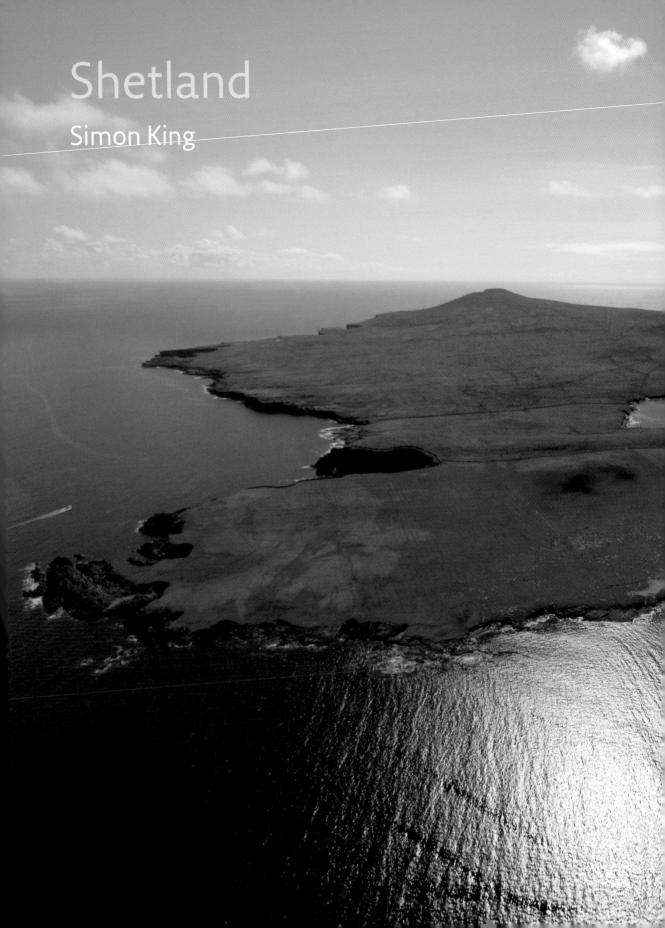

Shetland

Simon King

But if the Farne Islands were heaven, I was yet to discover my Nirvana. The sea had played a central theme throughout many of my *Springwatch* venues, nowhere more so than the place I was to visit, and fall in love with, in 2006.

The Shetland Islands (not "the Shetlands" as so many people mistakenly call the islands – its a bit like saying "The Britains") are the northernmost outpost of the British Isles. The very name had fuelled my imagination for many years, having read the works of the late, great Bobby Tulloch, and the seminal film and book by friend and mentor, Hugh Miles. Hugh had filmed the Otters on Shetland, and had deployed a technique of approach championed by John Baker in his book *The Peregrine*. Baker and Miles both found that by walking the same patch of ground, wearing the same clothes (potentially stinky, unless you have a matching set to change in to from time to time), and generally behaving in a predictable manner, they could, with time, become part of the landscape – enough to be accepted by the wildest spirits in the neighbourhood; the Peregrines and Otters respectively.

We couldn't hope to develop such a relationship with the Otters we were watching in so short a time, but fortunately we were able to tap into the expertise and local knowledge of John Campbell and Terry Holmes, gentlemen who had been watching a population of Otters for many years and had come to know their habits intimately.

For the first time in the series, we decided that I should stay in more or less one location, so rich were the Isles in bird and mammal life. And central to our mission this time was the lives of the Otters.

Allow me for a moment to expand on the difficulties involved, when trying to reveal wild mammal behaviour on live television.

Birds build nests. Obvious I know, but it's the key to watching their behaviour with live cameras. They will predictably return to the same place, on a regular basis, and do interesting things. And most of them do it in daylight. Mammals don't. Actually, some mammals do, sort of, but they still present huge challenges to the goals we try to reach with the programmes. Take the badgers at the farm in Devon as an example. Badgers are one of the few British mammals that predictably return to the same den (or sett), and do so communally. As wild mammals go, they are relatively easy to watch. The key word here is relatively. They are very shy,

Looking north. Bleak but beautiful. Next stop – the Arctic

Doing a "live" piece for Simon often involves him sitting in the rain watching television! He may be "commentating" on pictures being sent by a camera elsewhere on the island. Or he may be watching Bill and Kate talking to him from the comfort of their cosy barn in Devon! What's he saying here? You provide the words!

they have keen senses, and generally shun human contact. All this is par for the course with wildlife film-making. Our stock and trade is watching nervous creatures without disturbing them. But Badgers are also nocturnal, and *Springwatch* transmits at a time in the evening when only the most adventurous insomniac of a Badger is likely to poke its head above ground. The result? The now well-established running joke of Bill and Kate waiting for the ever elusive badgers to make an appearance on air. And predictably, 9 times out of 10, the critters show themselves just as the closing credits start to role.

Imagine then, the challenge presented by trying to bring wild Otters to the screens with live TV. The Shetland Isles are quite probably the best place in Britain, perhaps in the world, for watching these lithe, lovely creatures. This is due to a healthy population and to a combination of environmental conditions that together affect the otters' behaviour in a favourable fashion for watching them.

For starters, many of the Otters in Shetland spend the majority of their time on the coast. This doesn't make them Sea Otters (an entirely different species that lives in Alaska, Islands north of

Japan and California), it just makes them European Otters that like the sea. And this preference gives us the opportunity to watch them more predictably than their neighbours in freshwater habitats. On a river, or even a large loch or lake, a hunting Otter can disappear in the blink of an eye, either by rounding a bend or slipping into tall, bank-side vegetation. Once you spot an Otter on the sea, it is very likely to remain in view for some time so long as it is not disturbed. Unlike an Otter in fresh water, it usually has just one landfall choice, and with care and practice you can second-guess where they are likely to come ashore and so get good views of them out of, as well as in the water. Coastal Otters have a daily rhythm dictated by the shifting tide. Not all otters use the same tide state, but individuals tend to have a preference. Of the two families we watched during the series, one female and her two cubs tended to prefer hunting about 2 hours before high tide, whereas her neighbour, with a single cub, would be out and about two hours after high water. Their activity period (which usually lasted about 2–4 hours out of any 24) shifted by about an hour each day, along with the tide times. Otters on freshwater tend to have their rhythm more closely linked to the pattern of night and day, and are often busier after dark. Not good for watching them.

There are many other subtle factors that help make coastal Otter watching fruitful and on Shetland, they are all there.

OK, so we have the best place in the world for otter watching, we have the help of local experts who have watched their otters for many years, and kindly allowed us to tap into their knowledge. On our team are two of the most Otter friendly and knowledgeable wildlife cameramen in the business, John Aitchison and Charlie Hamilton James. We have the people, we have the kit, we have the location. So what are the chances of our seeing an Otter on live telly? Probably less than 1%! We have done everything in our power to give this a go, but there is so much that can (and does) go wrong. First of all, as I've already mentioned, Otters have a pretty short activity period during the day. For us to be in the right place at the right time during one of those windows whist we are live on air is a long shot. (we did check the high water times and scheduled to watch the territories with the live cameras during the most likely periods). Then there was the weather. Shetland is magnificently unpredictable when it comes to climate. One minute you are bathed in saffron sunshine, and the next a gale is

Simon is here demonstrating the standard unavoidable "naturalist with binoculars" pose. The photographer will have asked Simon to look through the "bins". Simon will sigh, but do as he's told. Then the photographer will say, "I can't see your face." Whereupon Simon will drop the bins and look wistful as above. Note how his finger position allows you to read the name of the binocular manufacturer. Bill is equally adept at assuming this posture – but with different binoculars

blowing in from the sea bringing with it lashing, icy rain. Wonderful stuff, but when you're watching otters, a calm sea is a huge help. Trying to pick out their low profile against a choppy surface is very challenging. Otters also have a very good sense of smell, and a whiff of human scent will usually send them skulking away to another part of their territory. With an onshore wind, not too much trouble, but if the breeze swung around to blow offshore, taking with it our scent, then we had to keep a long way from the coast making it even harder to find the animals. Add to this the paraphernalia necessary to get live pictures from such a remote spot (a story in itself) and you begin to think that this ambition may be an act of folly.

But ...We were lucky! We did it! Now, for those of you who saw some of the shows, you could be forgiven for wondering why I was getting very, very excited about a tiny little brown splodge on a rock whilst we were on air. But I got a HUGE thrill out of our being able to bring a live image of an otter into millions of homes. And given the circumstances, hopefully you will now understand why.

We did enjoy lots of much clearer, closer views of the Otters

throughout the weeks we were on air but the majority of these, were recorded by our specialist camera team much earlier in the day than our live transmissions. And what astonishing views we had. Ebb and Flow, the two mothers, their cubs and Busta the adult territorial male, gave us a wonderful insight to the world of wild Otters, all in a three week period. It took a lot of dedicated Otter watching in some pretty rough conditions, but moments like one of the cubs chasing, and being chased by a lamb, made it all worth while.

Otters were, of course, not the only animals to feature during our stay in the Shetland Isles. This archipelago has an Arctic feel about it, and the wildlife to match. The climate is in fact quite mild, heavily influenced by the currents of the ocean that surrounds the islands, but the landscape is, in many places, reminiscent of arctic tundra. The almost complete lack of trees may suggest a land that is too cold to support woodlands, but the truth is that trees were wiped out by human deforestation followed up with massive overgrazing, largely by sheep. There is now an initiative to bring woodland back to Shetland, with an ambitious tree-planting programme. But until the ravines and sheltered areas are once again bristling with birch, oak and aspen, it will remain a stark landscape. No less beautiful for that. Some of the animals you see here are real arctic jewels, like the Arctic Skua. A close cousin is the Great Skua, or Bonxie as they are known in the north, a bird whose Shetland name means bully, and which lives up to its reputation. Large birds of prey are rare up here (Sea Eagles may make a comeback having been wiped out, but they are still a rarity in Shetland), and the Bonxie fills the role of scavenger and predator. They can also be particularly fiery when it comes to defending the nest from danger. And however kind your face, however benign your intentions, Bonxies see you as trouble, and act accordingly. For a bird about the size of a Herring Gull, they can put on a fearsome show of guts and strength, screaming out of the sky, directly at your face, feet down, beak open, and hellfire in their eyes. Enough to encourage you to leave their nest site that's for sure. On Shetland that can be easier said than done, particularly on the Island and sanctuary of Noss, where there is a huge colony of Bonxies. You go from one crazed attack to the next as you make your way to the wonderful sea cliffs on the eastern face.

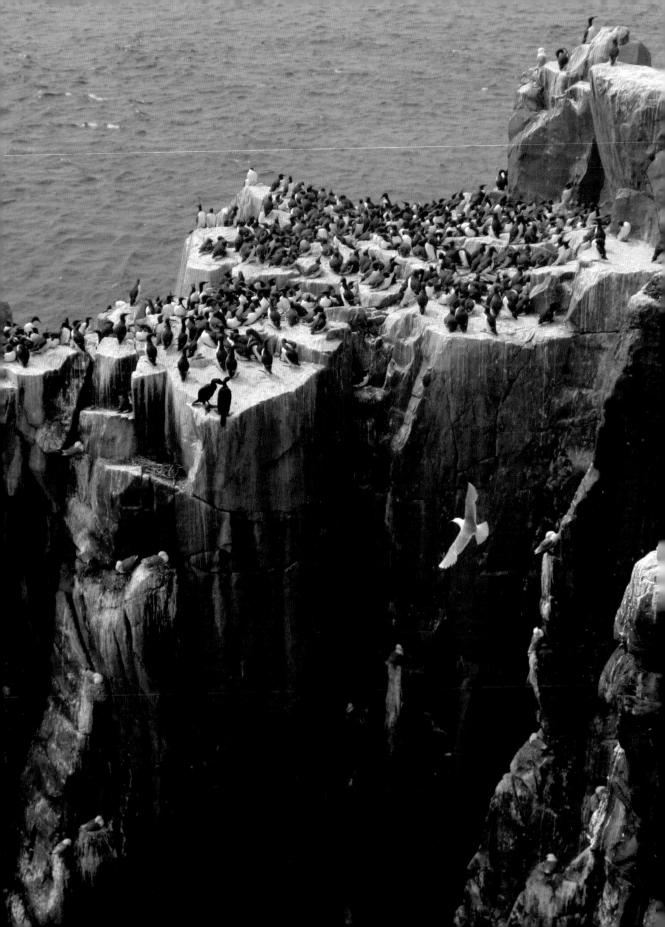

There are so many world-class sea bird spots on Shetland, it's hard to know where to start. But you could do worse than plumping for Sumburgh Head on the south end of the main island. Sumburgh is easy to reach, a gentle walk, very beautiful and absolutely rammed with seabirds including very accessible Puffins. And yes, they are absolutely adorable. It is, in my opinion, largely due to our tendency to warm towards creatures that look or behave a little like ourselves (penguins, meerkats, chimps) that Puffins have earned a place in our hearts, even if we've never seen them in the flesh. In a way, it's pretty odd, given that if they do resemble a human being, it's a rather clumsy, pompous clown wearing a tuxedo. I'm betting that if you met one of our own species in a bus queue with the same physique, manners and make up as a puffin you would, at the very least, be on your guard! Whatever the reason why, puffins are lovely, funny and, in Shetland, very obliging. I spent hundreds of hours sitting on the edge of their colonies, surrounded by cooing clowns. In fact, the sound they make is rather more like a distant chainsaw than cooing, but the simile doesn't sound as cute.

Whilst on Shetland I was given another of our traditional "Irrelevant Line" challenges by the production crew. (see the section on the Farne Islands for a full description of the rules of the game). This time my line was "Sometimes it's hard to be a woman", the opening sentiment of a Country and Western song. Hmmm. This was going to be tricky. Not the easiest thing to say when you are 6 feet tall, 12.5 stone and with a face full of stubble.

My saviour came in the form of a wonderful bird called a Red-necked Phalarope. These little wading birds are very rare indeed in the British Isles, but Shetland harbours a healthy population of breeding birds. They are very pretty, and very confiding. Whilst I was watching them they would come to within a few metres of where I was standing. But it is their breeding behaviour that is perhaps their most extraordinary feature. Unlike most birds, it is the females that have bright, colourful plumage. The males are far more subdued. And the same can be said for their character. Whilst the males skulk in the watery vegetation, the ladies search for a suitor and then flirt outrageously when they do lay eyes on a fella. Once they have convinced a male to mate with them, they lay their eggs in a nest prepared by their mate, and that's it. They shoot off in search of another bloke to fertilize another clutch of

The seabird colonies of Britain are literally amongst the most spectacular in the world. They are particularly the envy of nature lovers in the European countries that are bereft of both sea and birds!

eggs, leaving the father holding the baby. The male phalaropes do all of the incubation and tending the young, whilst the girls go off to play. And so ... sometimes it's hard to be a woman, but not if you're a Red Necked Phalarope! I got it in ... More cheers in my ear!

For all the exotic qualities of Bonxies and Phalaropes, Otters and Oystercatchers, there was one animal that we dared not even hope that we might see whilst in Shetland. The coastal waters can harbour good numbers of whales and dolphins at certain times of year, and most dynamic among them has to be the Orcas, or Killer Whales. It does sound implausible that such a huge predator makes British waters its home, but a few families of orca regularly patrol the Shetland coastline during the spring and summer, hunting for seals. Their movements around the coastline are fast and unpredictable, and any sighting is usually over within 20 minutes or so. The first clue that the orcas were in the neighbourhood came in our second week of transmission. The report of a brief sighting on the weekend, off the west coast, sent us scrabbling with cameras to a wild headland, in the hope that we might catch a glimpse. We spent several hours scouring the sea with binoculars, but no joy. On the same weekend, a few of our crew took one of the ferries to the outer islands (without camera gear...isn't it always the same?) And they too had a brief view of the dramatic black dorsal fin of a family of orcas as the cruised by.

But lady luck smiled on us once more, during our final week on the Islands, when a pod of ten or so orcas chose to cruise around Sumburgh Head whilst we had our camera teams in place watching the puffin colony there. Even now, I find it slightly surreal to think of those magnificent animals carving through the surf, then cruising out into open water, and here I was, perched on a rocky headland in the British Isles.

In many ways, the Orcas summed up the spirit of the Shetland Isles: Dramatic, wild, very beautiful and a curious mix of the familiar with the exotic. In fact, that reasonably describes an average Saturday night in Lerwick! Seriously though, the people of Shetland were incredibly hospitable, truly embracing our efforts to portray the Islands that make their home. I spoke with many who had travelled widely, but who could never imagine living anywhere but Shetland. And I can see why.

Orcas. You may have seen them at Sea World, but *this* is where they belong. And this is Britain – not the Canadian Arctic or South America

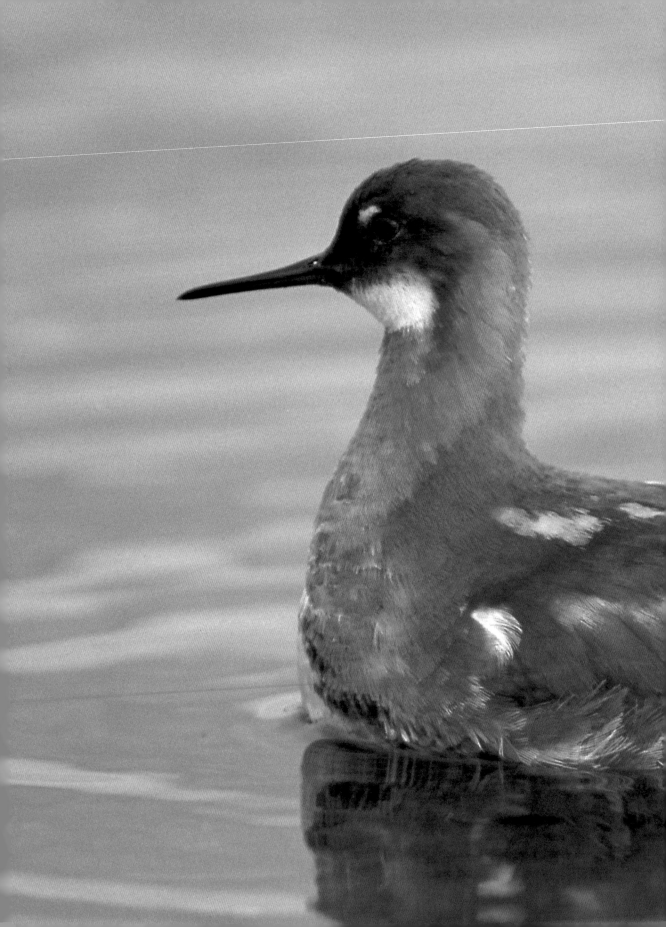

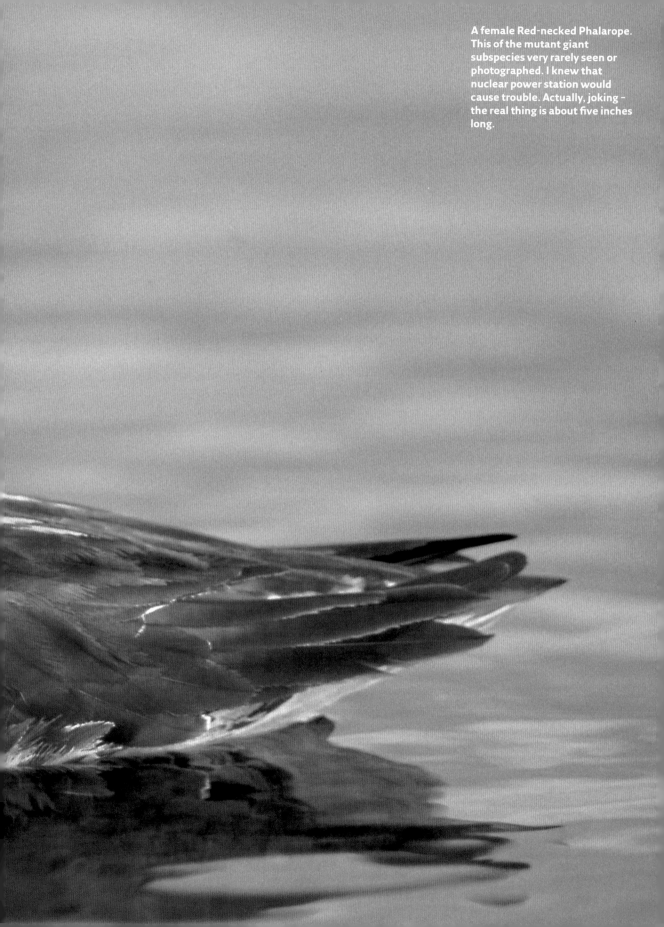

A female Red-necked Phalarope. This of the mutant giant subspecies very rarely seen or photographed. I knew that nuclear power station would cause trouble. Actually, joking – the real thing is about five inches long.

Otters

Stephen Moss

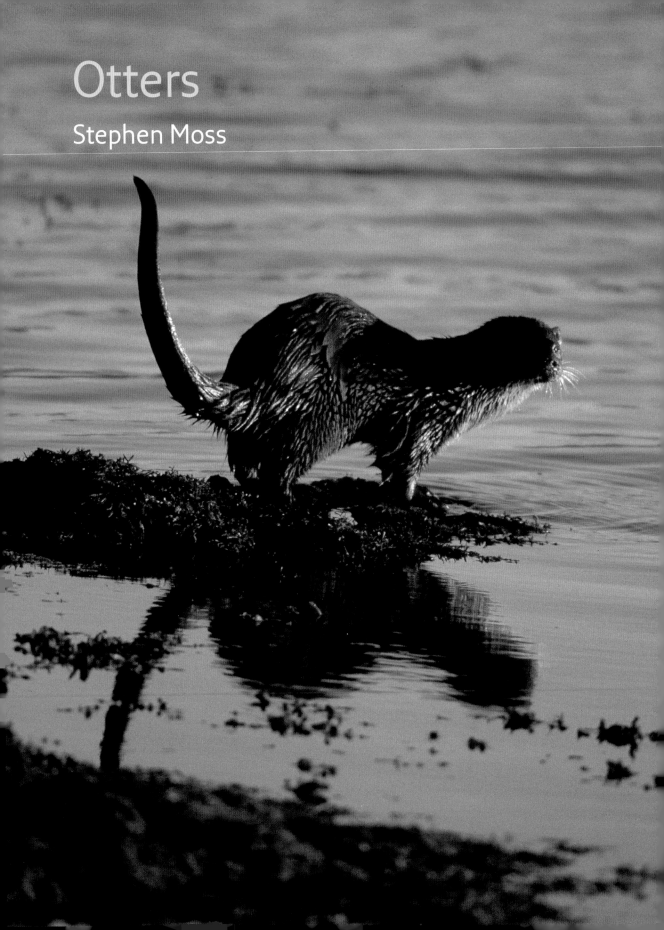

One of the highlights of Springwatch 2006 was undoubtedly Simon's close encounters with the Otter families of Shetland. The Shetland Isles are one of the very best places in Britain to see wild Otters, and during the three weeks of live broadcasting we enjoyed some of the most extraordinary scenes of intimate otter behaviour ever filmed.

Otters were once persecuted mercilessly, using otter hounds to track them down, because of their supposed effect on fish populations, but during the 20th Century their public image turned around, and they became one of our most popular wild mammals.

Two authors were largely responsible for this change in the otter's fortunes: Henry Williamson, a naturalist based in North Devon, whose book *Tarka the Otter* was first published in the 1920s; and Gavin Maxwell, a Scot, whose novel *Ring of Bright Water* first appeared in 1960.

The latter sold more than three million copies, and achieved even more widespread fame in 1969, when the film of the book starring husband-and-wife team Bill Travers and Virginia McKenna was released. Meanwhile *Tarka the Otter* has inspired a feature film, an opera, a tourist trail and a railway line along the edge of the Exmoor location where the book was set.

Following the Second World War, the British Otter population suffered a catastrophic population decline. This was mainly as a result of poisoning by agricultural pesticides, although persecution and habitat loss were also partly to blame. By the 1970s Otters were virtually extinct in lowland areas of England and Wales, and their future looked bleak.

Fortunately the clean-up of our rivers came just in time, and today, although not yet back to its previous levels, the Otter population is growing very rapidly. As numbers increase, Otters have started to recolonise many of their former haunts; and can now be seen in towns and cities such as Winchester and Bridgwater in the south, and Leeds and Newcastle in the north. One was even recently found (unfortunately dead) on the Thames in London.

Despite their comeback, seeing wild otters on lowland rivers is almost impossible: they are almost exclusively nocturnal, and so good at concealing their presence it takes a real expert to find them.

On the northern and western coasts of Scotland the situation is rather different. Here, although Otters can still be elusive, if you know what to look for they are much easier to see. This is partly because their daily life is governed by the tides, so they are much more likely to be seen during the day than their riverine counterparts down south.

A male, or dog Otter, is generally between one-third and one-half as heavy again as the female, weighing in at about ten kilos, and reaching more than a metre in length. Despite their size, however, they are easy to miss, especially if they are basking in brown seaweed at low tide.

Otters are superbly adapted to their 'semi-aquatic' lifestyle, with special features including a thick layer of fat beneath the surface of their skin, and are covered with some of the densest fur of any mammal, to retain warmth in cold water. Few animals are so effective and mobile both in and out of the water: whether running and playing, or diving for fish, the Otter is the epitome of mammalian grace and beauty.

Otters breed (and also hole up to rest) in dens known as holts: either on a riverbank concealed by vegetation, or beneath rocks or in holes on the coast. They are territorial, marking their home ranges with their droppings, which have a sweet, rather musky smell and are known as 'spraints'. In the absence of actual sightings, these are often the only clue to an otter's presence.

Cubs can be born at any time of year (though in Shetland usually in the summer months), and generally come in litters of two or three. They remain in the safety of the holt for about ten weeks, before finally venturing outside with their mother. As they grow they become extremely playful – though play-fighting is, as with many mammals, an important way to learn to defend themselves for real.

The cubs will spend up to a year with their mother, learning how to catch fish, until she considers them old enough to survive on their own. During this period she will keep a sharp eye out for intruding males, which have been known to kill another male's offspring so that they can breed with the female.

Today, in both urban and rural areas, conservationists are giving Otters a helping hand: either by building artificial holts along riverbanks or lakes, or providing underpasses beneath busy roads – Otters are especially vulnerable to being hit by motor vehicles.

In several parts of Scotland, including Shetland and the Isle of Mull, local experts run guided walks to look for otters. However, as with any wild animal – especially one as elusive as the otter – success can never be guaranteed!

Thursday 1st June

I have never seen Simon so happy! There he was, soaked to the skin, no doubt freezing cold, wind blown, and with his woolly hat so soggy it was going to need putting through the mangle. But beneath the hat, his eyes were twinkling like a schoolboy whose dad has just taken him to his first football match, his mouth wreathed in smiles as broad as if his team had won 6-o (presumably not England then!). Indeed it was a first. As Simon told us breathlessly. "Here they are, the first time ever, anywhere, that we've had live pictures of Otters on television". And there they were indeed. No matter that we were seeing them through a gauze curtain of Shetland rain and fog that made it hard to tell which of the soggy seaweed coloured stones actually was an Otter. I have to confess, initially, I couldn't be sure I was seeing one at all. I turned to Kate in the Barn – "It's a spot the Otter contest". Then we both saw a stone move, and both squealed with excitement! "There, there it is, next to that stone". "What stone?" "That one!" "Where?" "There, it moved. The stone that moved!" Not a bad description at this range and visibility, but then the "stone" slithered down to sea, leapt in, sunk beneath the surface, popped up again and swam away. We were excited. Simon was overjoyed. And we were delighted for him. As for the viewers, I have no doubt they enjoyed the amazing, sunlit close-ups of a cub catching and crunching up a huge crab that was "recorded earlier today". But I'd also like to think that at the moment that 'stone' moved, 4 million people pointed at their TV screens and yelled, "There! There!"

After the show

And thus ended our first week of *Springwatch* 2006. As always, we finished the show with a quick resume of the state of all our 'live' creatures. In doing so, we realized how many there were! A lot!

The Moss Blue Tits – 7 young, 2 parents doing very well.

Humble Blue Tits – Also 7 young, but still not even with eyes open. Both parents feeding them but not as frequently as the Moss family.

Great Tits – youngsters fledged. Out there in the dangerous world – we'll try and keep an eye out for them.

House Sparrows – a new family. 4 small chicks in a nest-box

Remember those two Buzzard chicks? There's only one now. Where did the other one go? Do you really want to know? Put it this way ... this one was very hungry. But not any more. Sorry, but it's true. He's still very cute though

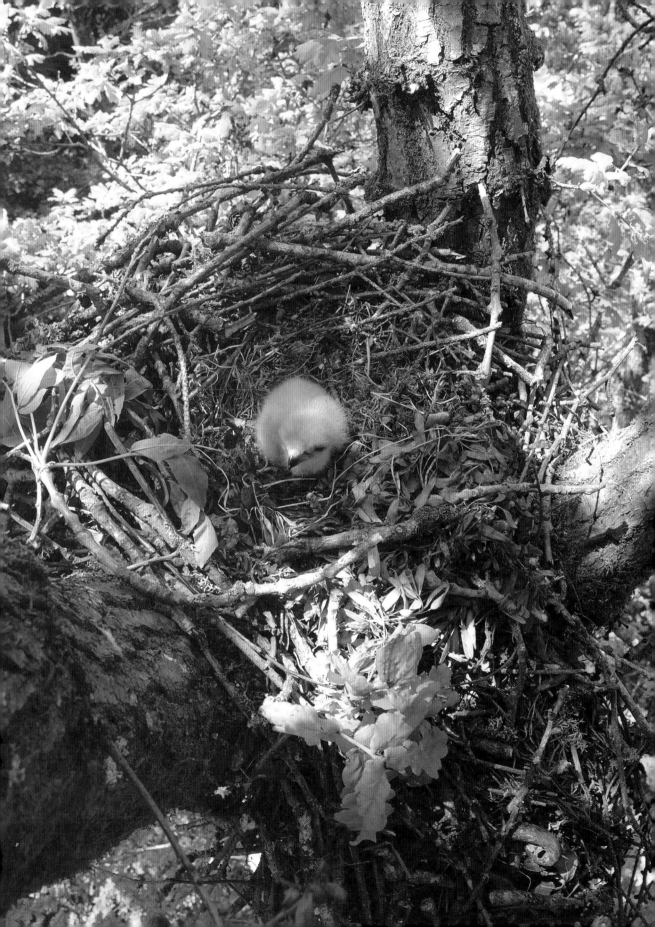

being fed regularly but only by a female. Where is her mate? There are other male sparrows in the farmyard, but they seem more interested in having sex with unmated females than looking after chicks.

Talking of which … *Pied Flycatcher*. Female, apparently a single parent, feeding 3 small chicks in a box. However, we have now found 'her husband' with "another woman", feeding another family, in another box, about 50 yards away. There are seven chicks in the box, BUT they are several days older than those in "our" box. This can only mean that the male mated with the female in the new box first, then nipped off and serviced his "mistress" (mother of the telly chicks), and has now gone back to his "wife", and is helping her raise the first family. We have decided to try and get a camera into the 'new' (or old!) Box. Meanwhile, we are concerned that, because of the males bigamist behaviour, the original 3 chick family will have to be brought up by the single-parent female. This may prove too much for her. There is a serious danger that she wont be able to manage alone. So will the chicks survive? Or will the irresponsible father have an attack of conscience, and go and at least help a bit?

These are the sort of questions that we are always left with on a Thursday evening. We wont be back at the Farm 'till Monday. And we wont be back live on telly till Monday evening. That's 4 days – in which anything can happen.

T.V. producers call it the "jeopardy". You might call it a natural "cliffhanger". Whatever it is, it is a perfect example of the way and how quickly things can change, and of the uncertainty of life, or – more specifically – of wild life!

We left the viewers with the inevitable exhortation: "Tune in next Monday to see the latest thrilling installment of SPRINGWATCH."

Even later that evening

On my drive back to London I realized that I had left out an awful lot from the last round up. It indicates just how much we have under scrutiny. Which is rather comforting . It means that if we lose any of our current stars there are plenty of others waiting "in the wings". An appropriate image, for the birds at least.

So here's a run down of la toute ensemble,

Red Kites – There were 4 eggs. Now 2 chicks, including a runt

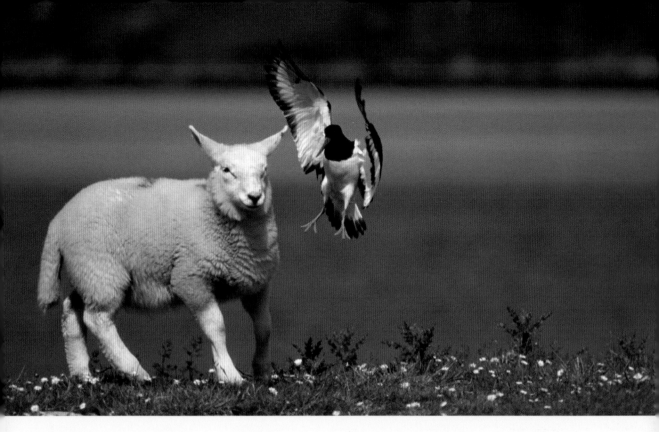

Simon's Shetland sheep were determined to get themselves on the show. There was a brilliant sequence of lambs being chased by young otters, and vice versa. This lamb is perfectly well aware that if he walks across the Oystercatcher's territory the bird will yell, leap in the air and generally put on a display that is bound to attract our cameraman. It did

which is surely in danger of being neglected, or ending up as emergency rations for its sibling, or its parents!

Ospreys – Not had time to visit them for several days. 3 chicks OK. But will Henry (the father of only one of them) accept them?

Pipistrelles – cameras on a "maternity unit", with many pregnant females, but will there be any births? And if there are, what are the chances of seeing, let alone filming a bat birth? As far as we know, it has never been seen in the wild, let alone filmed!

Barn Owl in nest box – no news. Presumably still there, but still alone!

Have I forgotten anything?

Oh yes, the *Badgers* – Popped out once at 7.40, and went straight back. So far, we have recorded a bit of playfighting and scratching, but – let's face it – they have been totally upstaged by the *Otters*!

Talking of which:

The plan for next week in Shetland. Simon will be roving around other parts of the islands, but they'll keep a camera on the Otters so we can get daily reports.

They already have found an *Oystercatcher's* nest with eggs – which are in danger of being trampled by sheep! As is Simon.

Blinkin' Badgers

Kate Humble

With their characteristic black-and-white striped face and lumbering gait, badgers are one of our most easily recognised mammals. Or at least they would be, if they ever graced us with their presence on live television!

The badgers on the farm were famous for their Greta Garbo like shyness – though invariably, as the credits rolled at 8.59pm each evening, they would begin to stick their noses out of their sett and set off on their nightly activities.

In some ways, this wasn't all that surprising. Badgers are, after all, nocturnal creatures, rarely seen out and about during daylight hours; and on those long June evenings it was often still light and sunny throughout the show.

Fortunately we had rigged up round-the-clock surveillance on these fascinating animals, with infra-red cameras taking over as dusk fell. This meant that we could monitor and record the badgers and their activities through the night, and bring you the best of the action the following evening. This took special care on the part of the technical team, as badgers are very prone to disturbance and may move to another, less accessible, part of their sett if they feel threatened.

The efforts were well worth it: one young male, nicknamed Dennis by Bill (after Dennis the Menace, or perhaps Dennis Wise the former Chelsea footballer?!) was particularly boisterous, and delighted in shoving his siblings aside; and occasionally having a go at the larger adults, who put up with his behaviour with admirable patience.

Badgers are medium-sized mammals, the largest British member of the mustelid family, which also includes the stoat, weasel, polecat, pine marten and otter. They weigh about eight or nine kg in spring, and put on another couple of kilos in autumn to build up energy levels for the coming winter. Contrary

Sure signs that you've got badgers – scratched tree trunks. Better than having a dug-up lawn!

The Fishleigh Estate is a working organic farm that is carefully managed to encourage and support as much wildlife as possible. The lake is large, has plenty of cover around its perimeter and two thickly vegetated islands in the middle. In early Spring it is thick with frog and toad spawn and frequently during *Springwatch* the grass around the lake has been crawling with tiny froglets. Pond skaters and water boatman scoot around the surface of the lake, reeds and irises provide perfect stems for dragonfly and damselfly nymphs to attach themselves too as they undergo the amazing transformation from voracious water monster to beautiful aerial acrobats. Swallows swoop low, catching flying insects to feed their young in the barn at the top of the field and one year we watched a pair of Dabchicks build a floating nests and hatch six, fluffy youngsters with humbug stripes and an endearing habit of riding around on mum's back. There's the River Torridge too, which flows through the lower part of the farm. Pete Walter, the farm manager, is careful not to let cattle graze right up the river's edge, leaving a wild 'corridor' for wildlife. A colony of Sandmartins nest in its banks and in 2006, for the first time, we filmed Kingfishers courting and excavating a nest.

The fields on the estate are not separated by fences, but by large hedges which provide homes and safe passage for numerous birds, insects and small mammals. The old farm buildings have roofs with eaves under which housemartins build their carefully constructed mud nests and there are extensive areas of mixed woodland. Here Peter Robinson, Fishleigh's ornithologist, has put up nest boxes of all shapes and sizes, to suit big birds like owls, Jackdaws and Stock Doves, and at the other end of the scale, Tree Creepers, tits and flycatchers. There are also hundreds of natural nest sites and the trees, wildflowers and grasses provide plenty of food. Roe Deer are frequent visitors to the woods and we occasionally catch them unawares on one of our hidden cameras. We've seen Foxes too, Brown Rats and Rabbits, but the mammals which are really in charge are the Badgers.

The Badger sett is deep in the wood in a dark, deeply shaded area amongst the trees. In our first year at Fishleigh a wildlife cameraman spent many days early in the Spring lurking about the woods with an infra red camera to try and remain as inconspicuous as possible. Not too far from the sett is the feeder station – a vast array of bird feeders hanging from a stand of horse

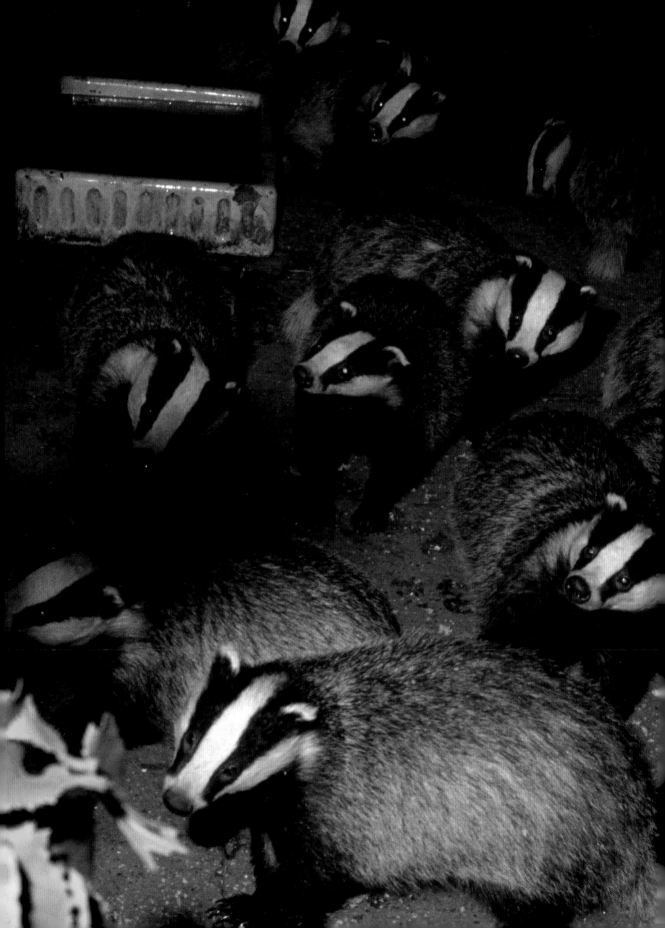

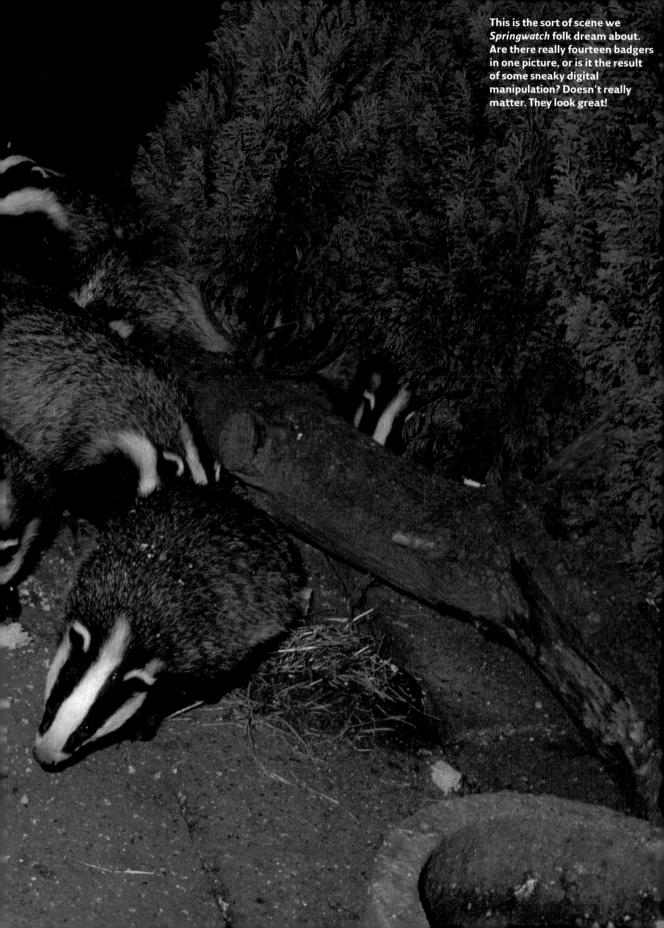

This is the sort of scene we *Springwatch* folk dream about. Are there really fourteen badgers in one picture, or is it the result of some sneaky digital manipulation? Doesn't really matter. They look great!

to popular belief, Badgers don't hibernate, but will become less active, and are more likely to stay underground for longer, when the weather is cold.

In Britain at least, Badgers live in social groups of between four and a dozen adults, in an often extensive system of underground nesting chambers linked by connecting tunnels, known as a 'sett'. On the continent they are less sociable, the reason being that in Britain the prevailing damp conditions make it easier for them to find food – especially earthworms – in a smaller area. As a result, a larger number of animals are able to live in one place. They are expert at digging for food and tunnelling to build their setts – indeed the name badger is thought to derive from the French 'becheur', meaning 'digger'.

Badgers are found throughout the country, apart from the far north, mountainous areas and offshore islands; and are commonest in the south-west. They also live in several towns and cities around Britain, such as Bristol and Brighton. However, unlike the Fox, which has moved in from the countryside to take advantage of free food, urban Badgers tend to be ancient populations that have lived in the area for centuries, and have found a refuge from the surrounding urban sprawl in parks or gardens. They take readily to food, especially peanuts; and today many people feed Badgers in their garden on a regular basis.

The UK population has been estimated at about 50,000 social groups containing over 300,000 adult badgers – a rise of over half in less than a decade. Badgers don't have any natural predators in Britain, but many are killed on our roads, with about one in five adults killed by traffic every year.

Generally, only one female in the group breeds in any given year. She may mate with the male at any time of year, but

chestnut trees. The ground beneath the feeders is littered with bits of seed and peanut and our cameraman soon discovered that as well as small mammals like mice taking advantage of this easy meal after dark, the Badgers would join in too. A Badger's diet is predominantly earthworms, but they do love peanuts! One night he managed to film a female Badger who was obviously heavy with milk. This was great news as we now knew that there were young cubs in the sett . Badgers have an unusual ability to mate all year round but delay the implantation of the foetus. This means that whenever the Badger mates, she will always have her cubs in February. By the end of May, when we would be going live on air, the young cubs will certainly be ready to come out of the sett, and there are few things more entertaining than young Badger cubs exploring the wider world for the first time. Sure enough we were kept in fits of laughter as we watched the hopelessly naughty cubs play, fight and explore with each other and the adults.

Badgers are very sociable animals. They live in large groups and a sett will be home to several generations, although it will usually only be the dominant male and female who will breed. That year had been particularly dry and the badgers often emerged from the sett before the end of the programme, even though it was still light outside. This gave them more time to forage for worms, but gave us a unique opportunity to have live footage of badgers in their natural habitat, blissfully unaware that they were being watched by several million people! One cub, who appeared smaller than the other two, totally stole the show. Bill named him Dennis, after a badly behaved footballer, and Dennis lived up to his mentor. Night after night we watched him wind his siblings up until they leapt on him and a furious, tumbling fight would ensue, teeth bared, claws out, bottoms bitten. Just as suddenly they would break apart and scatter only for Dennis to start the whole thing up again with a cheeky nip on the back of a leg or well timed ambush from behind a tree. He may have been small, but he was utterly fearless, and had no qualms about taking on adults almost twice his size. This frequently started when he was being groomed. Badgers may look endearing, but they are infested with fleas, ticks and lice and spend a great deal of time scratching and grooming themselves and each other, often in a very undignified position. Dennis' problem was that he simply couldn't stay still for

delays implanting the fertilised embryo until the winter. Following a fairly short pregnancy of about seven weeks, she gives birth to between one and four (usually two or three) cubs in February. The cubs stay safely underground until April, when they emerge and begin the play-fighting and other activities that entertain us by the time *Springwatch* is on the air in June.

Badgers have always been persecuted, with the so-called 'sport' of badger-baiting still going on in a few parts of the country, despite having been made illegal since 1981. It is also an offence to destroy or damage a badger sett, but the practice still goes on.

Badgers are also unpopular with some dairy farmers because it is thought that they may be infected with bovine TB, a disease fatal to cattle. Currently the government department responsible for agriculture, DEFRA, is carrying out studies to see if there is a link between badgers and the disease.

If you want to see badgers, by far the best way is to join a guided walk organised by experts: your local wildlife trust should have details of outings on evenings throughout the spring and summer. The National Federation of Badger Groups (2B Inworth Street, London, SW11 3EP), can also tell you the address of your nearest group.

You may be able to find badgers for yourself by looking out for the key signs of activity: trails of crushed grass and vegetation under fences or hedges, or the setts themselves. But if you do find a sett, make sure you don't disturb the animals within. Badgers have a very sensitive sense of smell, so always stay downwind of a sett or they will quickly detect your presence.

long enough. He would lie on his back while an adult would patiently comb through his fur with her claws, but before long he would start to fidget and wriggle, the urge to nip would get too great and before long a full blown fight would break out. And if it wasn't Dennis being groomed, but one of the others, Dennis would often be caught taking a running jump at a contented pair of grooming Badgers and then all hell would break loose and fur would fly. One night we watched, speechless with laughter, as one adult finally at the end of her tether, picked Dennis up in her jaws by the scruff of his neck and dumped him unceremoniously back down an entrance to the sett.

That year was our best year for Badgers. Although they have continued to be one of the favourite *Springwatch* characters we have never again seen them as much or as frequently while we are live on air. In fact their unerring ability to appear out of the sett as the credits were rolling at the end of a show prompted Bill to wonder whether they too had been watching the show and were gathering outside the sett at 9 o'clock to complain about the lack of badgers on *Springwatch*. It became a running joke both amongst viewers and in the press and no show is complete now without at least one shot of a large hole in the ground. But thanks to our remote cameras, and the observers who sit up long past the time when we have all gone to bed, we have recorded some fascinating behaviour over the years. We've seen setts being cleaned out and new bedding being brought in: a bundle of dried grass held against the Badgers tummy with the front paws and dragged backwards into chamber. We've seen play fights, and serious, aggressive confrontations between territorial males. We've seen them digging for worms and chewing bark to extract beetles and larvae, chasing mice from the mammal table and unsuccessfully attempting to climb fences. We've seen adults with blissful expressions as they lie on their backs and scratch their nether regions with their claws and young badgers bounce and pounce and scamper until they collapse in an exhausted heap and nap in a pile before walking up and starting all over again. *Springwatch* just simply wouldn't be *Springwatch* without badgers.

Week Two – Monday 5th June

Bill Oddie

We return to the farm to discover that Summer – or is it late Spring? – has arrived. Three or four dragonflies over the pond, mayflies, midges and even a few micro moths flitting around. It seems that, this year, nature is a week or two behind, but today the insects have emerged at last.

The first thing to do is check out what has happened during the nearly four days since we were here last. Excellent – and frankly quite surprising – news: there are no tragedies at all. No chick losses, which is pretty amazing. The biggest 'news' is that the rampant lothario Pied Flycatcher male – now nicknamed Casanova – has been filmed – or rather videoed – feeding his 'wife's' brood. A new camera in the box has revealed 7 healthy chicks. But the real surprise was that he was also caught on surveillance CCTV paying an – albeit very fleeting – visit to his 2nd family – the 3 chicks being brought up by his hardworking 'mistress'. He didn't exactly hang about. He merely stuck his beak in and looked at his illicit progeny and then scarpered, quick. What was he thinking? "Oh blimey there's 3 of 'em! I do hope she'll manage on her own", or, " There are only 3 of 'em, so she should be ok. The wife's bringing up 7, so obviously she's the one who needs my help. Stands to reason doesn't it? So I'll go back there".

So was all this the facile reasoning of a typical male? Did he look on his 2nd family with guilt or pride? Or had his calculations assured him he had nothing to be worried about or ashamed of? At least he wasn't neglecting his domestic responsibilities entirely. He was helping out where he was most needed. Mind you, if his mistress failed to bring up the 3 on her own, presumably he'd have to confess he'd been irresponsible in getting her up the duff. If, on the other hand, both families fledged intact, he could claim he was merely carrying on the long cherished Pied Flycatcher tradition of bigamy! Let's face it, he'd enjoyed 2 women. 2 women had enjoyed him. And between them they had produced no less than 10 offspring. I mean, forget the morals – and indeed my anthropomorphising of the thought process – this behaviour was what biologists would call "a successful strategy for maintaining the species." Can't argue with that!

"Only doing my job mate. That's what we Pied Flycatchers do"!

The Pied Flycatcher was also doing a fine job of illustrating our claim that *Springwatch* is a sort of avian soap opera. Casanova was our Dirty Den. We looked forward to revealing his latest exploits on the show that evening

The hill. The lake. The loveliness of "the farm".

Casanova

Kate Humble

Pied And Spotted Flycatchers are two charming and fascinating birds that are amongst the most attractive and endearing species nesting on the farm. Both are summer visitors to Britain, spending the winter months many thousands of miles away in Africa.

Like the more familiar Swallow and House Martin, they migrate to take advantage of the best of both worlds. In Africa they can feed to their heart's content on insects under a baking tropical sun, and avoid the worst of the British winter weather.

Then, as the Earth begins to shift on its axis to signal the onset of the northern spring and summer, they start to head northwards, travelling thousands of miles and overcoming hazards such as storms, the desert heat and predators, to finally reach the British Isles. Here they can take advantage of the long Spring and Summer days to breed and raise a family, before heading back south again in Autumn.

Though they are closely related, and as their name suggests, both feed on flying insects, Pied and Spotted Flycatchers have very different lifestyles. Spotted Flycatchers often breed in gardens, especially old-fashioned ones with walls where there are plenty of holes and crevices where they can build their nest. The old farmhouse at Fishleigh, with its walled garden and plenty of insect food, is ideal, and the birds can often be seen flying out from a perch to catch their insect prey.

A particularly "fertile" male pied flycatcher that lived up to both his official and his nick-name! "He's black, he's white. He'll jump everything in sight!" Anon

2006 was a year of firsts for us. Thanks to some amazingly cutting-edge technology, which I confess is beyond me to understand or explain, we were able to get live pictures from an Osprey nest at Loch Garten in Scotland and from a Red Kite nest in Rockingham Forest in the East Midlands. We also had cameras hidden in the roof space of a building in the Lost Gardens of Heligan down in Cornwall filming a colony of Pipistrelle bats. This was a maternity roost of over 300 female bats who we were hoping would give birth while we were on air. This would not only be a new and very exciting event for us, but also for science, as no one had ever seen Pipistrelle bats giving birth. Unfortunately, our bats decided that to give birth live on *Springwatch* would be a little unseemly and waited until the day after the series finished to have their young! I'm not sure I can blame them ...

Down on the farm we had spent the two previous years marvelling at the number of Goldfinches around, but never finding a nest. This year we struck gold, as it were, and one of our eagle-eyed team found a nest high up in a large chestnut tree outside the front of the farmhouse. In the nest were five adorable chicks, whose sparse, spiky fluff made them look like little punk rockers. The female did most of the brooding and the male brought food for her which she regurgitated for the chicks.

But the star of the 2006, the villain we loved to hate, was Casanova. In previous years the farm has been visited by migratory Spotted Flycatchers: charming little birds that perch on fences and telegraph wires and will suddenly take off and flutter almost vertically upwards to catch flies. In 2005 a couple built a nest in the wisteria on the side of the house and laid one egg, which was swiftly predated, probably by a mouse. The pair was seen together again and they did build another nest and this time had three eggs. For the first few days everything seemed to be going well. We kept an eye on them from a distance, not wanting to risk disturbing them, but one morning there was no adult on the nest and neither of them could be found. The nest had been predated and we didn't see either of the adults again.

In the early May of 2006 a Pied Flycatcher made a nest in one of the nest boxes down in Badger Wood and laid four eggs. By the end of the month she had three chicks and one unhatched egg. The male – a very distinctive and rather handsome bird with his

148

available, Spotted Flycatchers can be encouraged to use an open-fronted nestbox similar to the design used for Robins; though as with any exposed nest this can mean they are at risk of attack by predators.

Sadly this is what probably happened during the first *Springwatch* in 2005, when at least one nest was deserted after not just one, but two clutches of eggs had been taken by an unknown predator. Fortunately, another pair then nested in the walled garden, and we were able to put live pictures from that nest on the air.

Pied Flycatchers, on the other hand, are mainly birds of oak woodlands, especially in the west of Britain, with mid-Wales and south-west Scotland their main strongholds. They are one of three classic migrants to breed in these lovely oakwoods: Redstart and Wood Warbler being the other two. Like Blue and Great Tits they nest in holes: either natural crevices or old woodpecker holes in trees, or in nestboxes.

Before ornithologist Peter Robinson started putting up nestboxes in the winter of 2001-02, Pied Flycatchers were only casual visitors to the farm, but since then there have been between one and three nesting pairs each year – a really welcome addition to the local birdlife.

Because they generally nest at fairly high altitudes the farm is probably on the edge of their range, but thanks to the provision of nestboxes - and the plentiful supply of insects, especially caterpillars on which to feed their young - this beautiful bird is now thriving there.

Incidentally, although both male and female Spotted Flycatchers look the same - at least to us - only the male Pied Flycatcher lives up to his name and sports a smart black-and-white breeding plumage.

One of Casanova's "partners" (above), illustrating the fact that the extra bits and pieces necessary to set up the camera in no way makes the nest box less desirable

black and white summer plumage – had been seen near the nest a couple of times, but seemed to be playing no part in the feeding or brooding of his chicks. Pied Flycatchers spend the winter in West Africa, returning to Britain in late April or early May. The male will usually chose a nest site and the female will build the nest. This nest looked very cosy, lined with animal hair, sheep's wool and feathers. And the female seemed unperturbed by the fact that she seemed to have been left to do all the care of the chicks alone. She

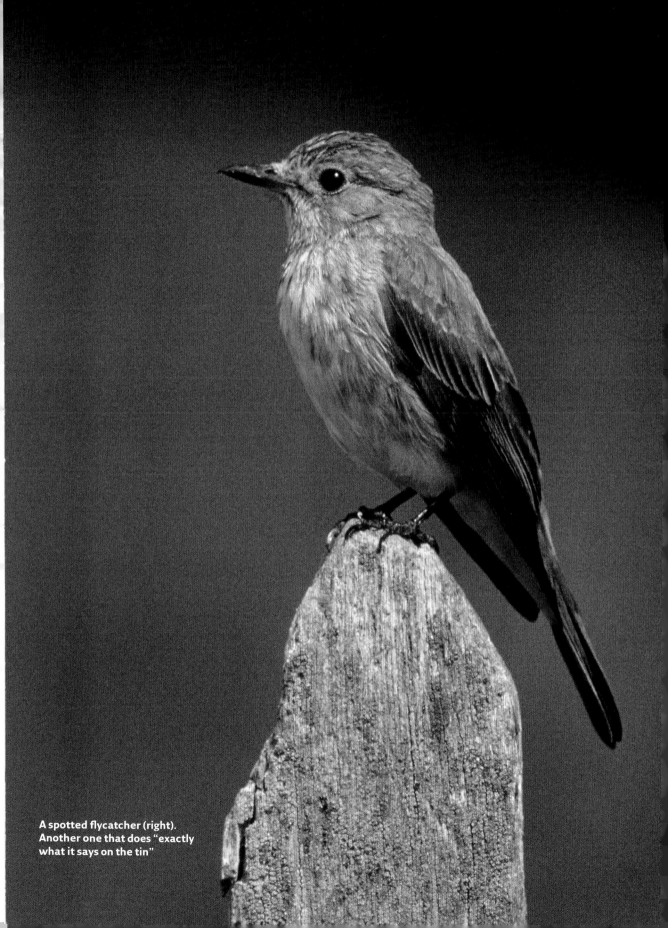

A spotted flycatcher (right).
Another one that does "exactly
what it says on the tin"

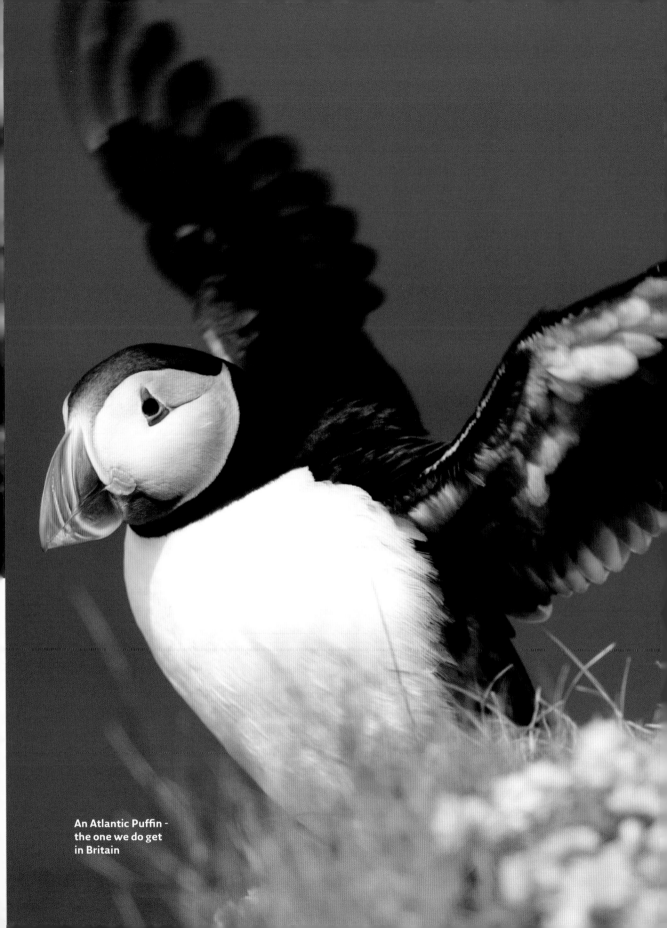

An Atlantic Puffin -
the one we do get
in Britain

Monday 5th June

Later that evening

We'd begun the program by quoting a comment in the TV listings of *The Independent*. It's the paper I read each day and generally consider as likely to print the truth as any other newspaper, and more so than many. Having said that, I have long ago learnt to distrust just about anything I read in the papers. Honestly, believe me, if you know the facts about any subject, and then compare what you know to be true with the version published in the media, it makes you very cynical. For example, I like to think I'm a fair expert on most things to do with wildlife. Almost invariably, when I read a piece in the newspapers – any newspaper – about, let's say, endangered species, I find it is riddled with inaccuracies and over-simplifications. At the most basic level, photographs show the wrong birds or animals. I once wrote an article on "British Seabirds", which was illustrated by a photo of Horned Puffins – a bird never seen away from the west coast of America and Japan! Similarly, my reference to Arctic Terns had been changed to … Sooty Terns – a tropical species that breeds in the islands of the Indian ocean, and has been recorded maybe half a dozen times in the UK. A Sooty Tern certainly wouldn't be happy in the Arctic! Headlines are another area to be deeply suspicious of. They are composed and chosen by editors whose sole purpose is to grab the reader's attention. To quote a widely and depressingly accurate cynical saying: 'Journalists never let the truth get in the way of a good story!".Which can be translated as – 'most headlines are gross exaggerations, or over-simplifications, or quite simply lies. Thus my piece on British Seabirds carried the true message that IF the population of sandeels continues to decline, then it is possible that eventually the UK breeding population of Puffins could be in very serious trouble. This was, as they say, the worst case scenario. However, the headline read: "British's Favourite Bird Doomed". Which is worse than worst case. It is simply not true. You may think the public – er, you – won't be taken in by such blatant scare-mongering, but they, you, we, often are. The day after the seabird article was published, I was accosted several times in my local shops by folk coming up to me and bemoaning the irreversible demise of the lovable sea-parrot. "Blimey, Bill,

that's terrible about them Puffins". "What's that?", asks someone in the check-out queue. Someone further back enlightens them: "Bill Oddie says they're extinct!" "Oh that's terrible" "But they can't be extinct, we saw lots of Puffins when I took the kids to the Farne Islands last month. It's them Arctic Terns that ought to go extinct, kept attacking us." "Bill Oddie says they are!" "He's talking rubbish!" "Well, it was in the papers". "Quite so!" I finally manage to address the whole queue:" "Don't believe everything you read in the papers. No, make that anything you read in the papers. The football results maybe, but that's about it. And the truth is that there is a shortage of sand eels, especially in the Northern Isles, its not actually as bad in the Farnes Islands, which is why Puffins and Arctic Terns are doing better there. You see, seabird colonies are notoriously volatile ..." "Yeah, and you're notoriously boring mate. Just fill your trolley, and stop holding up the check out."

Presumably he wasn't a *Springwatch* viewer. Mind you, I have to admit I was losing my audience anyway. That's one of the problems with trying to convey the truth. The truth is rarely simple. Start explaining about fish stocks, changing sea currents, and volatile seabird populations and – let's face it – most of us (and yes, I include myself) would sort of glaze over and lose interest. Whereas if you hear or read: "Puffins Doomed!", you – and I – are much more likely to take notice. I am all for grabbing people's attention – it's not that difficult! – but then you have to engage their brains, their emotions and – if appropriate – rouse them to action. That is not so easy.

So what was that little diatribe to do with *Springwatch*? OK lets go back to those TV listings. "Monday June 5th 8.00. BBC2. *Springwatch* begins its second week. Bill and Kate find out if the baby birds have survived the weekend. Any reason that they shouldn't have?!"

So what's that supposed to mean? Were we being accused of making up fictitious dangers? Cliffhangers invented purely to make the gullible viewer tune in on Monday? Rich innit? A newspaper accusing us of exaggerating the facts in order to attract readers – sorry, I mean viewers. The fact is, that all that accusation illustrated was – yet again – that it's the papers who tend to get it wrong.

"Any reason they shouldn't survive the weekend?" 4 days. Well yes, there's plenty of reasons actually! Every day in the life of a

Young House Sparrows. An increasingly rare sight in British cities, especially London, where "the cheery Cockney sparrer" has almost disappeared. Why? We honestly don't really know. To balance things up, though, they have spread all over the world and are now common in the Americas, Africa and even Australasia

young bird is potentially its last. They may starve to death because there is a food shortage, or because one or both of their parents might be killed by a predator – a cat, a rat, even a motor vehicle. Or the chick itself could be taken and eaten by anything that regards a chick as a meal – cats, rats, Grey Squirrels, Crows, Magpies, Jays, even Great Spotted Woodpeckers. Or there could simply be a shortage of caterpillars. Or severe weather may prevent parent birds from hunting, or cause the youngsters to freeze to death. Nest boxes can collapse. Trees can be chopped down. Bushes trimmed and nests destroyed. The truth is that a large percentage of newly fledged birds won't make it past the first few days out of the nest. "Any reason they shouldn't survive?" I should say so!

In fact, we always returned to Devon, after the weekend break, expecting some bad news. The relief and surprise today was that there was so little. We already knew our farm families were all intact and grown a little bigger. News from further afield was that the runt Red Kite had not become a family Sunday lunch. There had been no nasty Badger or Otter incidents.

The one and only tragedy had occurred in the House Sparrow nest box. There had been 3 chicks raised by a single parent female. During the day last Thursday, it had looked as if all 3 would make it, despite one being clearly a little smaller than the other two. Then Thursday evening, one chick decided to leave the nest, and flutter over to the nearby grain barn. Theoretically, it should've been able to feed itself, but it couldn't. So mum had to feed it. Frankly, this should not have been necessary. There was grain in the barn, and plenty of it spilt. Even a newly fledged chick should've been able to grab a seed of grain. Hardly a challenge. Grain doesn't exactly run away. But no, Sparrow chick number one seemed incapable of feeding itself. This meant chicks 2 and 3 were being neglected by mum. The consequence of this was sadly, inevitable. Over the weekend, the smallest chick succumbed to starvation. Our camera recorded its final twitch. Had it been able to speak, no doubt our microphone would've captured the last words as well. Probably something along the lines of: "It's OK brother, I don't blame you for going early, so mum neglected me! I forgive you". Or maybe less sympathetically, "You selfish little ... I told you you were too young to leave the nest". Or maybe just a truly pathetic cry of: "mum, mum, I'm so hungry ... I can't ..." And the nest was silence. To be honest, it was a truly sad moment, and

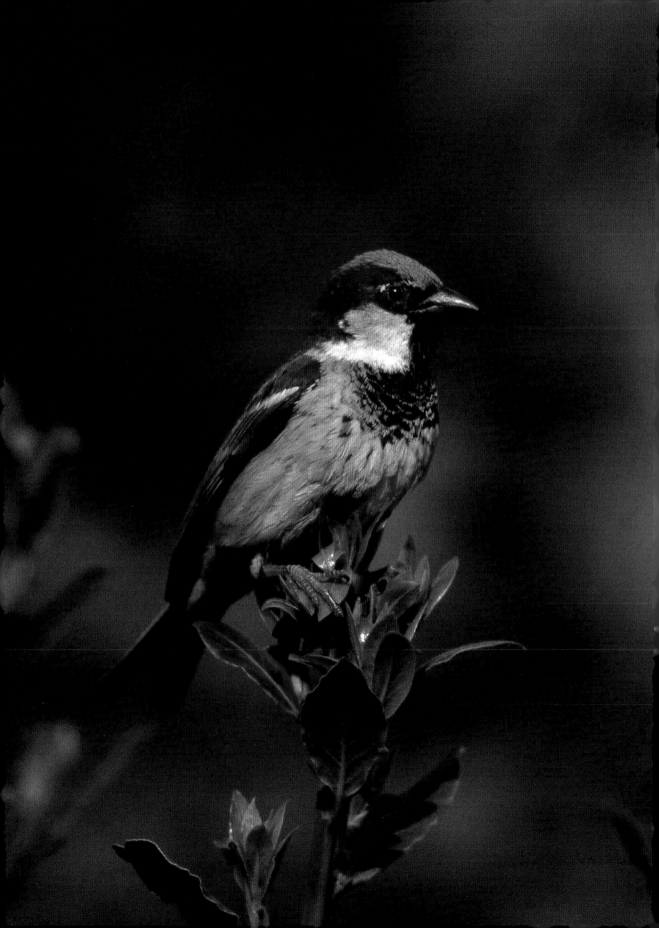

A male House Sparrow. A truly
handsome little bird, even if he
can't really sing. The chirrupping
is still very jolly.

when we showed it tonight, no doubt 4 million viewers bit their lips and maybe even shed a tear. Realistically, it also has to be recorded that the producers thanked fate for providing a classic soap opera incident. "Sad to lose a Sparrow, of course, but its what the audience wants." No, not really, *Springwatch* isn't a soap, it is reality TV. But real reality. As some consolation, and to provide a desirable happy postscript, House Sparrow chick number 3 soon decided that sharing a nest box with a recently defunct sibling – an ex sparrow, no less – was incentive enough to get out and face the big wide world. So, our Monday update also recorded the 3rd fledgling leaving the nest box. And be fair, 2 out of 3 wasn't bad. Nevertheless, neither of the fledglings looked entirely safe out there in the barn. In fact, they looked so vulnerable, we elected to close the show with their "jeopardy." Would the House Sparrow fledglings survive 'til tomorrow? Out there in the big dangerous world, they are too young to be confident or elusive. They are potential meals for rats, cats, crows, or anything else that fancies a snack. The show ended with a close up of one of the youngsters looking almost brilliantly pathetic. It cowered behind a wooden beam, with only its head visible. There was the undeniable glint of fear in its eyes, and its mouth, still with the yellowy lips of the juvenile's gape, was set with the edges turned down, for all the world like the classic mouth shape of the "mask of tragedy" so beloved of pretentious theatre groups. Little tufts of feathers on each side of its head completed the undeniable stereotype. Talk about the tears of a clown: that baby sparrow had pathos written all over its doleful little face.

Will it live or die? Tune in tomorrow! 4 million people did!

Tuesday 6th June

Or to put it another way 6/6/06

Despite the demonic portent in the date – all those sixes. Something to do with the Omen isn't it? – the Tuesday show was a very cheery affair, which – at least as far as Kate and I were concerned – struck a nice balance between frivolity and information. Close to home, as it were, there were no distressing reports of defunct sparrow fledglings being found. This didn't mean they were definitely safe. They could have been safe in the farm cat's tummy. But we preferred to think they were still alive and chirruping, even if not loud enough to have attracted our roving cameraman.

There was also a feeling of just how far *Springwatch* was extending its boundaries. We were able to report that, over the weekend, no less than 250,000 people had attended 815 *Springwatch* Events all round the British Isles. On Shetland, Simon's Otters were safe and well and he was now introducing the nation to the eerie calls and extraordinary sleek looks of Red Throated Divers. Even further afield, one of our radio tagged Super Geese – a Light bellied Brent Goose actually – had safely arrived on its breeding grounds in Arctic Canada. Carrying the *Springwatch* ethos to the New World.? Well, sort of. Plus, down in Cornwall, the camera had recorded behaviour never before observed – mutual grooming by Pipistrelles, and one to one nose rubbing! A charming gesture of mutual empathy between pregnant females. Now all we needed was the ultimate bat coup – an actual birth. A pipistrelle baby. A pip's pup. That would be something very special!

That's the thing – when everything's going well, you always want more!

A skyful of Brent Geese. To be fair, none of them are any more "super" than any other! Every single one is rather charming and dapper, and undertakes an incredible journey

Wednesday 7th June

Everything is going very well, but it can be better.

There is perhaps some inevitability about what happened at this morning's production meeting. We are now about half way through the three weeks. Half time. And what happens at half time during a football match? Oranges, OK, maybe an energy giving drink ... But also, a team talk. And how many times does a manager just say: "Oh its going fine. Just carry on like that, and we'll win. Probably." Not often. Even if your team is already winning, there will be warnings about complacency, getting tired and losing concentration, almost invariably ending with a challenge. "First half not bad, let's make the second better. Never forget that. It can always be better."

So what about the *Springwatch* half time talk? Well, yes indeed, there was a slight fracas this morning. Mainly, I confess, instigated by me. Continuing the football team analogy, I am definitely not the manager. I am a player. Arguably the captain. Kate would be vice captain. The chief coach , responsible for tactics, would be the day's producer, Alex(andra) or Colin. The manager, responsible for team selection and overall club policy would be Tim, the "series producer". Fiona, the executive producer – is harder to define in footballing terms. Perhaps the chairman of the club, answerable to major shareholders, i.e. The BBC Bosses. Yes, that sort of works.

Anyway, the thing is the morning meeting is basically a team talk before the match. The match being this evening's show. The director tells us what's going to be in it – the contents and running order. And we all have a chance to comment on the details and anticipate any tricky bits. No doubt, like a manager after his team talk, the day's producer is hoping that the players – me and Kate – will say "OK, boss. We understand. That's great. We'll do our best." And that's the end of it till kick off, or – in this case – the actual broadcast. We do have a "technical" and a "dress" rehearsal, before we actually do the real thing, but that's a bit like the footballers warming up and running through a few moves. We shouldn't be arguing in the afternoon. Hopefully, we won't be arguing at all. But if we do, then it happens during the morning meetings, and I'm afraid it's often me who starts it.

And so it was this morning. Having glanced at the running order and contents I put my hand up to speak, no doubt a gesture

the others slightly dread. I dare say their inner thought is: "Oh dear. Here he goes!" Instead of saying that out loud, someone asks "Yes Bill?" No matter who says it, their voice always reminds me of a slightly weary school teacher who has really had enough of answering rather obtuse questions from an over insistent pupil. Or am I paranoid? Oh definitely. Anyway, I explained my concern: which was that there seemed to me to be too many "pre recorded" items tonight, and frankly I had been feeling this was the case for the last couple of shows too. "We are losing the live feeling" I suggested. "Why be live if most of the show is already recorded?" The immediate question to answer at the meeting was: "Does Bill I have a point?" The question I have time to consider now, is the bigger one of "Why be live?" and secondly "What proves that a show is live?". The answer to the first question is pretty universally accepted: a live broadcast feels more real. There is an extra frisson about the fact that you are watching what is happening right now. Football analogy again. Being there at the ground is best. Live on the telly the next best thing; "recorded highlights" fine, but it's not quite the same is it? But there is a

"If a picture's worth a thousand words ..." What does this one say? Is my expression seeking inspiration or showing exasperation? The two producers – Alex and Colin – look, well, let's say a bit weary. As for Kate – I'm just grateful you can't see her face. I suspect a glare. At me!

crucial difference between live football, and live wildlife. Unless things have gone very much awry, the players will definitely turn up and play, and the cameras will not miss any of the action. Birds and animals are not so reliable. And another thing, heaven knows referees often complain about the difficulties of controlling players. They should try controlling wildlife. It really can't be done.

So, if you asked me what makes a show live it would not just be the frisson of seeing great things happening there and then, it would also be the possibility that things might go wrong. Worse – or better? – it's when things do go wrong. The mistakes. They are a challenge to us, but I suspect the viewers love 'em! Animals tend to create mistakes anyway. Like the number of times Kate or I say "lets go over right now to the Badger sett" and all we can show you are holes. 10 seconds ago there were 5 Badgers performing photogenically, fighting, scratching embarrassingly private parts and indulging in passionate embraces. But no sooner has the director uttered the words: " coming to Badgers next" – than the whole lot disappear underground as if by magic. No Badgers. Just holes. And we are left uttering those words that make *Springwatch* irresistible fodder for comedy parodies: "Well, it's a pity you weren't with us a few minutes ago. To Kate and I, Badgers and blank screens are almost synonymous. Simon probably felt much the same about his Otters. Both species are masters of mistiming. But it is real. It is what happens, and I am sure the viewers appreciate it. Do you? As long as we have pictures of "Badger action we filmed earlier" Those are what we refer to as the "prerecords". Very necessary, but they are the equivalent of those "edited highlights". Great stuff, but it is even better when it happens live.

Fortunately, the birds tend to be more reliable and visible than the beasts. My current complaint was that there was a danger of us losing those unpredictable and yet almost always charming sequences, where we just did a live "round up" of the various nest boxes. OK, we'd be lucky to see some piece of incredible action, but surely that didn't really matter? There is something very comforting about checking that our feathered friends are simply safe and well. The mother may be sitting on eggs. The chicks may be asleep but they are still lovely to look at. And stay on any one box for a minute or two, and we are almost guaranteed a feed, or a bit of wing stretching, or the endlessly alarming moment when a

baby squeezes out a white faecal sac, shrink wrapped poo, which is then neatly removed by a parent. I suppose it is a bit like dog owners are supposed to do with their pet's excretions. I bet they wish dog turds came ready wrapped.

So that was my complaint – or should I say concern? – during the half time team talk. Fortunately, everyone pretty much agreed. "Yes, it is going very well, but let's not lose the live." That evening's show featured a extra portion of nest visits, during which I found myself waxing sentimental to the point of delusional soppiness, so much so that Kate felt it necessary to snap me back to reality. I well remember the exchange:

Me: You know Kate, call me a sentimental old thing, but looking at these baby birds and their parents caring for them like this – they seem to me to symbolise a real devotion to family values.

Kate : Really?

Me: Yes. You know, I reckon we humans could learn a thing or two from the birds.

Kate: You do do you? Bill, may I remind you that, during little more than a week, we have featured a Buzzard chick that ate its little brother. A Sparrow fledgling that blocked the nest hole, so that the mother couldn't feed the other youngsters, with the result that one of them starved to death. We have also got a young Jackdaw, so evil looking we've called it called Damien; and we've got a male Pied Flycatcher that we have just discovered has got not one, not two, but three females all up the duff at the same time, and frankly he's not exactly paying maintenance to any of them! Good examples for humans. I think not.

Me: Well, er yes but, no but, yes but. There are some birds that are great foster parents. We've got a terrific film about Cuckoos ... which, of course, lay their eggs in other birds nests, and then, as soon as the Cuckoo chick hatches, it throws all the other eggs and the babies out of the nest, so that they... mm ... yeah, I take your point. I obviously am a sentimental old thing. Anyway, it is a great film.

Let's go over to Simon in Shetland...

Which indeed we did, so Kate could give me a consolatory hug, which I admit had the affect of completely compensating for my disappointment at the dubious morals of the birds I have for so long tried to champion.

The Buzzard getting bigger, despite having no more siblings with which to supplement its diet

Thursday 8th June

And in tonight's programme I had reason to comfort Kate. She has chosen to form an emotional attachment with a so - called "super goose", who is either perverse, disorientated or dead. Having christened the Brent in question Floyd, after helping fit him with a ring and a tiny radio transmitter, Kate had sent him on his way from Northern Ireland on the 16th April. The very next day, he disappeared off the radar, somewhere near the island of St Kilda, which is in the outer Outer Hebrides. This was a reasonable enough place for him to have got to, being about a day's flight – for a goose – north of Ireland. However, after a few days silence, it was assumed that at best his transmitter had fallen off – as Kate commented: "they should've used stronger elastic" – or at worst, he had been shot. The latter fate seemed a little unlikely since he had disappeared at sea, and I am not aware of many deep sea fishermen who pass the quiet times taking pot shots at passing geese. Added to which, the seas up there are so rough it would be a fine marksman who could hold a rifle steady enough to pick off a flying bird! So Kate was able to comfort herself by accepting the "weak knicker elastic theory" until ... 21st May. When we received news that a couple of birdwatchers had spotted a Brent Goose sporting a red and yellow ring. They had asked a third birder, who was armed with a telescope, if he could read the letters on the ring. He duly did so, and he told the couple. Alas, by the time they had contacted BBC Northern Ireland, they had forgotten what that letter was! They were pretty sure it was either K or H. This narrowed it down to either the missing Floyd, or to Douglas, whose transmitter had been working sporadically, and had been last heard of heading towards Iceland. This circumstantially led us to believe the goose that the couple had seen was indeed Floyd, since the report had come from South Uist which is in the Hebrides, not that far from St Kilda, where we had last heard of him. However, that in itself, when we thought about it, was rather puzzling. If Floyd was alive and well (if no longer broadcasting) he should have carried on further north from St Kilda towards Iceland, like all the super geese should have done. We estimated that by 21st May, he should have been somewhere near Reykjavik, not on South Uist. So, having lost his transmitter, had he turned back? If so, why? Surely he hadn't reasoned: "oh well, I'm not

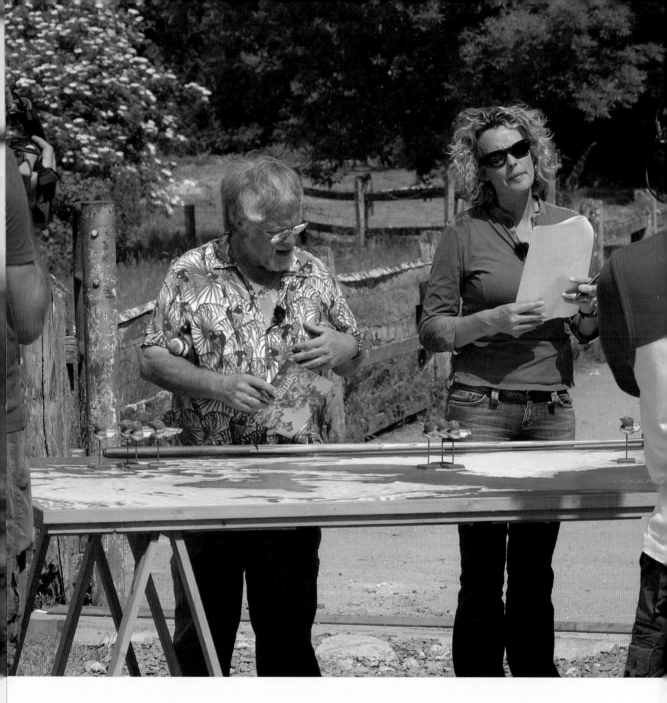

The Super Geese "operations" map – a gimmick that was at least more fun than the birds themselves! Note my attempt to whoop things up with a garish shirt, and note the fluffy Blue Tit under my arm in case we get really desperate!

flying all the way to Canada if I'm not going to be featured on the telly. I reckon I'll go back and have a nice peaceful summer in the Hebrides. Might even bump into that cuddly Kate woman again, I hear she goes diving round these parts." Or perhaps he had been shot, but only winged, and rather than try to make Iceland, he'd managed to flap back to the nearest land (believe me, St Kilda itself is no place to convalesce. Very rocky, very wild.) Injured geese do indeed often have to stay on the wintering grounds

A Wood Mouse. By no means only found in the woods. Particularly partial to garden sheds and even inside the house. Anywhere there's easy food available. Which is why they raid nest boxes whenever they fancy a nice mouse-sized egg

the Wood Mouse had not intervened. If the original family had been not 3 but 6, would Casanova have decided that two partners was enough. 13 offspring is pretty prolific. Or if he had mated with a third female, would that have been a risk? If the third family had been small – say 3 or 4 – maybe it would have been ok. But if it had been another 7? Would 21 have survived? That's an awful lot of hungry mouths to feed. Surely, he would have been spreading himself a bit thinly, as it were? So, as it turned out, was that moment when he popped in and "counted" only three chicks the moment he "decided" to start family number three? Numbers, calculations, decisions. Do birds brains work that way? Or is it some sort of instinct? And why do Pied Flycatchers practice this kind of polygamy and not other very similar small birds? How little we know, and what fun it is finding out. Or not! Personally, I rather like the fact that we certainly don't know everything. We never will.

There's a deep thought for the weekend. Which is, by the way, looking good weatherwise. In fact it is already getting very very warm. Climate change? Global warming? Let's not go there. That was last year's *Springwatch* theme, and boy is that complex. I mean, not that I don't have opinions, but hey come on ... The World Cup starts this weekend.

The Final week
Monday 12th June

The first morning of the final week. As always, the first thing I did when I got back to the farm was go and look for moths. Now this may seem a little quirky at about eleven o'clock in the morning, but it's a habit I got into during the very first live broadcasts from Fishleigh three years ago, when *Springwatch* was called *Britain Goes Wild*. Our production village is illuminated at night by a number of security lamps. They are not big and they are not even very bright, but they are apparently irresistible to moths. The lamps are only about six inches off the ground (angled upwards) so it's no big effort for me to wander round and check them. But in broad daylight? Yes. Presumably the moths land on or near the lights during the night (like moths to a flame, as it were) but instead of getting frazzled, they just snuggle up and fall asleep. Some morning there are masses of them, some clinging to the stem of the light, others nestled in the nearby grass. Some of the bigger ones seem to find any nearby rubber tyres particularly comfy. However, so far this year, the weather has been largely rather chilly and damp. Not what moths like. But over the weekend it has got a lot warmer, and the evidence was before my eyes when I did the moth round. I am not going to go into a lengthy eulogy about the joys of moth identification, but suffice it to say that today there were about twenty odd different species, fast asleep and easy to get a good close look at. A few of them conform to the image I suppose most people have of moths – small and rather dingy, although clearly not addicted to nibbling clothes! – but the rest was a fine selection, demonstrating why I find moths absolutely gorgeous. They also often have deliciously descriptive names. The Buff and White Ermines, wearing little furry cloaks. Angleshades, that presumably got their name because their shape does indeed resemble one of those "angled" table lamps. Or did the lamp get its name from the moth? A lovely little pink spotty thing called a Peach Blossom – a new one to add to my *Springwatch* moth list – and always the most impressive, the alarmingly large and yet delicately patterned Hawk moths, so fond of those tyres! Today there were several Poplar Hawks and a single Elephant Hawk Moth, which is actually pale pink. A pink elephant?

A Poplar Hawk Moth demonstrating its remarkable camouflage, which has evolved so that it is virtually invisible on one of my shirts. Isn't nature clever?

Did someone name that after downing a bit too much wine? Alas apparently not, because it is actually named after its caterpillar which can swell up at one end so it resembles an elephant's head . Only much much tinier of course! Mind you, both caterpillar and insect may be diminutive for an elephant, but they are pretty enormous for a moth! I am always trying to wangle more moths into the programme. I even suggested Moth of the Day as a regular feature, but its never quite happened. This year I had to

A Buff-tip Moth, but bigger than life size, that does a simply brilliant impression of a little bit of birch twig. Most mornings several were perched on or by our lights

admit it would have been a bit pathetic for the first fortnight, since there weren't any moths around, until now. In fact, that in itself is quite surprising, since despite – or possibly because of – the rise in temperature it bucketed down throughout the night. It cleared up in the morning, but we were a little concerned that the deluge may have affected our baby birds. As it turned out though, we discovered that quite a few of them had decided that the rain may well have improved their chances of finding food out in the big wide world, rather than sitting in a crowded nest waiting for mum or dad to bring in a caterpillar, that wouldn't be enough to go round the whole family. So, the après-weekend update on the show consisted largely of which chicks had fledged, and which were looking like going any minute. The Blue Tits were certainly leading the field. The Moss family had all left their box. One of the Humble Tits had set an example that morning, which the rest of his siblings would surely follow. Casanova it seemed had made an accurate appraisal when he'd decided that his first female could manage to bring up triplets without his help. All three had gone. And to prove they hadn't been gobbled up by the Wood Mouse that had had the three eggs, the youngsters were filmed flitting around the woods, with mum close by, keeping an eye on them, and occasionally bringing them snacks, in an effort to encourage them to copy her and go find their own caterpillars. This is how it works when it's time for the youngsters to leave home. It's the parents that tend to make the decision. They begin to feed the chicks less and less. And they will even tease them by dangling a tempting caterpillar through the nest hole and then retracting it before anyone can grab it. If they really want to rub it in, they may sit within eyesight and eat it themselves. Presumably the chicks are then driven by outrage and hunger into protesting with a lot of squeaking and wing flapping. Universal bird language for "feed me". The parents will often call back, presumably the equivalent of saying " If you are hungry, come out here and find your own food. It's too crowded in there, we are exhausted from looking after you for nearly three weeks, and you are all big enough to fend for yourselves." This usually provokes little heads to appear at the nest hole, and do a bit more pathetic squeaking, as if to say:. "But we don't know if we can fly yet!" To which presumably the answer is "well, you won't know until you try!" Eventually, most of them pluck up courage and take the plunge. In some cases quite

literally. Kate and I get very attached to our birds, and we do care about them, but when one of them doesn't so much flap as plummet, you can't help chuckle! Especially if they sit there with an embarrassed look, that surely says "you didn't see that did you?" or " If you did see that, you weren't filming it were you?" Or "if you were filming it, you're not going to show it to anyone are you?"

We are of course mindful that even baby birds have dignity to protect.

No no, of course we won't show it to anyone. Only 4 million people that's all. And if it's really funny, it will probably get into the "highlights" item in the last show. It might even qualify for the Christmas Special "clumsiest bird of the year" award. Let's face it, if you are worried about losing dignity you don't appear on TV Reality shows. And that applies to birds and animals, as well as humans.

Talking of comic potential, Damien the Jackdaw has been teasing us all day. One minute he had his head in the hole and looked about to leave. The next, he'd flopped back down and fallen asleep. All day it had been going on. He's off. No he isn't. He's up, he's down. He's out, he's in. He's right up in the hole with his feet on the ledge. He's gone to sleep again. This carry on started off as quite amusing, but it was beginning to get a bit exasperating. There had been a camera on him all day but it is up to one of our "box watcher" girls to press the button when they see something worth recording. By tea time, the girl in question had accumulated about an hour's worth of footage of Damien looking as if he was about to leave, and then not. She hadn't missed a moment, and she had of course made it her personal resolution that she would record his departure, even if she had to carry on like this for two more days. But then nature called. Not unfortunately to Damien, but to the girl. She literally ran to the porta-cabin loo, and ran even faster back. Need I tell you what happened? During the one short time she wasn't at the camera controls ... Damien went. She came back, stared at the screen, and saw an empty box. She was so distraught she practically offered her resignation. It was not accepted! We just knew that Jackdaw was evil. Damien indeed.

I suppose though you couldn't actually accuse Damien of being uncooperative. Unlike the badgers. For over two weeks now they simply have not "performed". In fact they have barely been visible.

Jackdaws (right), diminutive crows that always seem to me to deserve the adjective "perky". The name is actually onomatopoeic. "Chack"-daw. Say that first syllable out loud and then listen to the next Jackdaw you see!

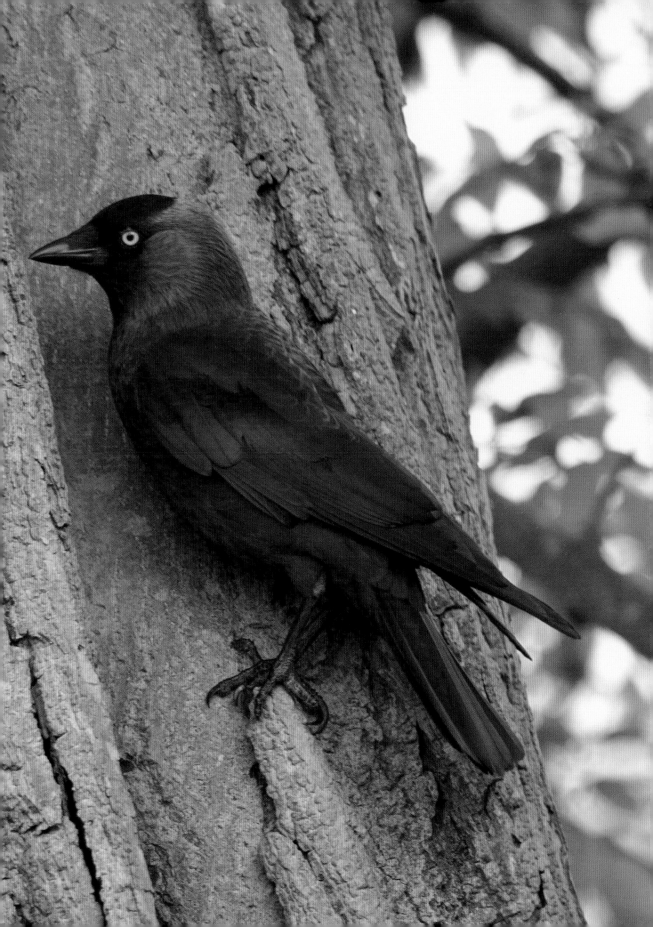

Members of the crow family are not the most popular birds with the British public, so we took a bit of a risk when we put cameras in a Jackdaw's nestbox. But having observed the parental care of this pair, and the behaviour of the 'spoilt only child', as Bill and Kate soon dubbed him, you may have changed your mind about these overlooked but rather charming birds.

Of Britain's eight breeding species of crow, the Jackdaw is marginally the smallest (a shade shorter than the much more colourful Jay), and easily the smallest of the mainly black species such as the Raven, Carrion Crow and Rook. Just over a half a million pairs breed in Britain, and that number is rapidly increasing, as Jackdaws are adaptable birds that seem to be able to take advantage of a wide range of habitats and food sources.

Like all crows, they are clever birds; but unlike the other British species they nest in holes in trees, or in chimneys and cracks in church towers – or when they are available, as on the farm, in large nestboxes.

The larger boxes put up by Peter Robinson on the farm certainly get used to the full: in some years Grey Squirrels raise a litter of young early in the season, to be followed by a pair of Jackdaws. Then, late in the summer, once the Jackdaw chicks have left the nest, Stock Doves move in! This shows just how important a nestbox can be, especially in an area with a lack of natural nest holes.

Normally Jackdaws have between four and six young, but those that nested during Springwatch in 2006 were an exception, with just one chick surviving to maturity. He was, as Bill and Kate put it, 'spoilt rotten'. Like a sulky teenager, though, he didn't seem to appreciate attention from mum and dad; though he did eventually fledge and leave the box after much coaxing and encouragement. In the end, the parents had to refuse to bring food, so eventually he had to come out and feed for himself!

There are five other members of the crow family regularly seen on or over the farm. Jay, Magpie and Carrion Crow all breed, though the first two are relatively scarce. Despite having been blamed for the decline of many farmland birds, such as the Yellowhammer, Linnet and Grey Partridge, there is no evidence to suggest that these species are at fault, though of course they do take eggs and chicks from a range of small birds' nests – as of course do a whole range of other predatory birds and mammals.

Rook and Raven do not breed on the farm itself, though Rooks did have a small rookery of about 15-20 pairs near the main house until 2002, but failed to return in 2003, and have not since bred on the estate. Ravens, our largest crow (and indeed the largest of the world's 120 or so species of crow) do breed nearby, and are much commoner than it used to be in Britain as a whole, spreading from their western strongholds into many new areas.

OK, how many Badgers in this picture (right)? Including the ones underground

They don't wait for any humans to go to the loo. They simply wait until it is pitch dark and *Springwatch* is off the air. The fact is we have had very little live Badger action. Fortunately, our remote control cameras are recording for much of the night, and these pictures are going out on the *Springwatch* website. And apparently quite a few people are watching them. Be honest, it is rather better value than the *Big Brother* all night broadcasts. I mean who does want to watch a dozen people you don't know fast asleep? And why? At least the Badger watchers see a bit of action. In fact, quite a lot of action. Ok we will show the edited highlights on the real show, but as I have already argued it's not quite the same as it happening live before your very eyes. I suppose it's only like people staying up all night to watch live cricket from Australia. Anyway, realizing that there are nocturnal Badger spies out there we have decided to set them a task. The truth is we really don't know how many Badgers there are in our sett. There is a veritable labyrinth of tunnels in a Badger sett, so chances are, however many you can

adult Buzzard would have been at the bottom of the trunk with its beak wide open, and ... But no, we're pretty sure our toad made a safe landing, and hopefully hopped off back home..

Despite these bizarre goings on with live food, life in the Buzzards nest was generally very charming and quite tender. The chick, still hardly the prettiest baby on the block, would frequently be nuzzled and groomed by its attentive parents. There was however, one rather alarming moment that we could hardly believe when we first saw it. Basically it looked as if one of the parents, on taking off from the nest had left one of its feet slightly dragging behind, and in doing so had literally kicked its baby in the head! It looked violent, and we felt impelled to run it again in slow motion. Sure enough the offence was revealed in all its cruel clarity. The parent takes off, the foot is clearly left dangling dangerously, and wallop! The baby's head is all but clouted off its shoulders. The parallel to the football field was irresistible, considering we were in the early stages of the World Cup. The adult Buzzard had clearly committed a heinous foul. The only question really was "was it intentional?" or a complete accident. We ran the slow motion replay again. It didn't look good, and the fact that the parent hadn't bothered to come back and check that the baby wasn't flat out with concussion wasn't helping. It can't just not have noticed! "You just kicked your baby in the head." "Really? I didn't feel a thing." "Well the baby certainly did. You must have felt your talons come into contact with something fluffy?" "Well, yeah, now you mention it, I sort of thought I might have accidentally caught something, but I assumed it was one of them toads." "A toad is not fluffy. It is slimy." "Ah well now, that's where you're wrong innit?! Frogs are slimy. Toads are dry and warty." "Ok, but they could hardly be mistaken for a baby buzzard could they? Especially not your own baby. Anyway, don't argue. We've looked at the slow motion replay. You could have had its head off. We'll take your word it was an accident, but just be more careful in future. You're lucky its a yellow card, not a red. Ok? You see wildlife TV is ahead of football – we already have video-refs.

The chastisement seemed to work. Never again did we see one of the parent Buzzards treating their chick with anything but TLC. Which was nice. We also now had a wickedly funny clip which we mercilessly showed at every opportunity. Foul of the day. Or should that be fowl of the day!? We were convinced it would be the

most memorable thing in tonight's programme. But we were
wrong. Simon totally upstaged us by filming a pod of Killer Whales
(Orcas) swimming within a few yards of the cliffs at Sumburgh
Head in Shetland. It was a truly fantastic sight and as it happens
one that I envied greatly. I have been to Shetland many many
times over the years. I have heard tell of Orcas, but I have never
ever seen them there. Simon goes on his first ever visit to Shetland
and not only sees them, he gets them on the telly! Not fair is it? Ok
then, we thought our Buzzard incident was fun, but Orcas are
awesome ... you win!

This could possibly be a very rare photograph of Bill and Kate actually rehearsing! Or maybe they are just trying to think of a witty line to spice up one of the less exciting bits!

Buzzards

Stephen Moss

One of the real 'big hits', on several series of Springwatch, has been the Buzzards, which nest in a tall oak tree in the woodland on the farm. Watching the chicks fight amongst themselves, or seeing a single chick crouch in search of shelter during a rainstorm, has given us some of the most memorable events of the series.

It also took a lot of ingenuity and expert help: with the aid of Peter Robinson, our crack team of camera operators and climbing experts managed to safely install a camera above the nest, more than 12 metres above the ground.

Buzzards suffered a major decline during the post-war era, for two main reasons. The first was that, as birds of prey, they were routinely shot by farmers and gamekeepers eager to safeguard their stock. The second was that as predators at the top of the food chain, like all birds of prey Buzzards suffered from the widespread use of agricultural chemicals such as DDT. These chemicals concentrated in the food chain so that the Buzzards were taking in large amounts of the poison, which had the effect of making their egg-shells thinner and reducing breeding success.

Fortunately, from the 1960s onwards there was a backlash against the pesticides, led by the American environmental writer Rachel Carson with her famous book *Silent Spring*. Slowly but surely, the Buzzard population began to recover, helped by more enlightened attitudes from farmers, who were less likely to reach for their gun than before.

By the early 1970s, the UK breeding population was up to about 8,000-10,000 pairs, which had increased to between 12,000 and 17,000 pairs by 1983.

Meanwhile the species was starting to spread out of its northern and western strongholds, and colonise the south and east of Britain; largely because of a campaign from conservation organisations to stop the laying of poisoned bait to kill the birds.

Today, not only are Buzzards found right across the country in suitable habitat, but the population has rocketed: the latest figures from the BTO and RSPB suggest that there are now about 40,000 breeding pairs. So in just three decades the Buzzard population has grown to rival – and perhaps even beat – the Kestrel and Sparrowhawk as Britain's commonest bird of prey.

Often the first indication that there are Buzzards in woodland is their sound: a rather pathetic, high-pitched cry often described as 'mewing' – very different from the sound you might expect from

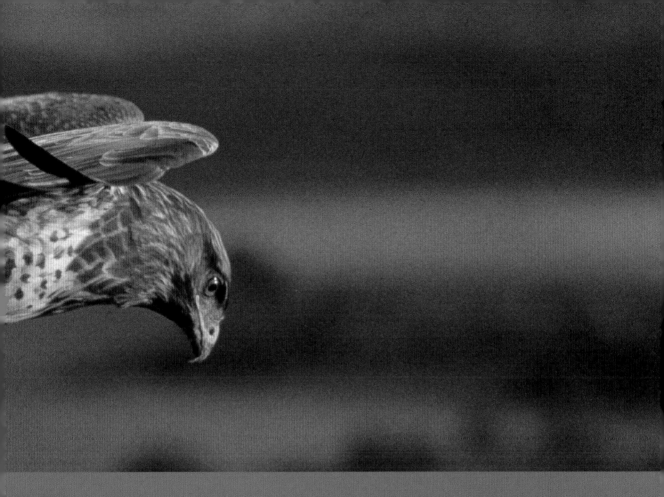

such a large bird of prey. On warm spring days several birds can often be seen soaring up in the air on their broad wings, taking advantage of currents of rising warm air known as thermals, produced when the sun heats the surface of the Earth.

Throughout the year, but particularly at the start of the breeding season in early Spring, Buzzards indulge in an impressive and often noisy aerial display, the male and female sometimes locking talons as they fly around each other. They then get down to the serious business of breeding: either building a large nest out of twigs lined with moss, or just doing a few running repairs to the old nest – Buzzards often return to the same nest year after year.

Buzzards lay two or three eggs, but unlike most songbirds, which wait until the full clutch is laid before they begin to incubate, they – and many other birds of prey – follow a different course. Eggs are laid two or three days apart, but incubated immediately, so that when the chicks hatch they are very different in size. The strategy makes sense, given that the Buzzards cannot predict the availability of food.

So in a good year, when there is plenty of food available, two or even three chicks will survive; while in a bad year only one (or in a worst-case scenario, none) will make it. The apparent 'bullying' behaviour by the larger chick towards his smaller sibling – which in some cases can even end in the younger bird's death by starvation – is known as the 'Cain and Abel Syndrome' after the Biblical brothers, one of whom murdered the other.

Buzzards feed on a wide range of prey: including small mammals (especially rabbits and voles), birds up to the size of a young pigeon or crow, and even smaller stuff such as earthworms and lizards. They will also feed on carrion if it is available. When food items are brought back to the nest the adult bird will rip pieces of meat off and feed them to the chicks, especially when they are small. As they grow bigger and stronger, the chicks are allowed to feed for themselves: good training for when they will have to get their own dinner!

Devon is quite a hotspot for birds of prey, and several other species have been recorded on or over the farm. Oddly perhaps, Kestrel and Sparrowhawk are not present in very large numbers – surprising in the case of the Sparrowhawk given the amount of potential prey. However, perhaps because of its damp climate, Devon is not known as a stronghold for this species.

Blue Tits

Kate Humble

What *would* we do without them?

Without doubt, the most popular characters to appear in the various live events, from *Wild in Your Garden* to Springwatch, have been the various families of Blue Tits. Over the years we have marvelled at their antics, admired – or occasionally worried about – their parental care, and frequently waited with bated breath to see whether their chicks would survive the night. Together with their close relatives, the larger Great Tits, they have provided more entertainment than most soap opera characters – and all this without a single appearance on 'I'm a Celebrity, Get me Out of Here!'

Tits are the classic nestbox birds – which makes them ideal subjects for the round-the-clock monitoring and camera observation required by Springwatch. They are also amazingly tolerant of the occasional but necessary intrusion into their lives required when placing cameras inside a nestbox. This makes them

Blue Tits may be one of our best known and commonly seen birds, but that doesn't make them boring. Over the last three years it has been the fortunes of the various Blue Tit families nesting on the Fishleigh estate which have provided some of our most dramatic moments. In 2004, our first year at Fishleigh, we lost our hearts to Scruffy. She had built a feather lined nest in a nest box in the woods, not far from the Badger sett and laid her first eggs at the beginning of May. A week later she was incubating a clutch of eight eggs – a fairly typical clutch size for a Blue Tit. These little birds won't live for more than a year, two at most, so it is vital for them to raise a large, healthy family.

Scruffy took her duties very seriously. She incubated her eggs for two weeks until the first three hatched, followed by the rest of them the following day. By the time we did our first live programme, a week later, poor Scruffy was not looking her best for the cameras. Her chicks were now a week old and had about another week before they would fledge. They were still blind, but had voracious appetites and although Scruffy was helped with feeding duties by her partner it was she who appeared to be taking the brunt of the pressure. The feathers on her head started to get particularly ragged and worn as a result of intense foraging amongst branches for caterpillars to feed her hungry brood and constant trips in and out of the nest box. She also spent a great deal of time in a rather undignified position, head town, tail up, cleaning her nest and removing parasites. A couple of days later the chicks began to open their eyes. They are not very lovely to look at at this stage. There might be the earliest sign of feathers, but essentially they are little bald, scrawny reptilian looking creatures with outsize beaks, lined, helpfully, by a bright yellow gape, which gives the adults a clear target to aim the food at in the gloom on the nest. Both adults were feeding the chicks, and they were recorded coming in to the nest box about eighteen times an hour. This is not as frequently as you might expect with such a young brood, but the quality of the food was clearly good – juicy green caterpillars, high in protein and perfect growing food for chicks. They flourished.

At the beginning of our second week on air, poor Scruffy was almost bald and by contrast her chicks were covered in the bright blue and yellow downy plumage typical of youngsters this age.

perfect subjects for live TV – indeed the distant ancestors of the Fishleigh Blue Tits were stars of the very first series of *Bird in the Nest* back in the early 1990s.

Things have moved on since then, of course, and the miniaturisation of cameras and lighting now enables us to see the nesting birds at all angles, without causing any disturbance.

The drama of the nesting Blue Tit families is so compelling because, as Bill and Kate frequently point out, this is the only chance these birds will get to breed – certainly this year, and quite possibly during their entire lifetime. Quite a few songbirds – notably the thrushes, Blackbird and Robin – have two or more broods during the course of a single breeding season (Blackbirds, for example, can have up to five broods a year).

This means that should a nesting attempt fail – perhaps because cold weather reduces the available food supply and the chicks starve, or the nest is predated by an intruder – the birds will get a second chance. It also means that when things are going well – warm, settled weather bringing plenty of food – multi-brooded species get a chance to raise a really large number of young.

Blue Tits just don't get that opportunity. Although in warmer parts of Europe, where the breeding season is that little bit longer, a few Blue Tits do manage to raise a second brood of chicks, that is very unusual in this country. So for the Blue Tits on the farm, along with the other three-and-a-half million breeding pairs in Britain, this is 'make-or-break' time.

The Blue Tit is a very common and widespread bird in Britain as a whole, including Devon, where it is only absent from the bleak, open country of Dartmoor. It is one of the commonest breeding birds on the farm, thanks partly

wonderful comic tufts above their eyes, making them look like little plump, pompous old men with unruly eyebrows. They were only a few days from fledging when we received some heart stopping news. The people monitoring the nest box cameras could only see six chicks. Had Scruffy, despite her Herculean efforts, been unable to bring in enough food to keep all eight alive? We were all glued to the monitors, desperately hoping that as the chicks had grown there simply wasn't room for all eight of them to be on view, beaks agape at once. A tense few hours followed until a sharp eyed observer spotted that that was precisely the case. Two of the chicks were hidden from view under the others, but a sort of rota seemed to be in place and all of them were getting fed. All eight fledged successfully a few days later, leaving the nest box with a frantic fluttering of their new wings and landing, not altogether gracefully, in the canopy where they continued to be fed by their proud parents. Scruffy, bald and tatty, could now begin her annual moult and would soon be back to her fine, feathery self again.

Scruffy's nest box was taken up the following year by another family of blue tits. Nine chicks had hatched in the middle of May and it was clear from the start that they had excellent parents. The chicks were clearly strong, very healthy and were being so well looked after they seemed to be developing particularly quickly. Peter Robinson, the ornithologist at Fishleigh, rings as many birds as he can every year to keep a record of their fortunes. The adult male – although Blue Tits appear identical the male's plumage is a brighter blue – had a ring so we knew his history. He had been born two years previously a kilometre and a half away on the other side of the farm, one of a brood of ten chicks. Both he and his female were constantly in and out of the nest box with caterpillars – in a one hour period they were record-feeding the chicks over forty times. Go out and have a look for caterpillars in the spring and you'll get some idea of how hard these birds were working!

By contrast a Blue Tit family that had taken up residence in a sparrow box on the side of the cowshed wasn't fairing nearly so well. As both broods had hatched within a couple of days of each other we decided to follow and compare the progress of both families, Bill 'adopting' the woodland family whilst I watched, with increasing despair, the desperate story of the cowshed family. A

to the abundance of suitable food – which in turn is because of the abundance of mature trees, especially oaks. The other reason Blue Tits are doing so well there is because they have taken avidly to the large number of nestboxes put up by ornithologist Peter Robinson.

Peter has watched the number of Blue Tits breeding in his nestboxes steadily increase over the past few years, from 38 nesting pairs in 2002 to 49 in 2003, slightly down to 43 in 2004, up again to a record 52 in 2005 – thanks to gloriously fine weather coinciding with the first Springwatch. In 2006, the total dropped again, to 45 pairs.

Like Blue Tits all over the country, the birds on the farm spend the winter months in loose flocks, often associating with other members of their family such as Great, Coal and Marsh Tits, as well as a range of small, insect-eating species such as Goldcrests and Treecreepers. They keep in touch with each other using a range of high-pitched 'contact calls', which helps to attract their fellow birds to a productive source of food, and also keeps the flock together, giving each individual the best chance of avoiding predators.

Blue Tits are, of course, one of the most frequent and familiar visitors to gardens, in rural, suburban and even urban areas. Again, they often arrive in flocks, and will take part in a well-established 'pecking order', in which larger birds such as Great Tits, Nuthatches and the powerful Great Spotted Woodpecker take precedence when it comes to space on the feeder. Blue Tits do punch above their weight, though – perhaps due to the sheer numbers or their pugnacious attitude – and will often hold their place on the feeder despite attempts by larger birds such as finches and sparrows to shove them off.

If asked how many Blue Tits

clutch of eight eggs had hatched only a couple of days after Bill's family, but within four days, only six chicks were left. We assumed, although hadn't seen, that the two dead chicks had been removed by the adults. This is important, because leaving a dead chick in the nest increases the risk of disease and parasites which will put the rest of the brood at risk. The remaining chicks were far less developed than Bill's and seemed much weaker. It soon became obvious why. They were being fed far less frequently and mainly on bits of seed. Although seeds are great food for adult birds, they are less palatable and rich in protein for growing Blue Tit chicks. What my family desperately needed was caterpillars and lots of them. The chicks were constantly hungry, begging even when there was no adult present. We were beginning to suspect two things. We had only ever seen one adult bird – a female. Was this a single parent family? Had the male died, or perhaps, which happens very occasionally, gone off and had another family with another female? It appeared, too, that our female was very young and inexperienced. This was almost certainly her first brood and without the support of another older bird she was floundering.

As the days went on the states of our two Blue Tit families couldn't have been more different. Bill's continued to be fed regularly on caterpillars and were thriving. The nine chicks all had their feathers and were beginning to show-off and stretch their wings. When they weren't being fed they sat contentedly in their nest, alert and active, preening their feathers and jostling for position. My six chicks had been reduced to four. Another two had died and the remaining chicks, far from being little bright feathery balls, were still bald and listless. There only appeared to be one adult feeding them but she was not bringing in much and what she did bring was not going to do anything to help the growth of her dwindling family. It was heartbreaking to watch.

Over the weekend after our first week on air, all nine of Bill's chicks fledged. The first four left the nest more or less together, the other five left gradually over the rest of the day. One of my chicks also left the nest, although sadly not under its own steam. It, like the other four previously, had simply been unable to survive on such a poor diet. We could hardly bear to watch the traumatic sight of the female struggling alone to remove the dead chick from nest box. She seemed to have hardly any strength left herself and more heartbreaking still, things weren't looking very good for

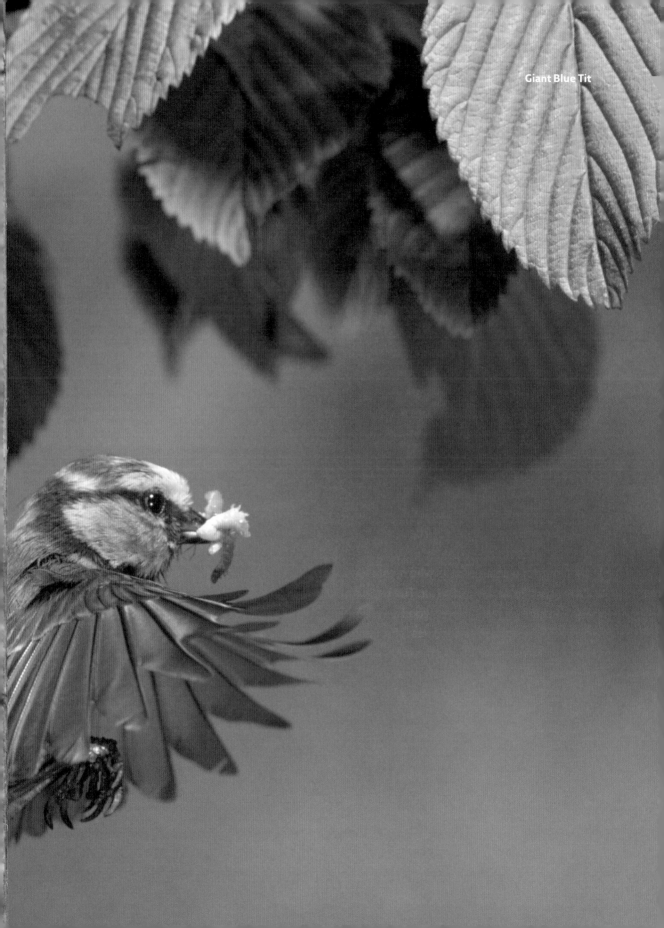
Giant Blue Tit

especially at the larger end. During the laying period the parents will often cover the eggs with the nest lining, perhaps as a precaution against predators that might raid the nest and take the clutch.

On the farm, Peter's studies have shown that the number of eggs laid does vary considerably from season to season: in 2002, a good year weather-wise, the average clutch was more than ten; whereas the following year, when wet weather had a dramatic effect on breeding success, the average clutch went down to about nine. Surprisingly, perhaps, the average clutch in the fine year of 2005 was down to eight; possibly because of cooler, wetter weather during May when the birds were laying their eggs.

Once the clutch is complete, the female will begin to incubate the eggs; though not necessarily immediately. Sometimes she will delay incubation for several days; but once she does begin, the process takes between 13 and 16 days. When the chicks hatch, the real hard work begins: adult Blue Tits must bring about 12,000 items of food – mostly moth caterpillars – back to the nest during the two to three weeks the young remain in the nest. That works out at between 550 and 750 items per day; or about 300 to 400 items per adult. Given that there are about 15 hours a day when it is possible to find food, this means that some adults have to find, pick up and bring back a caterpillar every two minutes.

During good years, experienced pairs are able to do this; but if the weather is wet and miserable, or the birds are not very experienced parents, then things get much trickier. Since we began live broadcasts in 2003, we have had one very bad year (2003), two good ones (2004 and 2005) and one average one (2006).

Peter Robinson's long-term

We weren't sure that the Blue Tit drama of that year could ever be surpassed. 2006 was our third year at Fishleigh and after the success of the previous series, we were all a bit nervous that we would be able to pull it off again. We needn't have worried. With Blue Tits around there is, it seems, rarely a dull moment.

By the end of May in 2005 our Blue Tit eggs had hatched and the chicks were about a week old. The chicks are usually in the nest for 14–15 days before they fledge, so by the time we went on air we knew that in all likelihood they would have left by the end of the first week. But May 2006 was the wettest since records began, with rainfall a staggering 25% higher than normal. This made life pretty miserable for our technicians who spent much of the weeks leading up to *Springwatch* going live, floundering about in the mud trying to lay cables and protecting nest box cameras from the deluge. And it wasn't just our crew that were suffering. Peter Robinson, Fishleigh's ornithologist, said this was a bad year for the birds, with many losing chicks and even whole broods. We had cameras on two Blue Tit nests, but as yet the eggs hadn't hatched, putting them at least two weeks behind last years families. But this delay meant we were able to capture on camera something that we never had before; that magical moment when the eggs start to hatch. The two nests, one down in the woods and one in the garden, were very different in style. The woodland adults had built a beautifully constructed nest of moss, much of which had been raided from our bird bath. The bird bath is set in a tree stump and has a camera mounted beside it, disguised with moss. It didn't take the adults long to completely uncover the camera but at the same time the camera was recording them. Had we decided to press charges for the wilful stealing of BBC equipment we had all the evidence we needed!

In this lovely, inviting looking nest, the female laid seven eggs. Six hatched the day before we went on air but we could see no sign of the other egg.

In the garden another pair had built a rather more shambolic looking nest – a messy tangle of leaves and twigs and horse hair. Their eight eggs had been laid a couple of days later than the woodland family's, but seven had hatched by the time we did our first live show. The late hatching of both clutches meant we could follow the development of the chicks literally from their first moment out of the egg. And even in those very early days it

study of the farm's birds has produced an important series of statistics, proving just how productive the Blue Tits can be. In the five years so far (2002-2006) the number of chicks fledging has never fallen below seven per nest, and has been as high as nine. The best year ever was 2006, when the proportion of hatched young that managed to fledge was a whopping 98% – showing just how productive the farm is for the tits' favourite food.

But even if a full brood does manage to fledge and leave the nest, the dangers are far from over: predators are always on the lookout for an easy meal, and many baby Blue Tits only survive for a day or two after leaving the safety of the nestbox. However, as a scientist once explained: if they didn't, after a few years we would literally be knee-deep in Blue Tits.

Birds like the Blue Tit have large clutches and broods precisely because the chances of survival are relatively low, especially compared to larger species. If even one or two survive until the following breeding season the parent birds will have done their job well.

This may be the only chance they get to pass on their own genetic heritage: the mortality rate of Blue Tits is very high, and not many individuals live for more than two or three years. However, conditions on the farm do seem to be excellent: Peter's ringing studies have revealed that some birds there do live for as long as five years.

became clear that once again we had a Blue Tit family set to flourish and another whose future looked decidedly less rosy. And once again, I chose to adopt the family that was to keep me and everyone else on tenterhooks right up until the last show of the series.

Bill's Moss family, as they became know, caused a bit of confusion early on. Initially we thought there were seven eggs and six hatched, but our third day into the series the Moss family had suddenly increased to seven chicks and one unhatched egg. The deep mossy nest meant it was easy for these tiny new chicks to get lost from view. So now we had two families of seven chicks, mine younger by just three days. Three days makes a huge difference to the appearance and development of the chicks, we discovered, but so does the abilities of the parents. Both families had two adults feeding the chicks and both were predominantly feeding caterpillars. But the Moss family were being fed over 40 times an hour, and mine only 17 times an hour. The Moss family were being fed perfect size caterpillars and both adults seemed adept both at feeding and making sure all the chicks got fed. By contrast my adults were struggling rather, partly because they obviously believed that size was everything. They brought in caterpillars so large they could barely carry them and the chicks struggled to swallow them at all. I was worried that they were developing much slower than the Moss family. My chicks were still bald and helpless, whereas the Moss family chicks were already getting downy feathers, their wings were in pin and they were much more active and lively. Could being three days older really make such a significant difference, or were my family doomed? We could only watch and wait.

By the time the Moss chicks were thirteen days old, their feathers beginning to appear out of the pin feathers and they were at the stage when baby birds look their most endearing. They were growing rapidly and getting increasingly active and being fed a staggering 78 times an hour! My family, at 10 days old, were less developed than the Moss chicks had been at that age. Their feathers were still in the pin stage and they were being fed less than half as regularly as the others. The adults were still bringing in vast caterpillars, which the chicks were better at handling now, but it was still not a pretty sight to watch a still semi-transparent chick struggling to swallow a great green caterpillar almost as big as its own head.

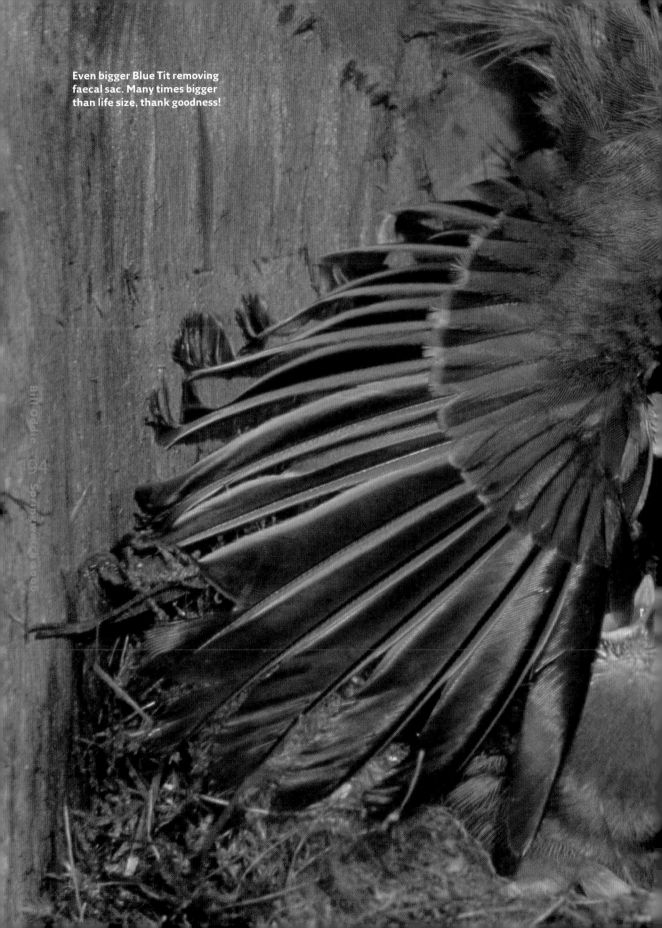

Even bigger Blue Tit removing faecal sac. Many times bigger than life size, thank goodness!

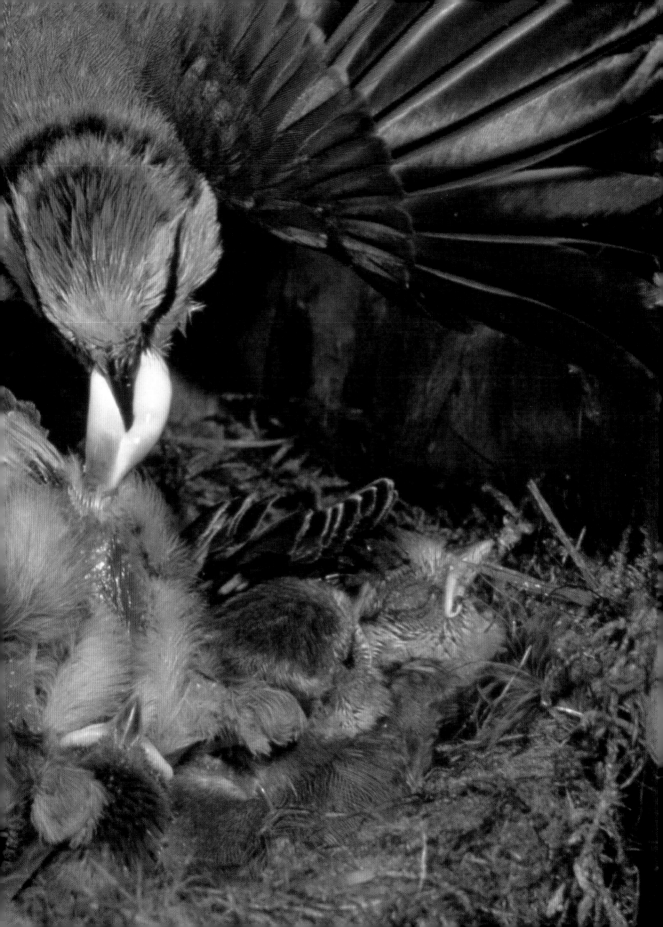

By the end of our second week we knew we would soon be saying goodbye to the Moss chicks. At fifteen days old they were fluffy, their wings were fully developed and they were constantly preening and stretching and hopping around the nest. They had been a joy to watch, a textbook family doing everything right. Sure enough, that weekend all seven chicks fledged in quick succession and our cameraman got lovely shots of them looking fat, healthy and slightly startled in the branches of a tree, the adults still in attendance. On Monday morning, the beginning of our last week on the farm, someone came running to our caravan to tell us that one of my chicks had just fledged. "It's too early, surely," I said and we rushed to gather round the monitors. Sure enough, only six chicks remained in the nest, but looking a lot more healthy and active than they had when we'd left the previous week. All that is, except for one. Now that there was bit more space in the nest box we could see that one chick was far less developed than the others and significantly smaller. A runt. But if one chick had fledged would that mean the others would soon follow suit, including the little runt, who was not big or strong enough to survive in the outside world? Once again it was the Blue Tits who were to keep us in awful suspense.

None of the other chicks did leave the nest that day, but three left one after the other early the following morning. That left just two and the little one who had now been given the less-than-flattering name of Runty. Sadly it was all too suitable. Much less active than the others, Runty sat hunched at the edge of the nest whilst the other two stretched and preened and hopped, fluttering up towards the nest hole, preparing to take that final leap of faith that would take them out of the nest box and into the garden. It simply didn't look like Runty was ready to follow them, but what would happen if he stayed in the nest box alone? Would the adults continue to feed him or would he be abandoned in favour of his siblings who would still be reliant on their parents for food. Would Runty simply get forgotten?

By the time we went on air at 8 o'clock that evening the two bigger chicks had fledged. Runty was still in the nest and although the site of him looking forlorn and lost was almost more than we could bear, we desperately didn't want him to leave either. It was just too late in the day and the adults would not be around to look after him. He simply wouldn't survive the night. But his survival wasn't assured even where he was. He needed food and throughout the

programme we watched anxiously for one of the adults to come in with food for their last little chick. They didn't appear. Yet again we were faced with a terrible quandary. Should we feed Runty, post mealworms into the nest box, try and prevent him from leaving during the night? We were so torn. Here was a little bird that we had seen emerge from the egg and watched every single day of its short life. Could we really leave him to his fate now? At 9 o'clock we went off air, our final image that of Runty, cheeping tragically in his lonely nest. The *Springwatch* message board was flooded with e-mails. Thousands of people wrote in, sharing with us the dilemma. Some were adamant that we should intervene, others equally virulent that we shouldn't, but nobody, nobody wanted Runty to die. Needing a nerve-calming drink, I went to the local pub with many of the crew. The pub is run by a tirelessly cheerful woman called Bev who has looked after us all for the last three years. As she handed my drink over the bar she gave me a Look. "If that little bird dies I'm not sure I can ever forgive you or myself." "Bev," I said quietly, "I can't do anything. We've agreed that we mustn't intervene. However, if you decide to sneak down to the farm under cover of darkness with a pocket full of mealworms, I won't tell a soul."

I have no idea what Bev decided to do but the following morning I went straight to the monitor room. The nest box was empty. "An adult did come back last night and fed him. He fledged at 6.30 this morning. Pete got some lovely footage of him in a tree being fed by Mum." So you see, there is nothing boring about Blue Tits!

Runty - just fledged and being fed by his mum

Tuesday 13th June

It bucketed down all morning. Cameramen have been sent out to capture the beauty of the rain. Glistening water droplets dripping off shiny green leaves, rainbow circles in the lake. You know the sort of thing. Very relaxing images, very New Age. However, the deluge could have serious consequences for some of our birds. But then again it has already occasioned some delightful scenarios, especially at the Goldfinch nest. Goldfinches are dazzling little birds at all times, but in the rain their colours seem positively glowing. What's more, the female has turned herself into a feathery umbrella by spreading her wings over the nest to keeps her chicks dry. The scene provoked an audible "aw" when she shuffled her position, and for a moment revealed her little family, tiny mites, still almost featherless, except for fluffy little tufts on each side of their heads, and with their eyes tight shut, as if dreaming of a sunnier day. The readjustment also momentarily revealed the marvel of the nest itself – made of moss and lichens, deftly spun together with spiders webs. How clever is that!?

The picture was so enchanting it was almost shocking to be reminded that the downpour could be fatal to the tiny family. If the mother were to leave her chicks exposed to the elements, they could very easily chill and die. Having had their cosy little bed tidied one of the youngsters presented its rump to its mother, and produced a neat "faecal sac". Normally, she would have taken it in her beak and dropped it some way from the nest. But, if she did that, even a short absence would leave the chicks vulnerable. On the other hand, there was no way she was going to let it soil the newly primped lining. So what did she do? She ate it! Now that's what I call maternal devotion. Almost biblical isn't it? Greater love hath no mother than that she eats her children's plop plops!

Meanwhile, there was a major drama unfolding in the Humble Tits nest box. The 7 chicks were in the process of leaving home, but the whole business was very protracted. Often, once one fledgling chick goes, the rest will rapidly follow. But not this lot. They had been leaving at what seemed like ever increasing intervals since first light. By early afternoon, there were still three more left to go. 2 normal youngsters and what is rather harshly termed in the natural world a "runt". It is not uncommon in bird families. It may be simply the outcome of a late laid egg. In

extreme cases, it is a rather macabre insurance against food shortages. Small birds generally wait until the clutch is complete before incubating, so that the chicks hatch at more or less the same time and are therefore the same age and size (except, in this case, one of them). Barn Owls, however, continue incubating throughout the laying process. The result is that eggs hatch at different times, and the chicks are of different ages and sizes. Sometimes the range is quite extreme. In *Springwatch* 2005, we had a Barn Owl family of six that ranged from the oldest – almost as big as its parents – alongside the teeniest – which was hardly bigger than a sparrow. Fortunately, all of them grew up and left the nest in one piece. For that mercy, the smaller ones could certainly thank Field Voles which were having a productive summer, and thus provided enough food for all the owls that loved to eat them. If, on the other hand, the voles had been in short supply, only the larger owl chicks would have been able to find enough food to keep growing. And, if they had run out of voles, they would gleefully have resorted to consuming the nearest emergency food supply – their baby brothers or sisters! Blue Tits, on the other hand, are not known for their cannibalistic tendencies (that would taint their cutesy image somewhat eh?) But, nevertheless, the very definition of a "runt" is that it gets fed less. This is probably because it started off small anyway, and is therefore not as assertive as its siblings. If a chick doesn't make a fuss it doesn't get fed. Our littlest chick – already christened "Runty", which we felt was a bit more endearing than simply "runt" – didn't actually look emaciated. He wasn't that much smaller or indeed slimmer than the others, but he did look decidedly peaky. His colours were rather washed out, as if he lacked the bright lemon yellow pigment, almost luminous on the rest of the family. Most worryingly, his wing feathers were far from neat or complete. We watched anxiously as the parent birds popped in and just as quickly popped out again. They were NOT bringing food. Encouraging the kids to leave, that was the idea. "If you're getting hungry, come outside." Judging by their plaintive squeaks and their gaping beaks, they obviously were very hungry. For a moment, we thought the two bigger ones were about to make a meal of their little brother. They both had an exploratory peck at Runty, but to our – and his – relief he obviously failed the taste test. But he clearly wasn't happy. At one point he climbed up

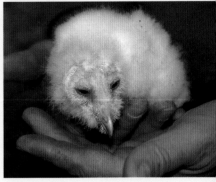

It's not only Buzzard chicks who are tempted to eat their brothers or sisters. If there's a vole shortage, then the smallest owlets have every reason to be nervous … To quote a Barn Owl friend of mine:
"Times were tough
And so was my brother!"
(But … better than nothing.)

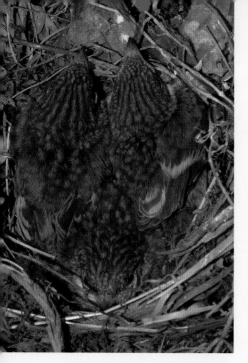

**Casanova's three chick family,
doing so well he left them to it**

to the hole and peeped outside – surely he wasn't being driven out? He may have felt like leaving, but he couldn't bring himself to do it. He almost immediately 'fell' back inside, and one of his brothers or sisters took his place at the "exit".

Mid afternoon, and the three of them were still in the box. It was becoming more and more likely that Runty was going to become a central character on tonight's show. But would his story be a weepy, or have a happy ending? Would he be left to starve? Or if he did try to leave – would he be able to fly? If he merely crashed to the ground he was surely destined to become dinner for something lurking in the undergrowth.

That evening

Our pre-titles tease (the bit before the opening credits) told of guaranteed drama. "On *Springwatch* tonight ... The saga of Runty the little Blue Tit." The situation was announced like an ominous news bulletin: "All day we have been watching the Humble Tit youngsters leaving the nest. This morning there were seven. By late afternoon three. Earlier this evening, two more fledged, leaving a single Blue Tit chick in the nest box. Alone. He is small and feeble. His name his "Runty". What's to become of him? During the next hour we may well find out. Whatever his fate, you will be witnessing it live. Let's just hope he is live eh?!" Sorry, couldn't resist it. Bad taste I know, but great telly. I mean, come on, when did you last see a housemate snuff it on *Big Brother*? Frankly, it wouldn't surprise me one bit if they did allow such a thing to happen. They might even try and make it happen! I can't say I am a huge fan of human "reality shows", but for those who are, if you want real reality ... Stay tuned to *Springwatch*.

So what happened?.

Whenever we cut to Runty during the show, heartstrings were mercilessly tugged. He was a forlorn little ball of fluff, in a big lonely box. What 'was" to become of him? Would his parents abandon him completely? Would he ever be able to clamber up to the hole again, let alone achieve a feeble flutter to a nearby branch? The relatively good news was that he still looked "healthy", and – even better – one parent (or both, but never together) did pop in now and again and appear to feed him. But did they really? On closer inspection, it seemed they were almost teasing him by sticking an empty beak into his gape as if to

enforce the message: "We told you – If you want food – you'll have to come outside". Kate claimed that she had seen at least one small caterpillar delivery, but I wasn't convinced. Then, as the evening wore on, even the sporadic visits ceased. To add to the pathos, Runty tried to snuggle down in the nest, as if he was either imagining his family was still there, or was trying to convince himself he didn't mind being alone. In the final "sign off" piece, I blatantly attempted to break 4 million hearts.

"Runty's parents haven't been back for a while. Maybe they will come and roost in the nest with him. Maybe they won't. It's getting dark outside. He's facing a night totally alone. We do not know what tomorrow will hold in store for him. Neither does he. For him, there may not be a tomorrow. The fact is, he may not survive the night. And if he does, he may face another day without food, unless he plucks up courage to leave the box. But, by then he may be too weak to try. Or even if he does manage to get to the hole – will he just plummet, and be nabbed almost instantly by a passing predator? Which fate is less awful? A quick death in the claws of a Buzzard perhaps, or a slow demise, alone and forgotten."

I cut short of playing "hearts and flowers" on the violin, but I didn't need to embellish the pathos. Runty's body language was enough – huddled up, fluffy, with one tuft of wispy cotton-like feathers on his brow, so young, so helpless, so alone. Not a word was needed. Not a note required. His little face said it all. In the control room, women wept and strong men gulped back their emotions. And in several million homes across the UK, families stared at their tellies and experienced the true meaning of helplessness and the harshness of nature. Mothers comforted their children. If only Runty's mother had been there to comfort him!

Meanwhile ,in the *Springwatch* control room, the producer was punching the air with delight. "Now that's what I call reality television!" As if to encourage our little hero to grasp true stardom by surviving at least another night – and if possible most of the next day or at least long enough to appear on tomorrow's show, someone began a slow chant, which was soon swelled by the inspiring voices of all the technicians in the gallery: "Runt–ee, Runt–ee, Runt—eeee!" Kate and I could just about hear this chorus of encouragement from where we sat in the barn, staring at the screen. Runty was still there. Still breathing. But was he listening too? Answer on page 204!

Barn Owl

Stephen Moss

Without doubt the Barn Owl is one of the most beautiful – almost magical – birds on the farm. The sight of this ghostly white creature floating along the hedgerows at sunset is one of the unforgettable experiences of being at Fishleigh.

Barn Owls have good and bad years – depending on the weather conditions and availability of their favourite food, voles, during the key months of the breeding season. 2005 was a vintage year for the species, not just down in Devon but all over those parts of the country where the Barn Owl still has its strongholds: mainly the rural areas of England, Wales and south-west Scotland.

That year, we saw Barn Owls almost every day during our time on the farm; and often caught sight of one or two hunting as we drove back to our hotels or B&Bs after the show was over. What a contrast the following year, 2006, when hardly a Barn Owl was seen throughout our stay.

Not surprisingly, with so few owls around in 2006 we didn't feature them on the live show. But viewers had a treat the year before, when our family of Barn Owls provided some of the greatest pleasure, entertainment and fascination of the whole event.

Mind you, we nearly didn't get them on air at all. That's because they weren't actually on the farm at all, but in a tumbledown cottage belonging to a neighbouring farm. The farmer kindly gave us permission to put cameras in, and we then spent a few days overcoming technical problems to get the pictures back to the main Production Village.

The problem was that as it was over a mile from the farm itself, we couldn't use the conventional method of cables to get the signal for the live pictures back to base. Instead we had to beam them back using microwave links – not quite the same technology as we use to heat up ready meals, but just as mysterious!

Once we did get the pictures up and running, we were amazed at what we saw. A family not one, or two, or three or even four – but five Barn Owl chicks, standing in a row as if lining up for a family photo.

Every now and then one of the adults would appear mysteriously at the back of the cottage, and the chicks would get extremely agitated – they knew that food was on the way. The adult would bring in a vole, and then the fun would really start!

Baby Barn Owls have an unpleasant habit of eating their smaller siblings if food is scarce – yes, it may sound rather unpleasant but it does make evolutionary sense. The adults cannot predict how much food is available, so they tend to lay more eggs, producing more chicks than they think they are able to rear. If food is more plentiful than they thought, all five will make it; if not, the smallest go to the wall, providing much-needed energy for their older brothers and sisters. Nature can be cruel sometimes...

So imagine our delight when, almost every time any food was brought in, the tiniest chick would make a grab for it – and often succeed. Having got his chance, he would then wolf the rodent down his gullet – despite his dinner appearing almost as big as he was! We're delighted to say that all five chicks managed to fledge successfully, leaving the nest about seven weeks after they hatched.

The bad news is that a good vole year is often followed by a bad one, as their populations run in cycles of boom and bust. When this is combined with a cool and wet spring, as happened in 2006, the Barn Owls are in trouble. Fortunately the good years appear to outweigh the bad, and the Barn Owl population is currently on the up, with about 4,000 pairs breeding in Britain.

This is nothing like the numbers there used to be, as low-flying Barn Owls often get hit by road vehicles, and have suffered from the huge rise in traffic over the past few years. Fortunately many farmers and other rural landowners are helping Barn Owls by putting up specially designed nestboxes where they can raise a family.

People often wonder how Barn Owls hunt and catch their prey. Unlike Tawny Owls, which live and hunt over a very small home range which they know intimately, Barn Owls tend to hunt over a much wider area, and in more open country such as field edges and marshy areas.

Their plumage – especially their wing feathers – is particularly soft, enabling them to fly low above the ground without making a noise. They use that extraordinary heart-shaped face to concentrate the sound of their rodent prey, and can hear the slightest rustle. Pinpointing the source of the noise, they then pounce.

As a result of their need to float low over the ground they are incredibly light – despite having a wingspan of almost a metre they weigh just 250 grams – about ten ounces. Though silent on the wing they can be very noisy at rest, earning the alternative name of Screech Owl for its blood-curdling noise. Because Barn Owls often perch in towers of churches or old buildings, they may be the source of ghost stories – invented to explain a pale, ghostly apparition making a bizarre noise!

Although still relatively scarce in Britain, the Barn Owl is one of the most widespread and cosmopolitan species in the world, found on six of the world's seven continents (the exception being, of course, Antarctica where there is nothing for the owls to eat!)

Wednesday 14th June

"Runty lives OK?"

10.45 a.m.

I have been back at the 'camp' for half an hour, but I haven't dared ask anyone about Runty. I have decided that it would be best to wait for the morning production meeting, where we can all hear the news together, and share our feelings. Grief, or relief?

An hour or so later. After the meeting

RUNTY LIVES! First we cheered, then we listened to the story so far.

Dawn broke. He was still there. Not looking exactly blooming with energy, but no worse. During the next hour he appeared to perk up visibly. And audibly. He had managed a plaintive little trill. Presumably the parents had been listening somewhere outside. They responded by feeding him. 6 times. Almost before the watching eyes he began to look fluffier, livelier, even a bit bigger, or – dare we say it? – more "grown up". Then at 6.50 am, he took his first tentative step towards the big wide world. Well, the nest box hole actually. A couple more shuffles got him to the edge of the exit. One small hop, and he had his beak sticking outside. Another hop and he was literally teetering on the brink of "freedom". Deep breath – 3, 2, 1, and ... he was out and off. Not exactly up and away, but at least not too rapidly down. The remote camera not only captured the whole brave and quite inspiring episode, but also a real living cameraman managed to find Runty perched in a nearby tree, well hidden behind leaves, but occasionally fluttering his wings and uttering tiny squeaks which basically pleaded: "I'm hungry!". His parents could well have ignored him. "You must get your own food. You've got to learn sometime. So, start now." Harsh but true. But no, instead he was soon rewarded when mum or dad brought him a juicy caterpillar not only nourishment but also a metaphorical pat on the back and a parental "well done son" (or possibly "lass"). And just to prove they loved him as much as we on *Springwatch*, and 4 million viewers, had come to, they brought him several more caterpillars, before our cameramen answered a similar need and went off for his breakfast. Well done him. Well done mum and dad . And most of all, well done Runty. A child star if ever there was one!

Of course the public would not know of this happy ending until

the evening programme, and I had a feeling we'd be keeping them in suspense until the very last item too. Meanwhile, during the rest of the day the extent of the nation's concern became evident. Literally hundreds of messages flooded into the website. Worries about Wayne Rooney's metatarsal were obliterated by concern about the fate of Runty. All of them expressed the plaintive plea: "Please, don't let him die". Though – rather contradictorily – there was a split between those who agreed that we – most probably Kate – should feed him mealworms, and those who considered this to be "interfering with nature". It does rather beg the question: if we didn't literally provide food for him – what else exactly could we have done to assure his survival? Have a word with his parents? Or put him up for adoption – Blue Tits only need apply. It has to be admitted that now and again a note of slight frivolity was discernable. For example we were contacted by a group of folks who claimed to have formed the RNLI. It was to do with sending a lifeboat to rescue him. The initials stood for Runty Needs Live Insects. Quite so. And he got 'em – well, caterpillars – but the public didn't know that. Yet.

Inevitably and predictably, I myself got a bit silly in rehearsal, claiming that we'd received all sorts of intimidating correspondence. Death threats from a family of tit lovers from Sicily: "If Runty dies – so do you!" To authenticate the threat, a severed squirrel's head had been left on Kate's pillow. I also warned of the fanaticism of the "Release the Heatherley One" campaigners , and reported late news that 3 blokes from "Fathers for Justice" had just been evicted from the nest box. I thanked the public for so generously sending food parcels: mealworms, dried cockroaches, bags of peanuts, and half a leg of lamb, which we explained was not appropriate food for Blue Tits, but would find a home on the Oddie household's table for next Sunday's Lunch.

There were also offers of money coming in – from 2p from various children, to £5 from a Mr. T. Blair, donated only "on condition that Mr. Oddie ceases all mention of the Iraq War." Of course, Mr. Oddie rejected the deal. Other viewers asked, quite reasonably, why the National Lottery's Breathing Places Fund (as promoted by *Springwatch*) couldn't be instantly renamed "the Runty fund" and cover any costs of saving him.

Alas, an official statement from the Lottery Committee ruled this out: "The Lottery does not support applications on behalf of

Blue Tits, unless they are gay, belong to an ethnic minority, or run a mime troup."

Now if all that skittishness sounds less like a rehearsal for a natural history programme and more like a stand up comedy routine – it only provides further evidence of what I have already admitted: afternoon rehearsals quite often get a bit silly.

But that doesn't mean we don't take things seriously. Far from it. Indeed quite the opposite. Without getting too grandiose I know I speak for all of us on the team that we consider the mission of *Springwatch* is not merely to "entertain", but also to inform, educate, enthuse and inspire. All big and serious ambitions. We also share another belief, that if you don't retain the viewers attention then it is all in vane. If they get bored and switch, we've lost. To enforce the point I am making and how it affects what we try to do on *Springwatch*, I once attended a seminar of program makers from all the TV companies. The title of which was "Can educational television also entertain?" To which the response surely is, not only can educational programmes entertain, they must! Otherwise its like teaching with no pupils. Preaching with no congregation. Inspiring the troops when they've all gone home on leave. I'd like to think that tonight's *Springwatch* exemplifies exactly what we are trying to do. If it did, we reached 4 million people.

Après Show

A lovely one. Really nice balance between sad, serious, silly, spectacular, sentimental – lots of 's' words! Kate and I enjoyed that almost telepathic and clearly affectionate rapport we have developed over the last four years. People who work closely together don't have to like each other for it to be successful. But it's much more fun when they do! Talking of which – as we were driving back to the Hotel, Chiara (my "minder", friend, confidante and surrogate fairy godmother!) and I were revelling in recounting the various joys of *Springwatch*. We all tend to get a bit soppy as we are nearing the end of a series. We agreed that the essence of the very special magic that *Springwatch* has for us for us is that it is a combination of the best of wildlife, with the best of people. It exemplifies and indeed requires what I believe to be some highly desirable qualities. Co-operation, shared enthusiasms and mutual goals. A team effort that involves young, old, male, female, and

"inbetweenies" in both age and gender. Some of it is typical natural history television, photogenically pleasing, intriguing and informative. Some of it is "light entertainment". The techniques involved can be very simplistic, or extremely sophisticated and challenging. The "ethos" sometimes 'cerebral', sometimes very emotional. As they say – all human life is here. And all wildlife too.

The *Springwatch* experience, for me, verges on the spiritual. It is inspirational. I am not religious. I don't believe in a God. I do believe in the wonder of nature of which we human beings are a unarguably an integral part. I also believe in the potential wondrousness of humanity. I suppose that makes me a "humanist." I have heard it argued that to be both humanist and spiritual is a contradiction in terms. This probably depends on your definition of spiritual. Mine doesn't involve deities or religions but it does imply joy, excitement, love, understanding, tolerance, an awareness of good and bad, disapproval of cruelty and the infliction of pain, and suffering, and conversely an approval of all those actions and , events and behaviour that alleviate such negatives and achieve pleasure and joy and comfort. Above all I believe that since it is surely unarguable that all humans belong to the same species, we should therefore be united not divided. But before I get embroiled in a very big discussion, let me just make one statement. There are many things in life that for me symbolise the joyful and positive potentials and achievements of humanity. *Springwatch* is one of them. Others include the making and enjoyment of music; great sporting events; hospitals, charities. It is in such things that I sense the spiritual strength and joy in life. Things the human race should be proud of! This is my religion. *Springwatch*, for me, is a little miracle. What's more, it is undeniably real. It definitely happens! Three times so far, and more to come!

Meanwhile ... Tomorrow is this year's final show.

Team spirits – and quite a few beers as well

Sharks and Eagles

Kate Humble

OK, you're a Basking
Shark. But what do
you do when you're
NOT basking?

Each one-hour *Springwatch* programme is made up of a collection of different pieces, a bit like a jigsaw, some live and some that have been filmed in advance. Bill and I will do our updates from the farm looking back over the events that have taken place since we came off air the previous evening. Simon will do the same, catching up with the characters in his particular location. During the months before we go on air there is a frantic round of filming to get other stories – either to include things that we simply couldn't show during a live broadcast, or to show a broader spectrum of creatures than we might find just on the farm and at Simon's base. We have the mini-epics, filmed by specialist cameramen, who spend many patient hours in the field trying to capture the intricate secret lives of our wildlife preparing for Spring. This is a time of territorial battles, the singing, posturing, preening and fighting. It's a time of nest building and courtship, dancing and bringing of gifts, rejection, persuasion and occasionally coercion all with the ultimate goal to breed and bring the next generation into the world. Each animal and bird has a different style and technique – the mass Romanesque orgies of ladybirds, frogs and toads, the gentile elegance of the crested grebe, the lonely, night-time wanderings of the hedgehog. Hours and hours of footage will be filmed to capture the whole story and it is then the job of producers and editors to turn them into five or six minute films that let us in on this otherwise hidden world. But much of our wildlife in Britain is reliant to a greater or lesser extent on people – whether it is a family who have discovered the benefits both to themselves and the birds by putting up feeders in their garden or those who have devoted their lives to the conservation of some of our most fragile species. The 'passionate people' films show not just what people can do for wildlife, but what wildlife can do and does do for people. Then there are the films that Bill, Simon and I present. These are real treats for us, as we sit down with the producers and give them a wish-list of the things we'd particularly like to see or do. In his decade presenting wildlife programmes, Bill had never seen a mole until he made a film about them for *Springwatch* 2006. My wish for that series was to try and get close to one of the biggest animals we will ever see in Britain and to attempt that, I had to go to Mull in the Outer Hebrides.

Mull is a magical island. As the ferry leaves the bustle of Oban

and ploughs across the steely grey sea it feels as if everything humdrum and ordinary is being left behind and what awaits can only be surprising and unexpected. We docked, drove ashore and into a blinding wall of rain. Not so unexpected, perhaps, as Mull is famously wet, but surprising as we had left Oban in sunshine. Island weather does change quickly and frequently, and hoping that Oban's sunshine was heading our way, we drove to the hotel to await a break in the clouds. It never came. We spent the entire day planning what we would do if only the rain would stop and we could venture out without the risk of the camera getting waterlogged and all of us contracting trench foot. We went to bed feeling pessimistic and fell asleep with the sound of rain pelting the roof.

We woke to skies that wonderful clear, egg-shell blue that seems to come after rain, dripping leaves and sodden grass twinkling jewel-like in the sun. We packed up all our gear and drove down to the dock at Tobermory to meet James Fairbairns. James and his family have been running whale and dolphin watching trips around Mull for many years, but it wasn't whales or dolphins we wanted him to help us find. We were looking for sharks. Basking Sharks visit the west coast of Britain during the summer months, the first ones appearing around late May or early June. They come to feed on our plankton: microscopic animals and larvae that form the very bedrock of the food chain in the sea. Basking Sharks are second only in size to Whale Sharks, the biggest fish in the sea, and can grow up to 7 metres long. They are completely harmless to humans, but unfortunately for the Basking Sharks, they were very useful to humans and that led to a huge decline in their numbers. They were killed for the oil in their livers – one shark could yield a tonne of oil. They are now protected by law and numbers are beginning to increase again. The best place to see them is off the coast of Cornwall, the Isle of Man and the Hebrides. Sightings had been particularly frequent around Mull that summer of 2005, so James felt we had a good chance of spotting one, but my wish went a bit further than that. I wanted to swim with one. There are strict guidelines about approaching sharks and boats are not allowed to get any closer than 100 metres. We would be out in the open sea and so it wasn't a case of me wanting to swim with the shark, more whether the shark would want to swim with me.

Kate's affinity with the sea means she gets to go to some lovely places.

The RIB nosed out of the harbour and into the Sound of Mull. This is one of the prettiest areas I know around the coast of Britain. There are hundreds of rugged little inlets and coves, the water bright blue over the sand, darkening to navy and grey over rocks and kelp. Seals pop their heads out of the water, looking for all the world like aquatic Labradors, and follow the progress of the boat; seabirds wheel overhead, and we scanned the water for porpoises or the tell-tale spume of water that hangs in the air after a whale has exhaled. But what we were really hoping to see was a fin – a dark triangle on the surface of the water that would give away the presence of a basking shark. James stopped the boat and we bobbed around, searching the surface of the sea with binoculars. We were still well within site of land, but sharks often feed near land where the plankton seems to congregate. "There's one!" James' well-practiced eyes had spotted a fin several hundred metres away, moving slowly through the water. Even at that distance it looked enormous. Suddenly I realised what I'd wished for; to get into the cold Scottish sea with an animal hundreds of times my size and weight and that could outswim me without even trying. I looked at Scott, a cameraman I've worked with a great deal, both above and under the water. "You're not scared are you, Humble?" he said, with a grin. "Bloody terrified," I muttered, tugging on my dry suit and trying not to feel like I was on my way to the gallows. Why oh why hadn't I gone to film a dormouse instead? James eased the boat slowly towards the fin, stopping at a respectful distance away. "It looks like it's feeding", he said and sure enough, it's sedate progress at the surface seemed to indicate that it was swimming open-mouthed, trawling for plankton by sifting the water through the filters in its extraordinary concertina-like mouth. I put my fins and mask on and dry mouthed with nerves, slipped silently off the boat. I put my face in the water. The first shock of the cold made me gasp. The sun was lighting up hundreds of thousands of particles in the greenish water. Basking shark food. I kicked slowly way from the boat and then just floated, face down, waiting. Nothing. And then I saw it, a shape emerging from the greenish gloom, getting bigger and bigger, until all I could see through my mask was shark. Its mouth, agape as it approached, suddenly – luckily – closed a metre or so in front of me otherwise I'm quite sure I could've been sucked in without it even noticing. This leviathan passed calmly

just beneath me, its eye making contact with mine for the briefest moment and then it swept past, the tip of its tail just grazing my knee with its final farewell flick. And then it was gone. I took my head out of the water, spitting out my snorkel, beside myself with relief and excitement. "Did you get it, Scott, did you see it?!" "I got a couple of shots, but we're going to need more." "It was like seeing an aeroplane under water, it was so huge." We hauled ourselves back in the boat. James was grinning – "It was good, then?" "It was one of the most memorable, most exciting wildlife encounters I've ever had," I said, "and we need a few more," added Scott, "or we won't have a film."

The problem with filming basking sharks is that they don't stay still. Most land animals and birds don't stay still for long either, but with powerful lenses it is possible to film them from a great distance. In the water it is different. The visibility that day was surprisingly good, despite the fact there was plenty of plankton and therefore plenty of sharks. But once the shark was more than about five metres away it became invisible. Regulations for swimming with Basking Sharks don't allow you to chase them, but as they swim between 5 and 7 knots without seeming to try, it is impossible to keep up with them anyway. Our only option was to keep doing what we had done the first time – spot one from the boat, get in the water and hope that it chose to come and look at us. Luckily for us Mull's Basking Sharks did seem particularly curious and we had a very good, if exhausting day, constantly getting in and out of the boat, lying quietly on the surface of the water willing the shark to come towards us, hoping, as they sometimes did, they would circle round for a second look. By the time Scott was satisfied that we had enough footage we had filmed perhaps as many as six or seven different basking sharks and every encounter was as breath-taking and wondrous as the first. And still just as frightening.

As wildlife is as unpredictable as the weather and we are at the mercy of both, we allow ourselves what we hope will be more than enough time to realistically get the footage we are after. On this occasion, the sharks had been so compliant we had some extra time on Mull which gave us the perfect excuse to call on Dave Sexton. Dave is the RSPB officer on Mull and during *Springwatch* of 2005 had looked after Simon and the crew during his week following the fortunes of the White Tailed Sea Eagles. Simon had

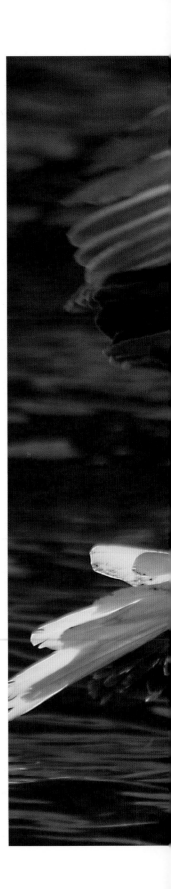

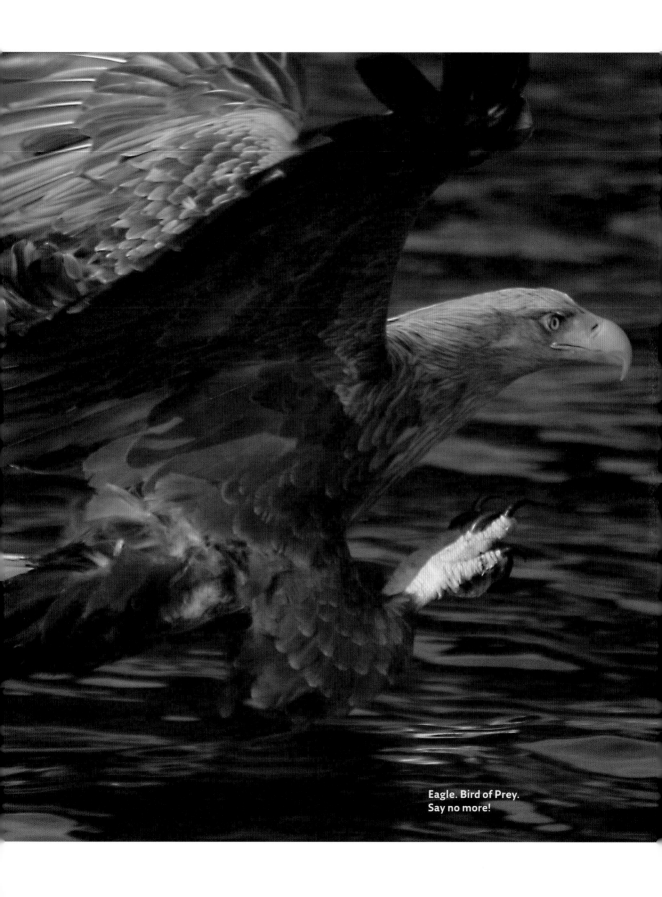

Eagle. Bird of Prey.
Say no more!

introduced us to Skye and his mate Frisa and their two chicks Itchy and Scratchy and we had watched with wonder, delight and sometimes alarm as these two magnificent birds battled with the elements to feed their demanding chicks.

Sea Eagles were native to Britain but had died out, largely because of persecution. In 1978 a programme was started to re-introduce them from Norway and the reintroduction site chosen was the island of Rum. One of the eagles that came to Rum was a female called Blondie. Six years later, having settled on Mull, she became the first sea eagle to raise and fledge a chick in the UK for seventy years. She went on to fledge many more chicks before she died in 2000, aged about 21. One of her chicks was Frisa, who was born in 1992. Sea eagles don't mature until they are about 5 years old and it wasn't until 1997 that Frisa paired up with Skye. Skye takes his name from his birth place, The Isle of Skye, where he fledged in 1994. When he was seen on Mull in 1997, he was still classed as 'immature' even though he was already paired up with Frisa. Their first nest site was far away from Loch Frisa, where Simon filmed them, and they did have one chick. Sadly, it didn't survive, almost certainly because its parents were young and inexperienced. The following year they moved to the woodland beside Loch Frisa where they still nest today. They built a nest – a huge platform of twigs – in the top of one of the pines and hatched two chicks. Again one of them died after only a few weeks but the other survived, despite its nest almost falling out of the tree in bad weather. Luckily the RSPB were monitoring the nest and managed to stabilise it before any harm could come to the remaining chick. She fledged and after a few years spent on Scarba and Jura, has returned to Mull and has fledged chicks of her own.

Skye and Frisa continued to breed every year and had had nine successfully fledged chicks by the time Simon went up to film with them for *Springwatch* 2005. They were still at the Loch Frisa site where the RSPB have a hide to allow people to watch the birds without them being disturbed. Itchy and Scratchy, the two chicks hatched that year had become television stars, but by the time *Springwatch* came to an end they still hadn't fledged and they had kept us on the edge of our seats as they stretched their wings and hopped up and down perilously close to the edge of the nest in winds easily strong enough to dislodge them. So had they survived? We phoned Dave to ask if we could come and visit and

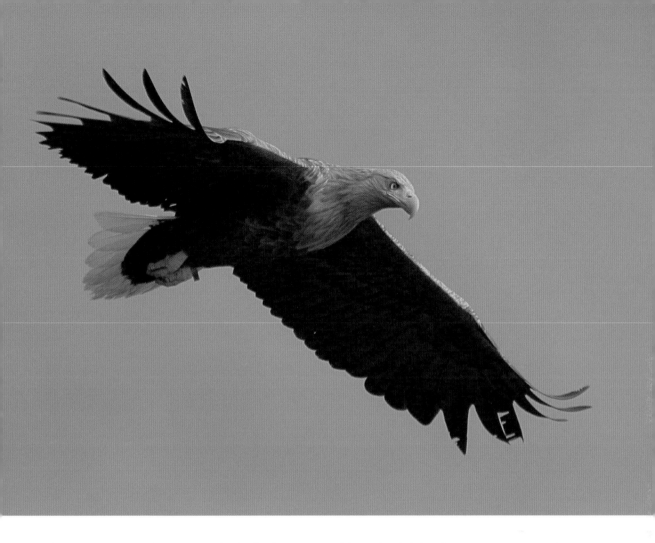

And if you're suddenly being reminded of the USA ... This bird has a head almost as white as an American Bald Eagle, and, yes, they *are* closely related

he invited us to meet him at Loch Frisa. It was over two months since the end of *Springwatch*, so we knew that the chicks, if they had made it, would've fledged and left the nest site. The news was mixed. Both chicks had fledged successfully and Dave had seen Scratchy only the day before. But Itchy had gone missing: there had been no reported sightings of him for the last ten days. This was worrying because in these early days they shouldn't be flying too far from the nest site and Dave was really concerned that something had happened to him. What's more, with the breeding season over and the birds dispersed there is no knowing where they might be at any one time. However, Dave had had reports of a sheep carcass being seen in a field a couple of miles the other side of the loch. The sheep had almost certainly died of natural causes, but a carcass like that will never go to waste. Crows, gulls and birds of prey, including sea eagles, will all happily take advantage of an easy meal and so we drove to a point where we could get a

view of it. There was plenty of activity when we arrived. Hooded crows swarmed around the unfortunate sheep, quarrelling and flapping and pecking at each other. Dave scanned the scene. "There's a sea eagle on that post," he said, pointing to a large indistinct brown shape perched on a fence a field away from the carcass. "Can you see who it is?" I asked, squinting through my binoculars. "No, I can't get a clear look at the tag." There is a comprehensive ringing and wing tagging system for the sea eagles on Mull, so they can be tracked and identified easily. Itchy and Scratchy have red wing tags with a white 'I' and 'S' on respectively. The eagle took off, surprisingly graceful for such a big, bulky bird, and in a few beats of its enormous wings it landed next to the carcass, scattering crows which rose up, cawing in indignation. We caught sight of a tag. It was red. So it was definitely one of our chicks, but which one? Dave was tense beside me. I knew he was desperate for the bird to be Itchy. We kept getting tantalising glimpses of the tag but nothing clear enough to read the letter. Finally the bird turned and gave us a full view of the tag. "It's an 'S'," said Dave, unable to keep the disappointment from his voice. But I was delighted. Here was a bird we had last seen as a rather scruffy and not terribly beautiful bundle of down with over-sized feet, poppy eyes and a head that seemed too big for its scrawny body. Now it was, quite simply, a magnificent sight, regal in its beauty and stature.

Suddenly the crows took flight again and we took our binoculars off the carcass and up to the sky. Two more eagles were flying in. They landed just short of the carcass. Both had the dark heads of immature birds, but we couldn't see the tags immediately. "It's Itchy," shouted Dave at the same moment as I read the white 'I' through my binoculars. "So who's the other one with him?" I asked. "I don't know, but it's a female by the looks of things. She's bigger than him." He lowered his binoculars. "Little bugger. He's far too young to be off chasing girls." And his smile was that of a proud father.

We left Dave after a few celebratory drams and with the plea to keep us in touch with the Itchy and Scratchy's progress over the winter. An eagle's first winter is a crucial time and their survival depends entirely on whether they have honed their hunting skills enough to find the food they need to keep them going until the richer pickings of the spring. During the run-up to *Springwatch*

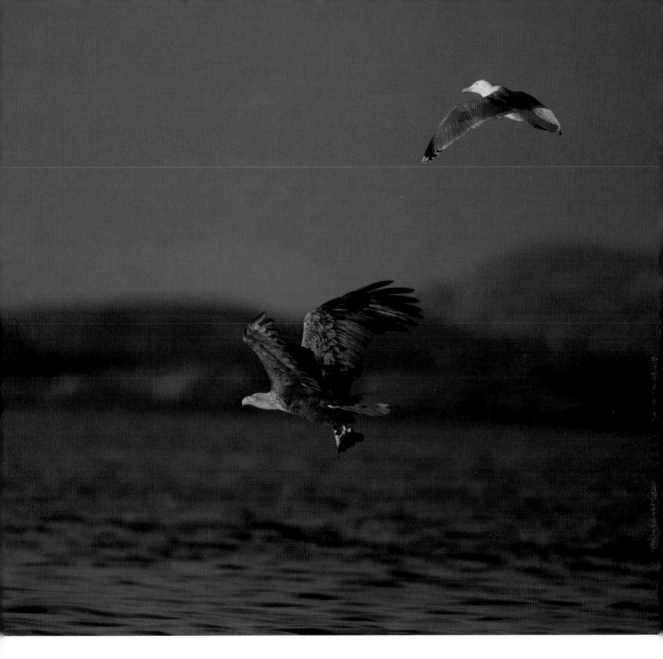

This gives you some idea just how big Sea Eagles are. The gull above is a Herring Gull - and that's a pretty big bird itself. Ironically, though, the gull is the one attacking. Sea Eagles only eat fish

2006, we heard from Dave that both Itchy and Scratchy had been seen, and both birds seemed to be thriving after the winter. Better news still was that Frisa and Skye had hatched another two chicks. Haggis and Oatie both fledged successfully in early July, bringing Frisa and Skye's total to twelve chicks in ten years. There are now just over thirty-five breeding pairs of sea eagles in Scotland. It is still only a few, but with the continued support of organisations like the RSPB and communities like that on Mull maybe one day these majestic birds will once again be seen in the skies above England and Wales.

The Last Show – Thursday 15th June

Bill Oddie

Last shows are always on odd mixture for us. There is elation, relief, anti-climax and sadness. By their very nature they tend to be retrospective, and therefore I suppose rarely actually exciting. Almost a bit predictable. A bit like England beating Trinidad 2 – 0. Tonight's show was pretty typical of the type. There were no new wildlife dramas. We chose favourite bits, and announced fictitious awards. The best value wildlife award went to the Buzzards. Action at their nest included the chick eating its sibling; the Toad that escaped by plummeting 60ft, and the frog that got swallowed alive. There was also the nest decoration scene – when the adults covered their offspring with leaves – and finally the infamous kick-the-chick "foul", definitely worse than anything that we have seen so far in the world Cup.

Kate and I chose personal highlights. Mine was my first encounter with a live Mole. Kate's was her intrepid "swimming with Basking Sharks" item. Rather her than me, and she does look much more fetching in a wet suit than me.

Early in the programme we challenged some of our animals to send us out with one last a spectacular live event. The bats had an

The signs held up in the photo read: HELLO, REMOTE CAMERAS, I ♥ Birds, FEED CAT, DOGS BODY, STORY, BIGGER BOSS, HI MUM, BIG BOSS

They're behind you! Part of our "extended family". There's 55 people in this picture (honest!) but that's by no means the whole team. *Springwatch* **is big!**

hour in which to give birth, and the Badgers a last chance to appear live at all! Neither rose to the challenge. Casanova the Pied Flycatcher was awarded a "Superdad" prize, and received 17 Father's Day cards, one from each of his progeny. We announced the coming of *Autumnwatch*, and trailed it with an all-action clip of Red Deer stags gouging the daylights out of one another. Kate also gave us the latest update on the progress of our Super Geese. There were now 4 in Canada, 3 still in West Greenland, 1 in East Greenland and 1 still in Iceland, but with a dodgy transmitter. Kate's beloved Floyd was still missing. We had finally heard from Ireland that the couple who thought they might have seen him, had now remembered the letters on the ring, and it definitely wasn't Floyd. Kate promised that *Autumnwatch* would also feature the Super Geese returning from Canada, assuming they ever got their in the first place. She couldn't help but express the hope that Floyd would then make a surprise re-appearance. "Fat chance", I assured her.

The series ended with the traditional "best of "images set to music. Shetland sent us a miscellany of Otters, seabirds, and

Orcas cut to a fine Highland Reel featuring some stirring traditional fiddling (violin playing, that is). The Badgers were made to frolic to the tune of "Duelling Banjos", which was more than they deserved. Whilst our Fishleigh Farm finale extolled the virtues of family values, with syncopated Swallows adding backing vocals to a funky track, on a video that would have done credit to MTV.

I offered a final analogy between wildlife families and "our family" that brought forth *Springwatch*, and thus reached out to the "extended family" that is you, the viewers. It was a little tortuous, and could have been somewhat maudlin, but hopefully it came out as sincere. Which it truly was. There was a farewell wave from Simon in Shetland, and from Kate and I in Devon. A promise or request to "see you all in Autumn". The voice in our ears instructed: "roll end credits". In came the theme tune, and *Springwatch* 2006 was over.

Except it really wasn't.

Nowadays, computers, web sites and various interactive facilities, not to mention leaflets,letters, phone calls and E mails, mean that very few programmes simply exist for only the duration that they are on the television. *Springwatch* is a terrific example of this wider service. Information is updated, campaigns continue, and the *Springwatch* phenomenon – I think that's the right word! – lives on well beyond the actual broadcasts. It is getting bigger and bigger, and it's still growing! That may sound like a line from a sci fi movie, but it is actually a dream coming true.

Friday 16th June

Three weeks. So long and yet so short. Kate disappeared even before the usual raucous "end of shoot " party, details of which are not for publication. I stayed on to do the *Really Wild Show*. It is the last one ever. The series has – as they say in TV land – been "axed". Personally, I think that is an outrage, and I hope it won't be long before it is replaced with something along the same lines. Meanwhile, it seems The *Really Wild* team can count on the sympathy of bats. The highlight of the show was news from Cornwall – the pip pups have popped! There they were live pictures of a Pipistrelle mother with a tiny youngster clinging to it. I

couldn't help noticing that it wasn't that tiny though. In other words, it was clearly not newborn. It had fur and baby bats are born naked. It was at least three or four days old! Which means of course that it had been 'hiding' from our cameras all week! Had it been saving itself for *The Really Wild Show*? Fair enough. But then again, if you were giving birth, would you want to do it in front of 4 million people?!!

6.30 p.m.
I am writing this in the caravan. It's 'peace at last' time. Most people have gone to get ready for the "wrap" party, or are in the pub getting an early pint down 'em. I may well be alone here again. Just as I was on the first rehearsal day, nearly a month ago. Only this time, the sun is streaming in through the open door, and I can hear the cheeping of a recently fledged Chaffinch, and the wonderful fruity music of a Blackbird in full song. There are even bees buzzing. *Springwatch* is over. Summer is here.

The End? Of course not ...

So, now what?

lushed with the success of *Springwatch* 2006, the powers that be at the BBC almost immediately announced that they wanted more. These things take quite a bit of organizing so we assumed that they were looking some way ahead. Like, for example, the following year. Options were mooted and debated. We could simply make the next *Springwatch* longer. Instead of three weeks, how about four? This was not enthusiastically received by the team, least of all we presenters. Much as we loved doing the show, by the end of three weeks, we were - to put it crudely, but accurately – totally knackered. Indeed, joking apart, the level of tiredness wasn't far short of exhaustion, especially for the directors and producers. Added to which, if we did 4 weeks, it would take us into July, which was surely summer? So wouldn't it then become *Summerwatch*? Added to which, that is when the daylight hours are at their longest, and TV audiences at their smallest. What's more, there was another factor to be taken into consideration. They not only wanted more. Like Veruca Salt, they wanted it now! Or at least pretty soon.

And thus came the announcement. "*Springwatch* is so successful, we have decided to follow it up immediately later in the year. We have come up with a title. It will be called "*Autumnwatch*" (devilishly inventive these marketing people). We have also come up with the locations. (Oho! Someone has been working on this one.) As is traditional, Simon will be deported somewhere very remote, namely the island of Rum in the Hebrides. Bill and Kate will of course be somewhere much more comfortable. However they will not be down on the farm in Devon. They will be based at the Wildfowl and Wetlands Centre at Martin Mere in Lancashire. (Good news for me, as I have friends there, and the facilities border on luxurious.) Simon will be presenting all the drama of the rutting season amongst a herd of Red Deer. Bill and Kate will be inundated by the arrival of thousands of migratory geese and swans. (Good!) We have also the dates firmly scheduled. The series will be only two weeks (only?!) as there won't be as many nesting birds as there are in spring. (That's true – there won't be any actually!) However, we are assured that autumn is still a very exciting time for wildlife (and for wildlife

Whooper Swans - perfectly happy to pose for this photograph, but not quite so anxious to appear on the telly! Even though we had spotlights set up for them

watchers too). So we - or rather you - will be on the air for the first two weeks of October. The transmission will be in the usual slot on BBC2, from eight o'clock till nine o'clock, each evening. It will, of course, be live! *Live?* Yes, LIVE!"

I'm not sure how long the pause was - a couple of days or a couple of seconds - before someone asked the inevitable awkward question.

"Er ... eight o'clock in October? Won't it be dark?!?"

And indeed it was dark. However, by the 1st October, optimism, fantasy and panic had contrived to convince most of us that doing a live show in the pitch darkness would be no problem at all. After all, we told ourselves, there are nocturnal creatures, like bats and Badgers, and night flying insects, such as moths, and we can take a torch and go hunting for fungi - mushrooms don't disappear at night. And in any case, Martin Mere is already equipped with floodlights that illuminate Swan Lake, where wild Whoopers are used to being fed in the late evenings, and will provide a magical spectacle. As if to celebrate the positive, on the first rehearsal, Kate and I found ourselves addressing the camera in the grounds of Martin Mere, surrounded by weeping willow trees festooned with high wattage bulbs, and with other lights glinting, twinkling and reflecting, in a psychedelic riot that was somewhere between Santa Claus' grotto, and the set for an outdoor production of *A Midsummer Night's Dream*.

An Early October Night's Nightmare, more like! Soon it wasn't only the willows that were weeping. By the morning of October 2nd, a certain acknowledgement of reality had occurred. One thing was now clear: Kate and I would have little or no wildlife that we could commentate on 'live'. There weren't any Badgers in the area. Bats had already gone into hibernation. What little fungi had been visible had either been picked or trampled. There were a few insects in the air, but there were so many bright lights needed to allow the cameras to show anything at all, that the moths must have been totally confused. Either they couldn't decide what lamp to be attracted to, or they were fooled into thinking that dawn was breaking, and they'd better get out of there fast. By the time we went on the air that night, I was trying to suppress my sarcasm:

"Welcome to *Autumnwatch*, coming to you live from Martin Mere. And don't the trees look pretty with all the fairy lights? And talking of looking pretty, here's the lovely Kate, who has promised

that tomorrow she will dress up as a fairy. Meanwhile, seen any wildlife today Kate?"

"Oh yes Bill. Believe it or not, there are 10,000 wild geese out there in the fields. In fact, if we keep really quiet we can hear them right now."

"Oh yes, they do sound like a lot."

"But of course, we can't see them. 'Cos it's dark."

"Mm. Frustrating, isn't it?"

"Yes Bill. It is a bit. But one thing we can see – even though it is dark – is the beautiful Whooper Swans that have flown back from Iceland just in time to be stars of *Autumnwatch*."

At this point we cut to the floodlit Swan Lake. It was totally birdless. Nary duck nor Coot, let alone Whooper Swans! An ominous voice in our ear pieces confirmed the news, or lack of it. "They say they should've been back a week ago. But they're not."

I struggled with my emotions – to laugh or to cry? – whilst Kate promised the viewers that "we'll be keeping an eye out for the Whoopers each day, and, who knows, they might even be back tomorrow. Honest, Meanwhile, let's go over to Simon King on Rum!"

Which is what we did. We were relieved – or was it jealous? – to see Simon looking merry as could be, explaining that he would be bringing us deer drama to die for, and that he had special infra red cameras that could see in the dark, and meanwhile, here was "some of the action that we filmed earlier in the day." It was fantastic!

And so indeed was *Autumnwatch*. Kate and I had to develop a slightly different attitude from our typical *Springwatch* mode. It started out as mild hysteria, but soon evolved into rather skittish jollity. Heaven knows, we'd had our silly moments on *Springwatch*, but on *Autumnwatch* we took it to new heights (or depths?). Indeed, so impressed were some viewers, that on an internet poll we were voted "best comedy duo!" "Even funnier than the Krankies!!!" It's that indomitable British spirit you know. When it bucketed it down during one show, we grabbed our brollies and broke into our "Singing in the Rain" routine. We huddled round a blazing brazier so I could do traditional 'Carry On' type double entendres: "Just warming up my nuts dear!" When we failed to locate any of our so called "Super Geese", we revived the old wartime spirit by doing parodies of RAF movies: "I'm afraid Floyd's

bought it over Iceland." On the more positive side, the Whooper Swans did eventually come back, and the constant sights and sounds of the Pinkfooted geese often transported us away to some place almost unreal. And during the day we thoroughly enjoyed the thrills and ambience of Martin Mere, which incidentally is well worth a visit whatever the time of year (during daylight hours, that is!).

But the thing Kate and I did the most of, was enjoy the rest of the programme. The pre-records, the mini epics, the passionate people – all ingredients of *Springwatch*, which were just as enjoyable in Autumn! It was also particularly uplifting, and intriguing to see Simon so totally in his element that we seriously began to wonder if he would ever be able to leave Rum. As the days went by, we watched him become so engrossed by and involved in the rutting rituals of the Red Deer Stags, that we began to wonder if he was actually turning into one himself. It was particularly disturbing when he began to bellow so authentically, that several hinds became clearly attracted to him. And it wasn't only the hinds. Human females began calling up radio shows and posting notices on the Internet, declaring that they found Simon's bellowing quite a turn on! I naturally responded to this with much derision and amusement, until I realised that Kate was beginning to feel the same way. I was so incensed that I challenged Simon to a bellowing contest. I can now admit that I have rarely felt so deflated as at the moment Kate announced, in front of 4 million viewers, that she was off to Rum as soon as possible. She didn't go, but whether that was 'cos she felt sorry for me, or was ashamed of her own fickleness, or just couldn't get a plane, I don't know. I know one thing though – no disrespect to Martin Mere – I wouldn't have minded being up there with Simon and his deer myself.

Pink-footed Geese – "Pinkies" to their friends. Their constant calling was a wonderful sonic backdrop to *Autumnwatch* from Martin Mere

Autumnwatch

Simon King

Springwatch keeps on springing up. It seems that what we have been doing for the past few years has struck a chord with the viewing public, and the demand for a new series each year appears to be stronger now than ever. The whole production team never ceases to be thrilled and flattered by the swathes of mail and e-mail correspondence that comes in the wake of a series. Indeed, it was this public interest and appetite for a continued coverage of what's going on in the British countryside that led to the commissioning of a new series in 2006; a series of live programmes which would chart some of the natural wonders that take place during the autumn. But hang on…what can possibly happen during the autumn in Britain that is either compelling enough, or predictable enough to make a live series sustain over a 2 week period about? Well, quite a lot as it happens!

Autumnwatch charted the fortunes of the natural inhabitants of Britain through the months of mist and mellow fruitfulness. Because we were to transmit the series in October 2006, to make the most of certain key events in the natural calendar we actually started filming in the autumn of 2005. I travelled from the Hebridean Islands to the New Forest looking for wildlife magic along the way. And we found plenty! We kicked off with some covert urban wildlife watching. Many of our city parks are first rate places for getting good views of creatures that, in the countryside are very shy and elusive. In early Autumn, Tawny Owls begin to re – establish territories and adult birds may start to encourage their youngsters to begin looking for a place of their own. The result is a lot of hooting. Any area with sufficient mature trees and a small mammal and bird population can host Tawnys, and some of the London parks are great for this. I'll interrupt this thought with a word of warning though. Mooching about at night, in a park, in a city, is sadly not necessarily safe. You won't get attacked by wolves or gremlins, but our own dear species – humans – can behave appallingly from time to time. So, if you do fancy a bit of nocturnal wildlife watching, check first with the park authorities that it is something they allow (many are closed at night), and make sure you are in a group large enough to avoid trouble. How sad that a public health warning has to be issued because of, well, the public!

OK, Owls then. From the middle to end of September through to November, Tawny Owls are very vocal and they will react to the

Robin. We think of them as garden birds but they turn up all over Britain, and often in some very remote and treeless places

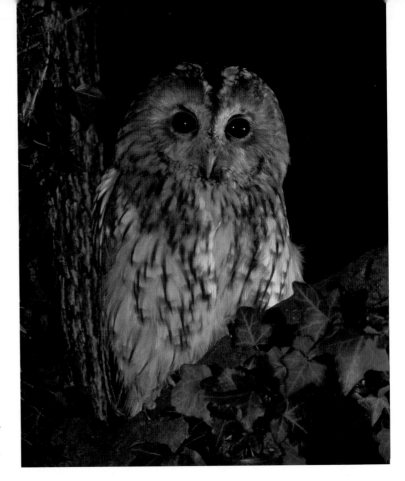

Tawny Owl. More often heard than seen. "Too-whit, too-whoo". That's two birds calling to each other. "Kee-ik", "Hoohoo". Go on, have a go

first hint of an intruder in their territory. Of course, the competition must be mottled brown, with a round face, a hooked beak and standing about 30cm tall. If you don't fit that description, you still have your voice to help you get a good view of an owl. Hooting back convincingly can elicit a dramatic response from a local pair, with them arriving to chase out the intruder and engaging in a hooting match. It is possible to mimic a tawny song by whistling but it does take a bit of practice and after 20 or 30 hoots, your whistle tends to dry up and turn onto more of a croak (mine does anyway!) A play back recording of a Tawny song is much more convincing and easier on your lips. Arm yourself with a portable CD player, a clear recording of a Tawny song (the hooting call, not the ke-wick high pitched call), a powerful torch and some red gel. The gel is for the torch, turning white light into red to prevent startling the very creatures you want to see. The science of sight is a little vague as to why this is so, but it is very likely that many creatures, particularly those with highly developed night vision, have restricted ability to see colours at the

red end of the spectrum. Whatever the physiology, red light is definitely less disturbing than white light for most nocturnal animal watching.

The London park where we filmed was surrounded by the roar of traffic and humanity, but within an hour or so of dusk, we had the local Tawny pair hooting back at us in a pool of red light. We went on to watch Foxes looking for earthworms on the playing fields and listening to migrating redwings flying overhead. First class wildlife watching.

Nocturnal wildlife was not new to live television. Some years before during the making of *Britain Goes Wild*, we had cameramen stationed in various corners of Bristol trying to record the nightly wanderings of the city's Foxes and Badgers. Cameraman Pete McCowen was given the task of using a thermal imaging camera for the job. These extraordinary devices pick up infra-red radiation from any object. A warm-blooded animal, ourselves included, shows up as a ghostly form in the viewfinder despite being in total darkness. On one evening, Pete carefully set up his gear in the cover of some bushes on the edge of a suburban park, hoping to record some of the local badgers looking for earthworms in the small hours of the morning. At around midnight, he was jolted into action by the appearance of a glow in the viewfinder. Curiously it appeared to be round, and bobbing on the far side of a wall some 100 metres away. The ball turned into a human head, followed by another, both of which vaulted the wall (followed by their bodies!) The two figures then proceeded to run wildly across the parkland. Hot on their heels, two more figures, with the distinct trim of police uniforms, leapt over the wall. It dawned on Pete that he was witnessing officers in pursuit of suspects, just as it also dawned on him that the suspects were making a bee-line for his hiding place! As the figures grew in his viewfinder (obviously oblivious of the stealth cameraman crouched in their intended bolt hole) he deliberated whether to make a dash for it, or to assist the police with their duty. As it turned out, Pete coughing and standing up, just as the two suspects reached his cover was sufficient to terrify them and send them off in the other direction. I never did learn if the police got their men, but I'm willing to bet that if they did, then the suspects must have been mightily impressed by the carefully laid trap that scuppered their escape.

What is Autumn?

Stephen Moss

A simple answer to this question would be, 'the opposite of spring'. Just as spring is a time when the natural world seems to be bursting into life, with flowers blooming, birds singing and many animals and plants taking part in the race to reproduce, so autumn is associated with nature shutting down for the winter.

Our summer visitors – not just birds but butterflies and some marine animals – head south to warmer climes, while many mammals go into a state if not of hibernation, at least of reduced activity. Those insects that have not died hide away in our garden sheds, logpiles and even inside our homes, in order to survive until the warmer weather returns. And of course the trees – at least the deciduous ones – shed their leaves.

But if autumn is so quiet, what about the rutting deer, for whom this really is the crunch time of year?! What about the millions of ducks, geese, and swans – not to mention waders and winter thrushes – heading our way to find a place to stay for the winter? And what about all the other signs of autumn: berries covering our hedgerows; fungi on the forest floor, and seals giving birth to their pups?

So if you thought, even for a moment, that autumn is a time of inactivity – a bit of a dull period in the natural world – then think again! As *Autumnwatch* showed, it can be a season of spectacle and wonder. And if you sometimes have to look a bit harder to see the action, then that makes it even more rewarding!

Just as there is plenty of argument about the precise timing of Spring, so there is about Autumn. The tidy-minded weather forecasters at the Met. Office insist on it running for the calendar months of September, October and November. Another definition would take it from the Autumn Equinox on September 21st to the Winter Solstice on December 21st.

But nature doesn't fit in with our human calendar, but has one of its own – or indeed several. After all, one can argue that when wading birds from the Arctic pass through Britain on their way south in late June, or Blackberries begin to appear, then Autumn has begun. Likewise some trees don't finally shed their leaves until well into December. Once again, as with Spring, it pays to take a more relaxed view of the season, and not worry too much about dates.

One big difference was that *Autumnwatch* 2006 took place in

Season of mists and mellow fruitfulness

the first two weeks of October – not even half-term, compared with the 'end-of-term' feel of *Springwatch* in early June. Many Autumn events had hardly begun to get underway, and the continued mild weather was delaying the arrival of some of our star characters, especially at Martin Mere. But as Bill and Kate pointed out in the final show, that meant that, in the words of 'Old Blue Eyes' Frank Sinatra himself, 'The Best is Yet to Come …'

The *Autumnwatch* Survey

Having become hooked on looking out for signs of spring, many people were keen to continue looking out for seasonal events all year round, which was great news for our partners at the UK Phenology Network. So autumn 2005 saw the launch of the first *Autumnwatch* Survey, asking people to look out for six signs of the changing season:

Ripe blackberries
The departure of Swifts
Ripe hawthorn fruits
Ripe horse chestnuts (conkers!)
Ivy flowering
The first brown tint on oak leaves

Once again there was an excellent response, despite there being only a single television programme to trail the survey. Over 38,000 records were received, which together revealed the continuing trend towards an earlier start to the autumn season. For example the average date across the UK for the first ripe blackberries was 5th August, compared to 14th to 30th August in the previous five years. The same trend appeared in records of hawthorn berries (average date 23rd August), which generally start ripening in September. The earliest records came well before we think of the start of 'autumn': in fact *Springwatch* had only been off the air for a week or so when the first ripe blackberry was noted, on 25th June.

Just over 14,000 records were also received during the *Autumnwatch* survey in 2006, linked to the two-week live event in early October. Again, ripe blackberries and hawthorn berries appeared earlier than usual, as did horse chestnuts – almost

certainly because of the record warm temperatures in July, which speeded up ripening.

All these results suggest that as some signs of autumn shift more rapidly than others, there is a danger of what the Woodland Trust calls the 'loss of synchronisation'. Many birds and mammals rely on berries as a significant food resource, especially later in the autumn and during the winter months. If berries continue to ripen earlier and earlier, there may come a time when the fruit is simply not available at the time when the wild creatures need it most.

This could be disastrous for migratory birds like the Whitethroat, which need to build up their energy resources in early autumn before undertaking the long and dangerous journey south to Africa. Their place is taken by winter thrushes such as the Redwing and Fieldfare, which arrive in October and November from the north and east, and also depend on berries such as hawthorn for food. Again, if the berries have ripened too early there may not be enough food for the birds.

What the *Autumnwatch* survey provides is hard evidence that seasons are not only changing at the beginning of the year, but towards then end as well. Now that the scientists have got this information – thanks to all of you who sent in your records – they are able to press for action on climate change to try to resolve the problem.

Meanwhile, the UKPN's wider survey of all seasonal signs also revealed the way in which, with earlier Springs and more prolonged Autumns, the winter season is virtually being squeezed out of existence. Now that 'spring' flowers such as snowdrops and primroses are regularly blooming in November and December, and even some birds are starting to nest at that time of year, are we seeing the end of the traditional British winter?

Hips and Haws, Roses and Hawthorns. These are Hawthorn fruits - excellent Thrush food

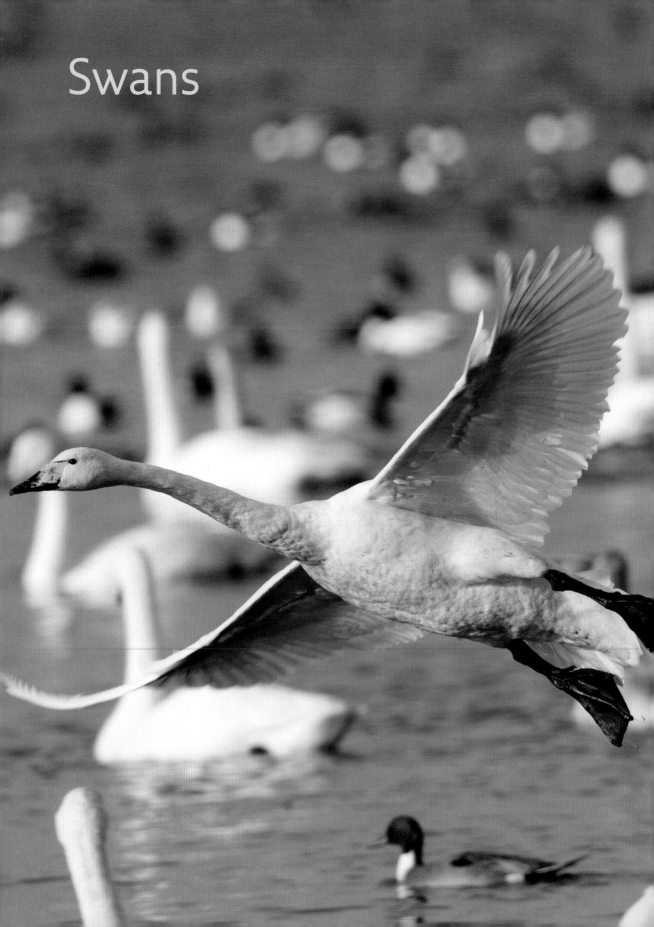

Swans

Of the three species of Swan found in Britain, two, Whooper and Bewick's, are often referred to by birders as 'wild swans'. This sometimes leads people to believe that our other native species, the Mute Swan, is somehow 'not wild' – a confusion not helped by the fact that in law, many of our Mute Swans are officially 'owned' by the Queen.

In fact all three live in the wild in Britain. The main difference is that while the Mute Swan is resident, living here all year round and breeding here, the Whooper (*left*) and Bewick's Swans (*below*) are both winter visitors to Britain, from their breeding grounds far to the north and east.

Britain is one of the best places in Europe for wintering 'wildfowl' – ducks, geese and swans. The reason for this is our very mild winter climate: even before the onset of global warming, the British Isles – especially western areas – have always been considerably milder in winter than locations farther east, such as the Netherlands, Scandinavia and the Baltic.

Even when it does snow in Britain, it rarely lies for very long; and in many western parts of the country it rarely snows or freezes up at all – enabling the birds to be sure of a consistent supply of food to give them the energy to survive.

As a result of this, hundreds of thousands of wildfowl return here each October and November, gathering on our coastal marshes and estuaries, to the delight of birders up and down the country.

The two species of 'wild swan' share another common factor: both have yellow and black bills, unlike the Mute Swan whose bill is black and orange in colour. To separate Whooper from Bewick's Swans, and be absolutely sure of your identification, you really need to get a fairly close look at the bill pattern: if there is more yellow than black on the bill, the bird you are looking at is a Whooper; if more black than yellow, a Bewick's. If the two are standing side by side identification is a lot easier: Whooper Swans are huge – as large as Mute Swans – while Bewick's are smaller, with shorter necks.

Where you are may also be a clue: wintering Whoopers are more likely to be found in the northern parts of Britain, with their stronghold in Scotland (and also large numbers in Ireland). However, there are other 'Whooper hotspots', including the Ouse Washes in Norfolk, Anglesey in north Wales, and of course the Wildfowl and Wetlands Trust Centre at Martin Mere in Lancashire, from where we broadcast for Autumnwatch. Occasionally, Whooper Swans stay on in the spring, and odd pairs have bred on lochs in places such as Shetland.

Wintering Bewick's Swans are much more likely to be found farther south: with hotspots on the Ouse Washes and Anglesey, and at the WWT centres at Slimbridge and Martin Mere; with very few in Scotland.

Their winter range reflects the places they have flown from. Whoopers wintering in Britain have flown here from Iceland, usually in family parties. Some migrate at incredible heights – a flock was once reported over the Western Isles of Scotland at an altitude of over 8,000 metres – almost the height of Mount Everest! However, many fly much lower than that, making them one of the species most likely to collide with wind turbines.

Bewick's Swans come from much farther east – the Siberian tundra – travelling across the Baltic and north-west Europe to reach our shores. This is a longer and even more perilous journey than that faced by the Whoopers, as they must pass over areas where wildfowl are regularly shot; as a result, many fall victim to the hunters.

All swans must migrate by flapping their wings – unlike raptors they are too heavy to take advantage of thermal air currents – so they stop frequently to refuel, at places such as the Baltic Sea and the polders of the Netherlands.

In recent autumns, when much of northern Europe has been enjoying unusually mild weather, swans have been staying put on or near their breeding grounds, or at stopping points halfway to Britain, rather than making the whole journey. As a result, many reliable places to see wintering swans have found themselves with very few, or even no birds, until much later in the season.

Bewick's Swans have an historical connection to Britain: being named after the early 19th century engraver Thomas Bewick, who published the first popular book on British birds. They also have a connection with the great 20th century conservationist and wildlife artist Sir Peter Scott, who founded the WWT at Slimbridge after the Second World War.

As an artist, Scott looked very closely at the Bewick's Swans that spent the winter on the lake outside his window, and soon realised that he could identify each individual by the unique pattern on its bill. With the help of his daughter Dafila, he painted an identification guide to every single swan at Slimbridge, enabling ornithologists to track individual birds, and reveal all sorts of secrets about their lifestyle. One male swan, Lancelot, returned to Slimbridge every winter for more than 20 years.

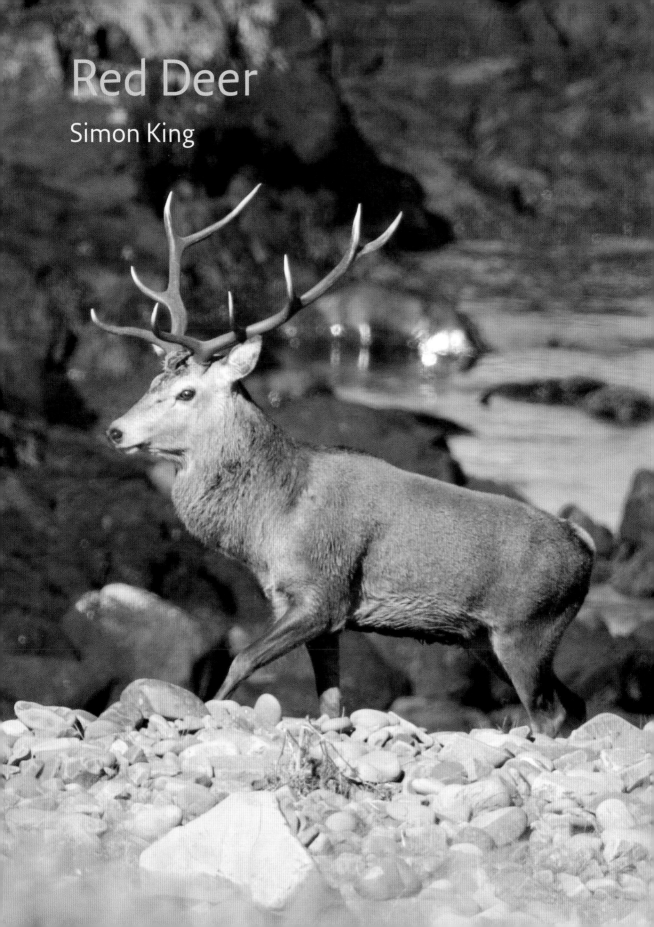

Red Deer

Simon King

A fine stag. Almost as majestic as Simon himself!

Our largest terrestrial mammal, the red deer is also one of the most magnificent. Celebrated as one of the great, iconic British wild animals, the image of 'the Monarch of the Glen' (originally painted in the mid-19th century by Sir Edwin Landseer) is one of the best-known of all wildlife paintings.

Male red deer reach well over a metre in height, with antlers spreading almost two metres across, and weigh up to 225 kg (about three times the weight of an average male human being). That bulk really comes in handy when the annual deer rut begins. Watching two big males in what is effectively a life-or-death struggle to pass on their genetic inheritance makes gripping television, as Simon and four million *Autumnwatch* viewers soon discovered.

The autumn deer rut is one of those great natural spectacles which you can see time and again, and never fail to be impressed. Like the fights between elephant seals, or the

Where some wildlife required pretty careful fieldcraft to watch without disturbance, the Red Deer I followed on the Isle of Rum were a very different deal. During the live transmission of *Autumnwatch*, I was stationed on this Hebridean island, owned and managed by Scottish Natural Heritage, to follow the antics of the stags as they battled for supremacy and the right to mate with the gathering hinds. Red Deer are widespread over much of Scotland, and there are populations on Exmoor and the New Forest amongst others, but nowhere else is there a population about which so much is known. A long term study, started some 30 years ago by Tim Clutton-Brock and which has continued unbroken ever since through Cambridge and Edinburgh Universities, closely monitors the behaviour of a population of some 400 deer in the study area at any one time. The result is an unparalleled resource of detailed information, and a large number of deer that are not terribly nervous of human beings. In fact, one or two of the stags were downright cocky whilst we were filming, and more than once we had these fellas trotting within a few metres of where we were sitting, as they chased off the competition or attempted to keep their harems together. And that makes your adrenalin flow!

Each of the deer has been given a name by the researchers, which is a clear indicator of its age and bloodline. Tanya 94 for example was born to a female named Tanya in, yes you guessed it, 1994. The trouble is, Tanya 94 is a bloke! I know it makes perfect sense for the study, but I had some difficulty describing the testosterone charged antics of these gladiators, whilst referring to them as Tanya or Portia! With a bit of discussion we came up with what we hoped would be more suitable macho alternatives, and over the 2 weeks of transmission we followed the fortunes of Caesar and Brutus, Percy and Maximus as they fought and flirted their way through the annual rut.

I had a complete ball, watching deer all day and jabbering about the things we had seen during the transmissions in the evening.

It is worth emphasizing just how unique this group of Red Deer is. For starters, living on an island they are of relatively pure blood. Some populations of Red Deer in mainland Scotland have been cross-breeding with the non-native Sika Deer, giving rise to hybrids. Having such a well established, pure population as the one

epic conflicts between male lions, it gets to the very heart of the way nature works: a winner-takes-all encounter in which all but one of the participants will be disappointed.

The rut takes place in autumn, generally from the end of September into early November, depending on the location. At this time of year, the mature stags (about five years old or over) will attempt to defend groups of a dozen or more hinds, against any other stag's attempt to mate with them.

This, as we saw, is an exhausting and very physically demanding process - a marathon rather than a sprint. From time to time, if a rival approaches, the defending male will engage in various levels of contest: from roaring, to 'parallel walks', through to full-scale locking of antlers. Not only do the stags risk serious injury every time they engage with each other; they also lose a huge amount of weight during the rutting season.

If successful, the winning stag can spend the winter putting lost weight back on, secure in the knowledge that he has sired a number of calves, which are generally born during the following spring - usually in May or June.

on Rum is invaluable. As I've already mentioned, the study is unique. No other large population of animals, let alone deer, has been so closely monitored for so long any where else on earth, and the results of the work have had and continue to have far reaching effects both in the conservation and management of the species and in the way which population dynamics of other creatures are considered elsewhere. It was our privilege to be able to dip into their world, long may the efforts of the research team continue.

Our own efforts to continue celebrating the wonderful Natural riches of the British Isles are ongoing too. *Springwatch* and now *Autumnwatch* (and who knows, perhaps a *Winterwatch* and *Summerwatch* and *Inbetweenwatch* and *Holidaywatch* etc, etc) look to be set in the television schedules for the next couple of years at least. It is our great good fortune and privilege to have the opportunity to continue following the wildlife of Britain throughout the seasons, and to applaud the passion and commitment of the people of Britain in their care and commitment to the country's wild life and places. Lets hope that all of us can continue to work towards a future where we are as sympathetic a part of the natural world as the animals and plants that give so many of us so much joy.

One of the undoubted highlights of *Autumnwatch* was a roaring contest ... between Simon and Bill. Simon won and was last seen competing to out roar all the stags on the island! Don't worry, that's as far as it went. He's OK now recording machines etc. etc. Nothing m- you can't nip back to the mainland and get it!

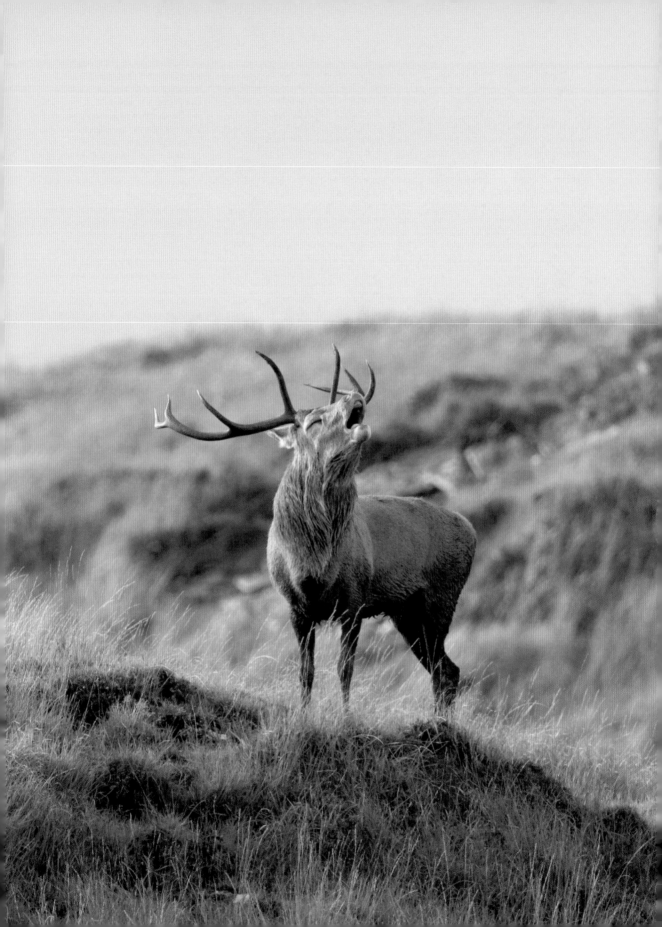

For *Autumnwatch* we chose the island of Rum, in the Inner Hebrides. Away from Rum, red deer are common and widespread across much of the Scottish Highlands, with other wild populations in upland areas of England such as Exmoor. Semi-wild herds of red deer can also be seen at Fountains Abbey in Yorkshire, and Richmond Park in south-west London. Here the rut is every bit as exciting as the one we saw on *Autumnwatch*, and a lot more accessible to most people.

Over the past few centuries numbers of red deer fell dramatically, largely due to hunting for food. However, increased protection, together with the lack of predators, now that wolves no longer live in Britain, has allowed the population to boom again, with over 300,000 individuals in the country as a whole.

Unfortunately, especially in Scotland, deer numbers are now beginning to affect the woodland itself, as they tend to graze and browse much of the lower vegetation – making the habitat unsuitable for rare creatures such as the Capercaillie. Deer fences, built to keep the deer out of the forest, had an even worse effect, as low-flying Capercaillie tended to collide with them and be killed.

Red deer are one of six species of deer regularly found in the wild in Britain. However, only two of these – the red and roe deer – are actually native species. The others – Fallow, Sika, Muntjac and Chinese Water Deer – were all introduced to this country. Fallow Deer have been here since Norman times, when they were introduced for hunting; while the other three species were all brought here from Asia at the end of the 19th

century, and released into ornamental parks from which they soon escaped.

Today these non-native species play a significant role in altering our woodland habitats, rarely for the better. The tiny Muntjac in particular has been blamed for the recent decline in the Nightingale population, as when feeding they remove the thick understorey of vegetation essential for this skulking species to breed. Worst of all, Sika Deer have hybridised so extensively with our native Red Deer that it is now thought that almost all Red Deer populations (apart from a few on isolated Scottish islands such as Rum), contain Sika genes.

Caesar (below) and a Fallow Deer (right) showing the main differenceS between the two large deer found in Britain – colour and antlers

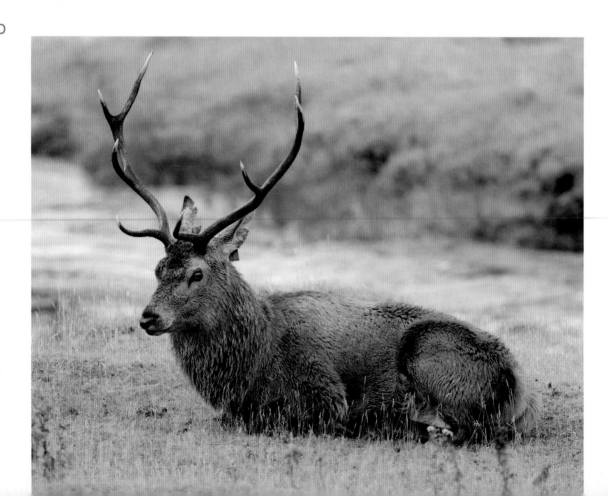

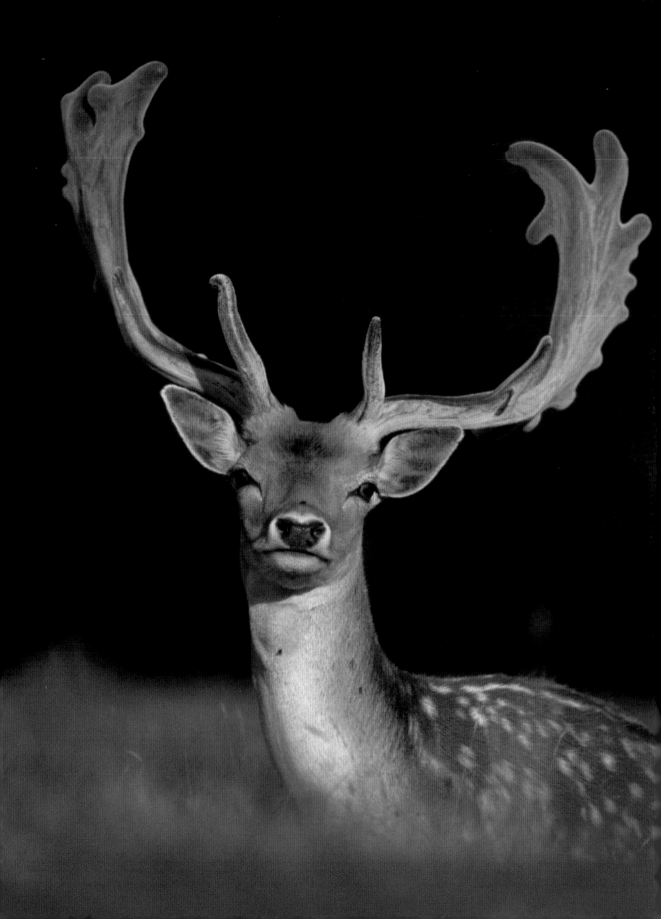

Starling Roost

It's easy to assume that Britain doesn't provide us with the really amazing wildlife spectacles we associate with far-flung places such as the African savannah or Arctic tundra. We don't have herds of Wildebeest or Caribou, for example. But one event – involving one of our commonest birds, and one we most take for granted – is truly awesome.

Starlings are not the most popular British bird – you won't find them topping polls of favourite species, which tend to be won by the Robin, Blue Tit or Puffin. This is partly because of their reputation of hustling the other birds off bird tables and feeders, as they sometimes arrive in quite large groups.

But in recent years, if we haven't quite learned to love Starlings, we do at least appreciate them more than we used to. Sadly this is in part because they have become a lot less common in the past few decades; due probably to modern farming practices which tend to reduce the amount of insect food available, the British Starling population has plummeted by as much as half – putting the species on the BTO's 'Red List' of birds of conservation concern.

Take a closer look at a Starling, and they do reveal a strange but undeniable beauty. Outside the breeding season their plumage is heavily spotted, giving them quite a pale appearance. Then, as Spring approaches, they moult into their breeding finery: basically black but with a glossy green and purple sheen – almost tropical in its exotic beauty.

Starlings are also highly accomplished mimics: able to imitate not only other species of bird, but also a wide range of noises with a human origin, from mobile phones to car alarms!

Many of the world's 100 or so species of starling have even grater skills of mimicry – such as mynas, popular cagebirds from Asia that can learn to imitate human voices.

The Starling is also one of the world's most successful birds – with a little help from its human friends. In the late 19th century, an eccentric American fan of Shakespeare decided to release every single bird mentioned in Shakespeare into North America.

Most did not manage to spread, but the 80 pairs of Starlings he liberated into New York's central Park in 1890 and 1891 did so in force. Today, just over a century on, those original 160 birds have grown into a population estimated at about 200 million individuals. Starlings have also spread, with human aid, across much of the rest of the world.

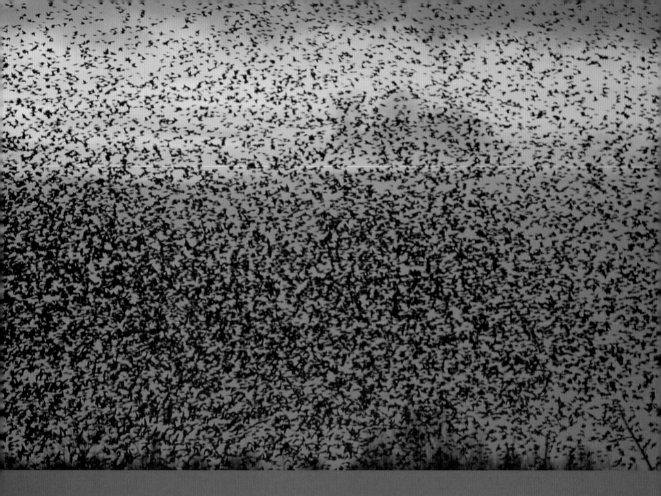

But here in Britain, the Starlings is associated with its extraordinary winter roosts. Once found all over the country – at Bristol's Temple Meads railway station, and even in London's Leicester Square – in recent years these have dwindled and disappeared, and nowadays there are only a few still in existence. Even so, when Autumn and Winter weather is mild the birds may not gather in such large numbers.

Famous roosts still active include the one at Brighton Pier, one at Westhay on the Somerset Levels (with up to five million birds, the largest in the country) and near Slimbridge in Gloucestershire.

It was here that Bill came a few years ago, during the filming of an episode of *How to Watch Wildlife*. He stood – silent for once! – as vast flocks of Starlings wheeled and turned above his head, creating all kinds of amazing shapes in the sky, before dropping down into the reedbed to roost for the night.

Every time we show the sequence we get more requests to do so again. It has even been used – with a fee going to the BBC Film Library – to advertise a well-known brand of lager! But why do they do it?

The obvious reasons are for safety and warmth: being in a huge flock massively reduces the chances – for any individual bird – of being picked off by a passing Peregrine or Sparrowhawk. In very cold winter weather, the birds can also keep warm by huddling together – vital to avoid losing precious energy.

But there is another theory, suggesting that the birds gather together to somehow communicate the best places to feed. It is unlikely that this happens directly, but it is possible that some birds are watching the healthiest looking birds, and following them out again when they depart at dawn – thus going to the main food supply!

Though by far the most spectacular, Starlings are not the only bird that roosts in huge numbers. Pied Wagtails gather on winter nights in city centres, industrial estates and other well-lit areas in order to stay warm and avoid nocturnal predators; while waders, ducks and geese form huge flocks – not just at night but also at high tide when they may be unable to feed.

Together these provide Britain with some of our most memorable spectacles –just at the time of year when we most need cheering up!

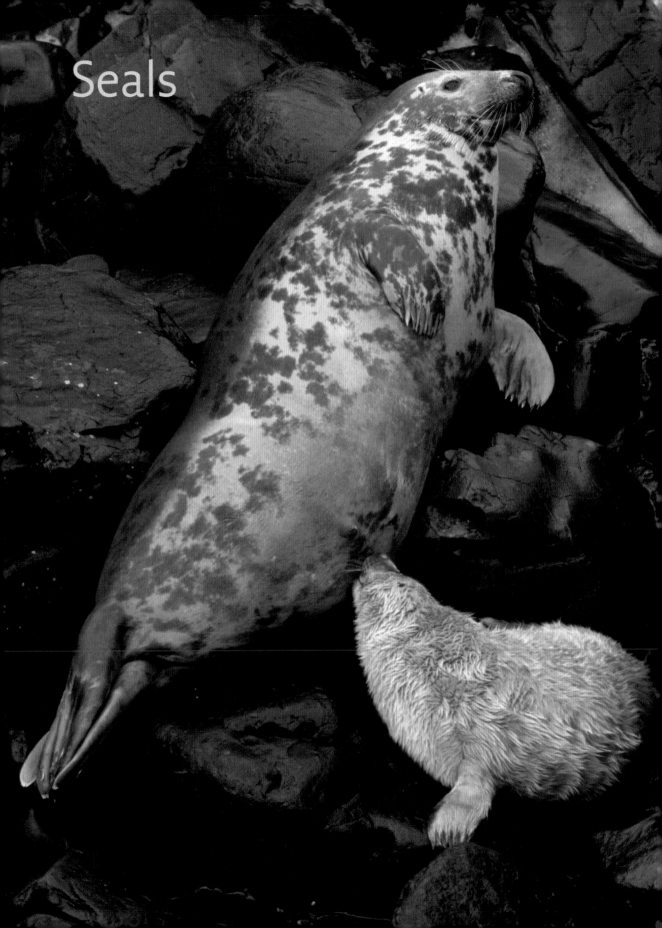

Seals

Another feature of *Autumnwatch* 2006 was the Grey Seal Diary, filmed during Autumn 2005 by wildlife cameraman Gordon Buchanan. Based on the remote and windswept Monach Isles, west of the Outer Hebrides, Gordon's personal video diary gave us an intimate insight into these majestic and beautiful animals, during a crucial time in their lives – the annual pupping season.

The Grey Seal – or to give its official name, the Atlantic Grey Seal – is the larger of the two species of seal found in Britain. Indeed with a length of over two metres and an average weight of over 230 kg (about 36 stone) the male Grey Seal just edges the Red Deer as Britain's largest native mammal. Common Seals are considerably smaller – weighing in at about 130 kg (about 20 stone); and far less bulky in appearance.

There are other differences between the two species – but not necessarily the ones you might expect. Both Grey and Common Seals can vary considerably in colour, so if you see a 'grey' seal you can not necessarily be sure which species you are looking at. Likewise, although Common Seals are more numerous than Greys in British waters, there isn't a huge difference in population between the two species (about 120,000 Common and 80,000 Greys).

In fact the best way to tell the two species apart is to take a close look at the shape of the head and the facial expression. Greys have a classic 'Roman nose', giving them a rather solemn, haughty appearance; whereas Common Seals have a much 'friendlier', more 'likeable' expression due to the upwards tilt of their muzzle and their V-shaped nostrils.

In Britain, both Grey and Common Seals can be seen off many of our coasts. However, Grey Seals tend to prefer more wild and rocky coastlines, so are more concentrated in the north and west of Britain, with outposts around the Farne Islands and Isle of May in the east. Common Seal strongholds include the Wash in East Anglia, and Scottish island groups such as the Western Isles, Orkney and Shetland.

Both species have increased in numbers in the past few decades, with the Grey Seal population doubling since 1960. Today, Britain plays host to about half the world population of Grey Seals, so it is vital that we safeguard the future of these fine animals. All seals are vulnerable to marine pollution and disease, and also come into conflict with fishermen, though evidence suggests that their main prey is sand-eels, which are not fished commercially. They do, however, take salmon from fish farm nets.

Seals spend about two-thirds of their lives at sea, hunting for food. Grey Seals feed mainly on sand-eels and cod, while Common Seals take a wide range of fish, shellfish and squid.

Our own encounters with seals tend to come when the animals have hauled themselves out onshore to rest, sometimes in gatherings of over 100 animals. They tend to appear rather clumsy on land, as unlike their relatives the sea-lions, whose flippers allow them to 'stand up' and walk along (albeit rather jerkily), seal flippers are not much use out of the water. Hence the 'banana-shaped' posture seals often adopt onshore.

Common and Grey Seals give birth at different times of year: common in June or July, and Grey in the autumn. On the remote Monach Isles, off the north-west coast of Scotland, the prime time for pups is October. At birth, a Grey Seal pup weighs about 14 kg (about four times the weight of a human baby), but grows more quickly than almost any other baby animal, putting on 2 kg a day thanks to the mother's incredibly rich milk, more than half of which is fat. This is equivalent of a human baby growing at a rate of 3 kg a week, which would mean that after six months it would weigh as much as a fully grown man!

Putting on weight may make the difference between life and death for the pup, as once it goes to sea it must be able to survive cold water temperatures for long periods. If it does survive, a male Grey Seal can live for 25 years, while females may reach the age of 35.

In the past, both Grey and Common Seals were hunted and killed: sometimes for their skins, and sometimes purely to prevent them feeding on fish stocks. Today they are protected under law, though in some circumstances they can still be killed under licence. However, organised culls of pups have been banned since the 1970s, due to the public outcry caused by the killing.

Approaching seals is never a good idea: adult seals can inflict a nasty bite, while if you touch or disturb a seal pup its mother may abandon it. If you want to see seals, it's much better to join one of the many organised boat trips around our coasts, where expert skippers will get you close-up views without disturbing the seals themselves.

So what's in the future?

Autumnwatch was not the same as Springwatch. But it was just as much fun. And just as successful. Audiences were around the 4 million mark, which was immensely gratifying, as it meant that not only were you – the public – maintaining your interest and enthusiasm, but also the BBC have seen fit to declare considerable commitment to the whole project. I began this book by using the phrase "Not so much a programme as a way of life", and I reckon it is a pretty good way of encapsulating the BBC's involvement. It is called "public service broadcasting". It is arguably the core of what the BBC does best. Other channels contribute, but no other broadcaster – and I mean none – does it as well or on such a scale. And it is ongoing. In 2007 there will be Springwatch and Autumnwatch. There are also already plans for 2008, which are likely to involve some new approaches and new locations. Also discussions about possible "spin offs". Plus the ever proliferating interactive services. Moreover, links and liaisons with the various Wildlife Organizations are constantly being developed, which has led to the provision of funds by the National Lottery. All of which leads to greater and greater involvement by the public.

The broadcaster serves the public, and the public serve the wildlife. Or maybe that should be con-serve!

Going further

I f you've enjoyed watching the *Springwatch* and *Autumnwatch* television series over the past few years, you may now want to leave the comfort of your living – room behind and get out to watch wildlife for yourself. If so, here's some advice on how!

Attracting wildlife to your garden

Wildlife – watching begins at home – though not necessarily in front of the TV set! Whether you live in a town or city, on a suburban estate or in the heart of the countryside, there'll be plenty of wildlife in and around your home. All you have to do is to make your garden as attractive as possible – by providing food, water, shelter and places to nest.

There are plenty of books on how to attract birds and other wild creatures – and on wildlife gardening at every level (see Further Reading, page 252). There are also several mail order firms providing everything you will need in terms of equipment, such as feeders and nestboxes; and of course food; check out adverts in bird and wildlife magazines. You can even buy special 'nestbox – cameras', allowing you to create your very own '*Springwatch*' for you and your family!

Exploring your neighbourhood

You shouldn't ever tire of your garden and its wildlife, but you may also want to explore the area on your doorstep. Even a walk in the park can produce surprises – especially early in the morning, before the other park-users are out and about, when wildlife thinks it has the place to itself.

Areas of water such as park ponds are always good value, as are any wooded areas; especially in spring when bird song and breeding activity is at its height.

If you find somewhere really promising, why not make it your 'local patch'; somewhere you can visit regularly to really get to know the wildlife and its comings and goings throughout the year?

Spreading your wings

As you get more and more interested in watching wildlife, you will eventually want to broaden your horizons – either by exploring new places, or joining up with like – minded enthusiasts, or both.

The Internet is your key to accessing new contacts and finding out about where, when and how to see particular creatures or visiting new places. Britain is full of amateur naturalists, who form groups, clubs and societies at the drop of a hat. Check out your local area – either via an Internet search engine or using the resources of your local library.

There are also many national, regional and local organisations such as the RSPB, BTO or Wildlife Trusts, who welcome new members and are highly experienced at offering guidance and practical support – for example lifts to nature reserves to those without access to a car. Most offer a range of events, outings and places to go; and if you get really involved, are always looking for members who can help run guided walks, organise talks or do practical conservation work. See the list of organisations on page 253. Or check out the BBC's website.

The RSPB and Wildfowl and Wetlands Trust also have a wide range of reserves and visitor centres – some of which, such as the WWT's London Wetland Centre and Martin Mere, have featured on *Springwatch* and *Autumnwatch* in the past.

The RSPB also runs its 'Aren't Birds Brilliant!' scheme, with watchpoints at rare birds' nests, staffed with experts able to show you the magic of species such as the Sea Eagles on the Isle of Mull, the Peregrines in Central London, and many other species up and down the country. Check out the website: www.rspb.org.uk/brilliant. As Bill himself says: "It's one thing watching birds and wildlife on the TV, but it's quite another to get out there and see for yourself!"

Finally, if you really want to spread your wings, there are all sorts of commercial holiday companies offering wildlife tours, both in Britain and abroad. Most offer a range of mouth-watering tours led by expert guides – though quality does come at a price.

249

Going further

Breathing Places

If you've been watching our various live wildlife events over the past few years, we hope you've been inspired to go out and become involved with wildlife for yourself. That's what Breathing Places is all about: seeing wild creatures, visiting the places where they live – and if you want to go one step further, giving those places and their wildlife a helping hand.

You can do this on any level: from going on a walk around a local nature reserve, joining a guided event such as Dawn Chorus Day or a bat walk, or by rolling your sleeves up and getting your hands dirty doing some active conservation work.

Over centuries, and in particular in the past hundred years or so, human beings have done massive harm to wildlife. We have polluted the land, freshwater and seas; persecuted so-called 'pest species'; and destroyed huge swathes of prime habitat to grow food, or build roads or houses.

But at the same time, a growing number of enlightened people have led the way in trying to redress the balance, and help safeguard species and the places they live. Organisations such as the RSPB and the Wildlife Trusts – and all our partner organisations throughout the country – do a splendid job in protecting places and wildlife against the many threats they face.

So for some time now we have known that wildlife needs people – but how about the other side of the coin? How much do people need wildlife? The answer is, it seems, that people need close encounters with nature to improve almost all aspects of the quality of their lives.

Not only does getting out and about to watch wild creatures improve your physical health; it brings huge emotional, psychological and even spiritual benefits, too. People who watch and enjoy wildlife on a regular basis have better mental health, a more active social life and even live longer than those who do not!

That's why the BBC – in partnership with a whole range of wildlife and conservation organisations (see below), has launched Breathing Places – a three-year initiative designed to get people back in touch with wildlife, for mutual benefit.

You can get involved in Breathing Places on several different levels: subscribe to our monthly e-mail newsletter; go along and visit one of the hundreds of Breathing Places already in existence; and if you want to, lend a helping hand.

You can even apply for a National Lottery grant to create a 'breathing place' of your own – in your local park, at your children's school, even at your workplace. And if you already know a haven for wildlife in your neighbourhood, then you can apply for a grant to help make it even better! For more details, visit our website www.bbc.co.uk/breathingplaces, where you can register your interest and get more information. If you don't have access to a computer, check out your local library for more details.

Another way to find out more about Breathing Places is to come to one of our events, held up and down the country to coincide with major broadcast events such as *Springwatch*. In June 2006 more than 200,000 people attended these events, having close encounters with wildlife, talking to nature experts, or simply enjoying a fun day out. Again, check out our website for details.

The Breathing Places campaign is a joint initiative between the BBC, government agencies in England, Scotland, Wales and Northern Ireland, and a wide range of charitable conservation organisations. These include Natural England, Scottish Natural Heritage, the Countryside Council for Wales, the Bat Conservation Trust, British Trust for Ornithology, Buglife, Butterfly Conservation, The National Trust, Plantlife, The Royal Horticultural Society, RSPB, The Waterways Trust, The Wildlife Trusts, The Wildfowl and Wetlands Trust, The Woodland Trust, British Trust for Conservation Volunteers, Community Service Volunteers, Environmental Campaign, Federation of City Farms and Community Gardens, Greenspace, Groundwork, Grounds for Learning, Learning Through Landscapes, and equivalent groups in Northern Ireland. The Open University is also our partner.

Ultimately, the purpose of Breathing Places is to encourage more than one million people to get out into their local neighbourhood – or beyond – and enjoy wildlife to the full. By learning more about our wild creatures, and giving them a helping hand where you can, we hope that you will not only bring benefits to our country and its wildlife, but allow you – and your family and friends – to reconnect with nature and enjoy all the advantages that will bring.

So go on – check out the Breathing Places website, or ask at your local library for more information, today!

Further reading

This list is not designed to be comprehensive, but contains a selection of the best field guides, site guides and other books that will help you make the most of wildlife watching in Britain – at any time of year! Most titles will be obtainable in high street bookshops, or to obtain them by mail order, contact Subbuteo Books www.wildlifebooks.com; or the Natural History Book Service www.nhbs.com

General

How to Watch Wildlife by Oddie, Moss & Pitcher (Harpercollins)

Collins Wild Guides: series includes *Birds, Wild Flowers, Butterflies, Garden Birds* and many more titles (Harpercollins)

Complete British Wildlife by Paul Sterry (Harpercollins)

Wildlife Gardening

How to Make a Wildlife Garden by Chris Baines (Frances Lincoln)

The Secret Lives of Garden Birds by Dominic Couzens (Helm)

Birds

Birds Britannica by Cocker & Mabey (Chatto & Windus)

Bill Oddie's Birds of Britain and Ireland by Bill Oddie (New Holland)

Collins Bird Guide by Svensson et al (Harpercollins)

Collins Field Guide to Bird Songs and Calls by Geoff Sample (Harpercollins)

Where to Watch Birds in Britain by Redman & Harrap (Helm) – NB: regional guides also available in the same series

Mammals

Collins Field Guide to the Mammals of Britain and Europe by Macdonald & Barrett (Harpercollins)

The Handbook of British Mammals by Corbet & Harris (Blackwell)

Insects

Complete British Insects by Michael Chinery (Harpercollins)

Enjoying Moths by Roy Leverton (Poyser)

Field Guide to the Dragonflies & Damselflies of Britain by Brooks & Lewington (British Wildlife Publishing)

Nick Baker's Bug Book by Nick Baker (New Holland)

Wild Flowers & Trees

Flora Britannica by Richard Mabey (Chatto & Windus)

Wild Flowers of Britain & Ireland by Blamey, Fitter & Fitter (A&C Black)

The Wild Flower Key by Francis Rose (Warne)

Collins Tree Guide by Johnson & More (Harpercollins)

Useful addresses

RSPB (Royal Society for the Protection of Birds)
The Lodge, Sandy, Beds SG19 2DL
Tel: 01767 680551
www.rspb.org.uk

The Wildlife Trusts
The Kiln, Waterside, Mather Road, Newark,
Nottinghamshire NG24 1WT
Tel: 0870 036 7711
www.wildlifetrusts.org

BTO (British Trust for Ornithology)
The National Centre for Ornithology, The Nunnery,
Thetford, Norfolk IP24 2PU
Tel: 01842 750050
www.bto.org

WWT (Wildfowl and Wetlands Trust)
Slimbridge, Glos GL2 7BT
01453 891900
www.wwt.org.uk

The Woodland Trust
Autumn Court, Grantham, Lincolnshire NG31 6LL
Phone: 01476 581111
www.woodland-trust.org.uk

Acknowledgements

So many people have been involved in *Springwatch* and *Autumnwatch* – and the other live events over the past few years – that it would be impossible to list them all, and unfair to single out individuals.

So first and foremost, to everyone in the television and online production teams and crews – thank you for your hard work, specialist knowledge and good humour; essential ingredients for live broadcasting, where anything that can go wrong usually does!

Live events such as these need huge back-up from elsewhere in the BBC, and we would especially like to thank everyone at BBC Learning and BBC Two for your continued support and enthusiasm for the project, as well as our colleagues elsewhere in the BBC Natural History Unit, at Children's BBC, and in the BBC Nations and Regions.

Outside the BBC, support and specialist advice from our various Partner Organisations – and the individuals within them – has been nothing short of incredible. The people who staff our voluntary conservation organisations and the government agencies have shown a commitment to the project right from the start; and have helped us extend the long-term reach of the broadcasts through the Breathing Places campaign. These organisations are listed on page 251.

We have had wonderful support, too, from the people working on the ground at the nature reserves and other sites from which we broadcast. Local people around these areas have also been very supportive; especially those around the Fishleigh Estate in Devon, and on the Isle of Mull and Shetland. At Fishleigh, owners Ian and Sharon Sargent, farm manager Pete Walters, and visiting ornithologist Peter Robinson have also been incredibly helpful.

Finally, we would like to extend our sincere thanks, gratitude and best wishes to you – our loyal audience. Since the very first live broadcast back in 2003 you have watched the programmes, logged onto the website, taken part in surveys, joined our campaigns, posted items on our messageboards, and attended our events. We just hope that you have enjoyed it all as much as we have – so keep watching!

Bill, Kate, Simon
and the BBC Natural History Unit production team.

Index

Picture Credits

Nigel Bean 4, 10, 16, 22, 25, 26, 27, 29, 44, 46, 49, 52, 59, 73, 75, 76, 80, 85, 86, 89, 91, 92, 94, 97, 99, 100, 102, 104, 105, 107, 108, 109, 110, 113, 135, 144, 146, 148, 150, 161, 165, 167, 168, 171, 175, 179, 181, 184, 200, 207, 218, 221, 226, 230, 242

Simon King 18, 30, 32, 34, 36, 37, 38, 41, 51, 56, 60, 61, 62, 64, 70, 74, 116, 118, 120, 122, 124, 127, 129, 130, 152, 202, 212, 215, 223, 234, 236, 238, 239, 240

Bill Oddie 6, 8, 79, 199

Marguerite Smits van Oyen 73, 120, 122

Jamie McPherson 20

Jo Morton 42

Laurie Campbell (NHPA) 132, 138, 225, 232, 244

Stephen Dalton (NHPA) 46, 49, 82, 149, 192

Andy Rouse (NHPA) 72, 128, 140, 216

Mike Lane (NHPA) 182, 210, 241

Dave Watts (NHPA) 189, 194

Alan Williams (NHPA) 15, 137, 156, 228

Bill Coster (NHPA) 68, 235

Robert Thompson (NHPA) 172, 177

Guy Edwards (NHPA) 158

Iain Green (NHPA) 67, 69

Hellio & Van Ingen (NHPA) 154

Simon Booth (NHPA) 168

Ernie Janes 246

Linda Pitkin (NHPA) 208

Daniel Zupanc (NHPA) 55